Game
Poems

The complete manuscript of this work was subjected to a partly closed ("single-
blind") review process. For more information, visit https://acpress.amherst.edu/
peerreview/.

Published in the United States of America by
Amherst College Press
Manufactured in the United States of America

Library of Congress Control Number: 2022948891
DOI: https://doi.org/10.3998/mpub.12758539

ISBN 978-1-943208-52-4 (print)
ISBN 978-1-943208-53-1 (OA)

Game
Poems

Videogame Design as Lyric Practice

Jordan Magnuson

AMHERST COLLEGE PRESS

AMHERST, MASSACHUSETTS

To Marisa, Magnus, and Iona.

"Who knows, but we may meet somewhere?"

Contents

Acknowledgments

This book owes a great debt to Noah Wardrip-Fruin, my former advisor at the University of California, Santa Cruz, who encouraged me to continue to develop, and to publish, the ideas that I began to work out as I was writing my MFA thesis at UCSC during 2017–2019. Noah was also a driving force in my decision to pursue an MFA degree at UCSC in the first place and served as an invaluable mentor during my time there; without his support, guidance, and encouragement in various capacities over the years, this book would simply not exist. I also wish to thank the other members of my MFA thesis committee, Susana Ruiz and Michaël Samyn, whose guidance significantly informed my initial explorations of this topic.

A great debt is also owed to Hannah Brooks-Motl, Acquisitions Editor at Amherst College Press, who was willing to read and consider my rather peculiar proposal, and who added invaluable insight to my project as a practicing poet with a deep knowledge of poetry. Thanks to Hannah's guidance and encouragement, this book's engagement with lyric theory is much more substantive than it otherwise would have been (though any errors or inaccuracies that may have crept in are

entirely of my own making). I also wish to thank everyone at Amherst College Press and Fulcrum who was involved with approving and producing this book, particularly series editors Anastasia Salter and Stuart Moulthrop for believing in this project, and the ACP Faculty Board for recommending it for publication. Thanks also to the anonymous peer reviewers of my manuscript for offering many keen insights that greatly improved the final book.

Many thanks are also owed to the generous individuals who were willing to read chapters of this book early on, whose feedback and encouragement significantly improved the final product, including Karith Magnuson, Matthew Fisher, Soraya Murray, and some brave volunteers from my Porter College arts seminar class. I owe a special debt to Karith for an initial round of copyediting that greatly enhanced an early version of the text. Thanks also to Thani and Brendan Magnuson for early conversations that helped shape my research, and to Kavi Duvvoori for the many exchanges about poetry, computational media, and videogames that greatly enriched it. Additional thanks are due to everyone who impacted the early stages of this project during my time at UCSC, including but not limited to the DANM faculty and staff, the members of my 2019 MFA cohort, and my EIS "podmates."

On the permissions front, I wish to thank New Directions, Graywolf Press, and the estates of William Stafford and William Carlos Williams for granting me permission to reprint some poetry in an open-access book, where other estates and publishers declined.

Of course, a book like this has deep roots, and there are ultimately more people who deserve my thanks than I can possibly name in one small list of acknowledgments. My gratitude goes out to everyone who has contributed to my creative journey over the years, including the many artists, poets, and game makers who have been my constant companions and sources of inspiration (only some of whom are mentioned in this book).

Thanks to Marisa for supporting me throughout this book-writing journey (which turned out to be rather longer than expected), and to Magnus and Iona for being constant sources of joy and wonder. Thanks also to my parents, Patti and Doug Magnuson, for passing on to me their passionate love of learning, and to the whole of my broader family for their steadfast support and enthusiasm for my peculiar interests.

Finally, thanks to you, my reader, for taking the time to read and engage with this book—a gift that I do not take for granted.

The thrilling question: What is poetry?

—Edward Thomas

INTRODUCTION
Why Poetry as a Lens for Videogames?

The question of why I propose to consider poetry as a lens for videogames is rooted deeply in my own encounter with games, and in my own practice of game creation. In 2008, I played the videogame *Passage*[1] by Jason Rohrer: a short pixel game that, in the words of its creator, "represents life's challenges with a maze."[2] On the surface, *Passage* is a very simple videogame: as the player, you move an avatar across a pixelated landscape, find a potential companion in a non-player character (NPC), explore a maze, and uncover some treasures while your avatar and companion NPC grow older and eventually die—all in the space of five minutes. Despite its simplicity (or perhaps because of it), *Passage* changed my perspective on videogames: on what videogames could be and do. The game was short, personal, and powerful; it defied typical gameplay expectations, and it seemed to punch above its weight.[3]

After playing *Passage*, I started making games that might be thought of as loosely in its vein: short, deeply personal videogames about the things I experience, the things I see and learn, the things that

Figure 1: *Passage*. (Image taken by the author during play.)

inspire me, and the things I'm afraid of. I've made games that attempt to convey something about the most basic experience of loneliness; games inspired by my time spent teaching English in Korea; games about the mundane but sacred task of caring for the gravesite of a deceased loved one; games about walking for hours with my infant son; and many more. I've been making these kinds of videogames for nearly fifteen years now.[4]

When I seek to explain these videogames to others, I'm often met with blank stares and puzzled looks. "Those aren't games" is a sentiment frequently expressed, and for good reason: my games do not require twitch reactions, have few clear rules or objectives, rarely last more than five minutes, and seldom include elements that would align with traditional notions of "fun." Rather, they are games about slowing down and paying attention, being present in the moment, sitting with some particular emotion, encountering the other. For their impact they rely not on fun gameplay or flashy graphics, but on simple representations, symbolism, metaphor, and rhythm.

But if the things I make are not traditional games, then what are they? How should I talk about my work in light of existing forms, frameworks, and traditions?

I have turned to videogame criticism and scholarship for help but have struggled to find resonant frameworks and language with which to talk about my work. Old dichotomies like ludology/narratology[5] have loomed large, and even as these dichotomies have broken down and been dismissed, they have left powerful legacies in their wake: on

the one hand, questions related to interactive narrative continue to be of first-order interest to game designers and theorists (for good reason), and on the other hand, much discussion of videogames, expressive computation, and interactive media continues to take place under the single broad heading of "game studies," which suggests— however subtly—that videogames are primarily a new type of "game";[6] a perspective that can be useful, but also limiting.

While the videogames I make can be fruitfully considered in terms of narrative or of traditional notions of gameplay, neither perspective seems completely satisfactory when it comes to identifying why the games "work," or what makes them interesting (for those who find them to be so). Consider *Loneliness*,[7] a short abstract game I made in 2010 in which the player controls a black square that they can move around a flat, 2D game world populated by groups of similar looking squares that interact with each other through simple patterns of movement and flee from the player's avatar when it approaches. I've gotten many responses to this game: some people find it uninspiring, but for others it resonates strongly enough that I receive the occasional email of thanks from an anonymous player. Why does the game resonate for these players? Studied as a traditional game, *Loneliness* is not particularly interesting: aside from the fact that it lacks any attempt at "fun balanced gameplay," it also lacks many of the basic components that game design textbooks say it should have in order to be a game at all[8]—and those simple rules and mechanics it does have aren't very exciting or innovative. Speaking as *Loneliness'* creator, I was aware of (and intentional about) making something that could be positioned at the outer edges of videogames as a medium (there is a player-controlled avatar, after all) but was never really attempting to make a good "game" at any point in the process.

The perspective that is most often shared to explain why *Loneliness* "works" is essentially narrative-focused and tends to echo some aspect

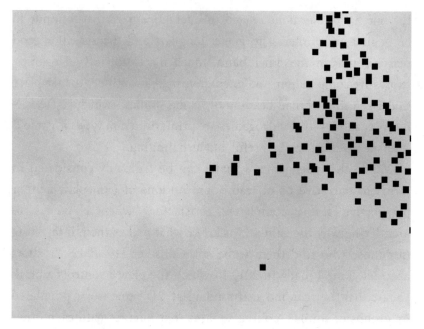

Figure 2: *Loneliness.* (Image taken by the author during play.)

of James Portnow's analysis of the game in his *Extra Credits* video lesson series:

> What's amazing about [*Loneliness*] is that it undeniably has a narrative, even though it features no words…but what's more incredible to me is how different that narrative can be for different people. …This game not only tries to put us in the emotional state of that crushing loneliness… but it lets us explore it, and this to me is the unique power games have.[9]

This is a flattering description of *Loneliness*, and a thoughtful analysis, but as with perspectives emphasizing gameplay, I feel that it leaves room for additional insight. It seems strange to me to focus an analysis of *Loneliness* on its narrative when the game is so short, and so sparse on anything that might be considered plot or character development. We can say that there are a few (only slightly different) miniature plot arcs embedded in the game—but are they *interesting* plot arcs? As

with other narrative media, I tend to judge the narrative dimension of the videogames I play by whether I find the story being told is worth conveying to others[10]—but *Loneliness* seems to fail this test miserably. ("I was a square. I approached other squares. They ran away.") And again, speaking as the game's creator (even if such a perspective is only of anecdotal interest), I was never attempting to tell a good "story" with *Loneliness*.[11]

Thankfully, there are many other perspectives to consider when it comes to understanding videogames, outside of the weary dichotomy of gameplay/narrative.[12] Game scholars have been positing interesting and alternative perspectives on videogames for as long as we have been making them—and the last few years have seen a particularly abundant outpouring of scholarship that seeks to break down (or ignore) old dichotomies. Scholars have studied videogames as computational media,[13] as visual culture,[14] as simulations,[15] as cybernetic systems,[16] as rhetoric,[17] as art,[18] as theater,[19] as documentary,[20] as riddles,[21] as rituals,[22] as toys,[23] as physical objects[24] and affective objects[25] and ontological "things";[26] as artifacts relevant to skill development,[27] learning,[28] social interaction,[29] and flow;[30] as texts ripe for queer analysis and play[31]—to name but a few recent avenues of study.

I have found many of these perspectives to be helpful and relevant in thinking about my own work, and yet none of them captures how I most often think about my games, or similar games by other creators, which is as a kind of *poetry*. Lyric poems, after all, are generally short; they are often intimate and personal; they often express or explore complex emotions; they often explore meaning in the moments and in the loose ends of life that don't necessarily have a nice narrative arc; they often attempt to slow the reader down, give pause, prompt reflection. In many ways, this list could be said to describe *Passage* or *Loneliness*; in important ways, it provides an opening for considering these games as artifacts that are not defined strictly (or primarily) by narrative, or by rhetoric, or by gameplay—or even by interaction or computation.

Make no mistake: digital poetry has been a vibrant creative field
for decades, with plenty of theory to go along with it[32]—but most of
this creative and theoretical work has been contingent on the notion
that the chief thread connecting digital and computational poetry
to written and oral traditions is a thread of linguistic sounds and
symbols, which generally excludes games like *Passage* or *Loneliness*
from serious consideration. As Mariam Asad notes, "Scholarship in
this field does not typically analyze videogames proper, but looks
at poetry created through new media."[33] The idea of using poetry
as a lens for videogames broadly speaking—that is, as a lens for
"what we talk about when we talk about videogames"—has seen
surprisingly little attention in game studies, or in popular discourse
around videogames.[34] I say "surprisingly," because poetry is a
major form that has been studied extensively in relation to other
varieties of popular media such as film, where concepts like "film
poem" and "poem film" have been widely discussed for decades.[35]
When videogames *have* been considered in relation to poetry, it has
often been to dismiss their poetic potential, as when Christopher
Funkhouser writes:

> Poetry in its traditional form may never take the shape of a video game
> because video games as we know them in popular form (i.e., lots of rapid-
> fire action, to which the player physically responds) are antithetical to the
> purposes of a certain style of poem.[36]

In a more hopeful outlook, scholars such as Johan Huizinga have
connected poetry to games broadly speaking by noting the playful
nature of poetry:

> In fact, the definition we have just given of play might serve as a definition
> of poetry. The rhythmical or symmetrical arrangement of language, the
> hitting of the mark by rhyme or assonance, the deliberate disguising of
> the sense, and the artificial and artful construction of phrases—all might
> be so many utterances of the play spirit. To call poetry, as Paul Valery has

done, a playing with words and language is no metaphor: it is the precise and literal truth.[37]

This line of inquiry offers a fascinating lens with which to consider poetry ("poetry as play") but offers little by way of a useful perspective on *videogames*, since an inversion of Huizinga's observation only leads us to postulate that if all poetry is play, then all videogames must be poems—but such an inversion ignores the tension that exists between the two forms, and the fact that we have done little to develop frameworks for conceiving of videogames as a medium of poetic expression. Poetry may be playful in nature, but not all games feel poetic, and in my experience the videogames that feel most poetic are often those that have least in common with traditional games. My interest is not so much in considering poetry in light of play, but in considering (and making) *videogames* in light of *poetry*. When I say that I think of certain videogames as poems, I do not intend this as a tautology, and I don't think other creators intend it as a tautology, either.

I mention other creators, because I am by no means the first or only game maker to think of my work as a kind of poetic practice. (I first referred to one of my own games as a kind of poem in 2010,[38] which was around the same time that some other creators also began using this kind of language, though at the time I wasn't aware of the fact.) Jason Rohrer has said that he aims to "construct a game the way a poet strings words together";[39] Auriea Harvey and Michaël Samyn of Tale of Tales have referred to *The Graveyard*[40] as "an experiment in realtime poetry";[41] Nina Freeman has compared the freedom of making videogames to writing poetry;[42] and Daniel Benmergui, Ian Bogost, Nathan Altice, and others have referred to their videogame creations as "game poems."[43]

But what does it *mean* for a videogame to be a "game poem"? What insight do we gain from such an identification? Few of these creators have offered more than passing remarks on how the two forms might

relate.[44] To liken a game like *Passage* to a poem is, on the surface, a rather blasé comparison to make: many people have reflected that *Passage* seems like a poem "in some way,"[45] but what that means (or why it matters) has rarely been very fleshed out. It's a poem because it's "as difficult to explain as a poem" writes Jason Fagone for *Esquire*, rather cryptically.[46] For critics and creators (including myself), calling a game "poetic" has often felt more like admitting a loss for words than sharing a moment of special insight: "What I have played can only be described as *poetic*,"[47] writes Raph Koster, referring to *Loneliness* and my other *Gametrekking Omnibus* games...but predictably (and understandably) leaves it at that.

When it comes to existing scholarship, it should be noted that the term "poetics" has been applied to videogames in a variety of ways, but often in a broad usage that has little to do with poetry as such.[48] D. Fox Harrell is a relatively rare example of a scholar who has applied the term to videogames in direct relation to poetry. In *Phantasmal Media*, he discusses the concept of "polymorphic poetics," which offers a framework for thinking about the way semiotics and metaphors operate within computational media.[49] Harrell does not consider poetry as a "lens for videogames" per se (he is more concerned with the lenses of cognitive science and semiotics, and more interested in computational media broadly speaking than in videogames), but his reflection on meaning-making and "poetic phantasms" in connection to videogames like *Passage* (which he relates to lyric poetry) is highly relevant to any discussion of what poetic intervention might look like for the would-be videogame poet, and I will draw on his work heavily.

Piotr Kubiński is another scholar who occasionally applies the term "poetics" to videogames in direct relation to poetry, suggesting that "the tools developed by poetics can sometimes also be helpful for analyses of games not focused on a plot or even those not using linguistic signs."[50] Kubiński does not precisely define how his concept

of poetics as applied to videogames relates to established traditions within poetry—outside of the general notion that "close playing" is related to "close reading"[51]—but his is another example of the kind of work I am interested in building on.

Other scholars, like Diğdem Sezen, have examined videogames as poems, but with a strong emphasis on narrative analysis:

> Recent approaches in contemporary narratology emphasised the need for a reappraisal of poetry's form, use of metaphors and world-building methods in respect to narrative construction in poems. Parallels between the forms of games and poetry were drawn in some of the earliest philosophical works on games and in recent theoretical perspectives on poetry. In this respect, a combination of the three—games, poetry and narrative—opens up new perspectives for IDN [Interactive Digital Narrative] design and analysis.[52]

Sezen's positioning of videogame poetics as a subset of contemporary narratology points again to the strength of old dichotomies and sits at odds with my own approach to game creation, and my interest in lyric poetry as a form long distinguished from narrative-first forms like epic poetry and the novel.[53]

In an important move away from literary perspectives grounded in either narratology or procedural rhetoric, Nick Montfort has examined interactive fiction games in light of the ancient form of the riddle.[54] Montfort's *Twisty Little Passages* is concerned with one specific subset of poetic tradition (the riddle) and one specific subset of videogames (interactive fiction) but provides a solid precedent for a broader consideration of videogames in light of a variety of poetic traditions. Other noteworthy examples in this regard are Mariam Asad's application of modernist poetry to game design analysis,[55] Thomas Papa's examination of haiku as a relevant form for

videogame analysis and creation,[56] Lindsay Grace's broad discussion of independent games in relation to poetry,[57] and Alex Mitchell's exploration of how Viktor Shklovsky's concept of "defamiliarization" might be used to craft poetic effects in videogames.[58]

Most recently, Jon Stone has investigated the interplay of poetry and videogames in his book *Dual Wield*, which builds on the theoretical groundwork laid by Astrid Ensslin's discussion of "poetry games" in *Literary Gaming*.[59] Where Ensslin is most interested in videogames that incorporate text/language after the fashion of digital poetry, Stone takes a broader approach and identifies four types of poem/game hybrid artifacts ranging from "poetry games" and "ludo-poetic intertextual mutations" to "ludokinetic poetry" and "poetic games." While Stone's interest in videogames is broader than Ensslin's, much of his attention remains on ways in which videogames can incorporate traditional poetic language/text, or ways in which traditional poetry can be game-like. His taxonomy is extremely helpful when it comes to thinking about various ways in which poetry and videogames can be seen to interact, but only a few pages of his book are dedicated to analyzing videogames that might be considered poetic apart from any inclusion of words/language (what Stone refers to as "poetic games").

I have found the work of Stone, Montfort, and the other scholars I have mentioned to be exceedingly valuable in providing precedent for considering videogames in light of existing traditions within poetry theory and practice. Still, I feel that additional perspectives are warranted since there have been few book-length attempts to apply the lens of poetry to videogames in a broad way—particularly apart from considerations of written or spoken poetic language. As these scholars and others have noted, videogames and poetry are both vast and monstrous in scope, and their potential points of connection deserve more attention from both scholars and practitioners than they have gotten to date. While I have long thought of the games I make as akin to poems, I have yet to find a theoretical framework that resonates

fully with my own creative practice or my experience of playing short expressive videogames—and that is why I propose to develop and share my own approach to using poetry as a lens for videogames.

This project may seem a hazardous undertaking, since it is not always popular to use methods and techniques from old media to "colonize" new media, and this book may appear at first glance to be exactly this kind of colonization: an invasion from old media territory that subtly suggests that new and old media are easily equated, or worse, that new media is inferior to the old. But I would counter that poetry is not a medium so much as a *form*, and not a form so much as a *mode of intervention* that can exist in any medium. (An idea that we will explore in the second part of this book.) I do look to established forms of poetry for help and inspiration, but it is not my goal to equate videogames as a medium with words, or to suggest that words or videogames are one superior to the other. Neither is it my goal to define games strictly in poetic terms, or to suggest that all videogames should aspire to be poetic. I only seek to explore some possible points of connection between videogames and poetry that I see as relevant to my own creative practice and my own appreciation of videogames, and that I hope might result in some interesting conversations we weren't having before. I present poetry not as a hidden key for understanding the True Nature of Videogames, but as one humble reference point that might help us see games in a new light and appreciate some games more fully.

My purpose is twofold: first, to show that it can be fruitful to consider certain kinds of small expressive videogames as poetic artifacts (what I will label "game poems"); and second, to provide some groundwork for those who might be interested in making these kinds of game poems in practice.

PART I

What Is a "Game Poem"?

CHAPTER 1

Thinking in Terms
of Lyric Poetry

What is a "game poem"?

As I noted in the introduction, I am not the first or only game maker to think of my work as a kind of poetic practice, or to use the term "game poem" to describe what I make. Still, there aren't too many of us using this kind of language, and what it means (or why it matters) for something to be a "game poem" has rarely been very fleshed out. These are the questions I propose to tackle in this book. But before we can jump into them headlong, there is no avoiding the more fundamental question that underpins them, that being:

What is poetry?

And here we are, barely begun, and already finding ourselves in deep water! For "poetry" is a category as vast and mysterious as any you are likely to find. To help narrow our focus, I have chosen to use the modifier *lyric* to describe the kind of poetry I will be using as a lens for videogames in this book. Depending on your background and predilections the term "lyric" may invoke a variety of ideas, and

possibly ring some alarm bells. Short, sentimental poems may come to mind, or you may imagine poetry of fixed verse form, poetry that is "old and venerable," poetry that is harmonious or musical in some way, or poetry that is simply conventional and unexciting. And while all of these have some basis in historical reality, the history and scope of lyric poetry is much vaster than any of these conceptions implies. So, what exactly is lyric poetry, and why consider this particular genre or category of poetry as a point of reference for videogames?

The short and simplistic answer to the question of definition is that lyric poetry is "what we talk about when we talk about poetry"—*most of the time*—and that is also the short and simplistic answer to the question of why it is a useful point of reference when considering videogames: because it provides a "poetic norm" for a medium that has not yet been seriously considered as offering much poetic potential. But both of these answers deserve to be more fleshed out.

First, regarding definition: the contemporary Western conception of "lyric poetry" as a category has a long and complicated history that has been thoroughly investigated by a variety of lyric scholars.[1] The concept has not been static through history, and there has been much disagreement along the way about what lyric poems are or should be. Citing Aristotle's *Poetics*, scholars have long distinguished lyric poetry from epic poetry and from drama: where epic poetry and drama are concerned to various extents with mimesis, narrative, and objective reality, lyric poetry is said, by contrast, to be non-mimetic, grounded in personal expression and subjective reality, and to be short where epic poetry is long. But as Gérard Genette has pointed out, this conception of lyric poetry (and this division of genres as such) never actually appears in the *Poetics* but is rather a formation that began to take root in Europe during the Renaissance, which was then attributed *ex post facto* to Aristotle.[2] The idea of lyric poetry as a non-mimetic counterpart to epic and drama grew and propagated after the Renaissance; then, during the nineteenth century (as Romanticism swept through Europe and the United States) lyric

poetry began to be codified as the poetic *genre of personal expression* that many of us are familiar with today. It is in this era that we began to associate lyric poetry with such persistent ideas as the "spontaneous overflow of powerful feelings" (William Wordsworth, 1798[3]), the intonations of a "lyric I" (Julia Ward Howe, 1857[4]), and the notion of "utterance overheard" (John Stuart Mill, 1860[5]). Finally, during the twentieth century, the term "lyric" came more and more to encompass all poetry outside of long epic poems, as more and more poems were read (often, again, *ex post facto*) as examples of this kind of non-mimetic personal expression—a process referred to as "lyricization" by poetry scholars.[6]

In the twenty-first century, then, "lyric poetry" can be thought of in an expansive sense, or in a more restrictive sense. In the expansive sense, the term has become increasingly vast, to the point where *The Princeton Encyclopedia of Poetry and Poetics* can make the claim that, "in Western poetics, almost *all* poetry is now characterized as lyric."[7] Far from indicating a small group of "sentimental" or "metrical" or "venerable" poems, the term "lyric poetry" today tends to encompass a huge range of poetic traditions from ancient lyric verse through contemporary free verse, rap, and even experimental poetry.[8] So, while lyric poetry includes within its ranks such venerable classics as Shakespeare's "Sonnet 18":

> Shall I compare thee to a summer's day?
> Thou art more lovely and more temperate:
> Rough winds do shake the darling buds of May,
> And summer's lease hath all too short a date;[9]

It also includes such modernist poems as Amy Lowell's "Circumstance":

> Upon the maple leaves
> The dew shines red,
> But on the lotus blossom
> It has the pale transparence of tears.[10]

As well as such contemporary offerings as Kellee Maize's rap song mashup, "Google Female Rapper," which features verses like this one, built on street vernacular:

> But this ism was given and it is written in visions
> Inside of alien prisons because I made my decision
> Before this body was given, knowin' that I would be spit'n
> White girl with ancestor wisdom
> Reppin for all of my women
> Piscean swimmin in um see, likin my venom, G
> I hope you understand me.[11]

And almost anything you can think of between.

In the expansive sense, then, the term "lyric poetry" can now be used almost synonymously with "poetry." But even as this expansive perspective on lyric poetry has taken hold via the process of lyricization, there is still a more restrictive sense in which the term "lyric" continues to refer (whether explicitly or implicitly) to a set of assumptions about poetry that were propagated during the nineteenth and twentieth centuries—assumptions related to the nature of poetic expression, the nature of poetic language, the nature of lyric speaker, etc.[12]

This interplay between the more expansive and more restrictive senses in which the term "lyric" is used is precisely what makes lyric poetry a useful lens for thinking about videogames. On the one hand, the largeness of lyric is useful because it would seem foolish to consider an obscure category of poetry as a starting point for thinking about game poems. Lyric poetry, rather than being obscure or irrelevant is, in the words of poetry scholars Virginia Jackson and Yopie Prins, "increasingly...a way to describe the essence of poetry, a poem at its most poetic."[13] Yet at the same time, the concept of lyric poetry is connected to various concrete ideas that have been well established and normalized over the last two centuries. This makes it a useful starting

place for making pragmatic observations and connections to another medium like videogames and allows us to sidestep some of the more mystical connotations that words like "poetry" and "poetic" carry with them. "What is poetry?" reads as a mystical question as much as anything else, where "what is *lyric* poetry?" has a more pragmatic connotation.[14]

What sorts of pragmatic observations can we make, then, about lyric poetry? While the lyric is a "notoriously elusive category"[15] whichever way you look at it, we can make progress here if we begin with normative conceptions and remember that the "lyric," like "videogames," is a category best thought of in terms of family resemblance rather than as a precise set of artifacts defined by hard boundaries.[16] Bearing these considerations in mind, there are several practical observations we can make about lyric poems thanks to the work of a myriad of lyric poets and scholars.[17] Observations such as:

1. Lyric poems are short.
2. Lyric poems are subjective.
3. Lyric poems make use of poetic address.
4. Lyric poems exist in a ritual, rather than a narrative space.
5. Lyric poems are hyperbolic.
6. Lyric poems are bound to metaphor and ambiguous imagery.
7. Lyric poems juxtapose signified meaning with material meaning.[18]

This list (which should be seen as a limited catalog of lyric *tendencies* rather than as a list of fixed defining qualities) is grounded firmly in post-Enlightenment conceptions of the lyric and does not attempt to trace the outer boundaries of the category or to be in any way avant-garde. It is a rather predictable, one might even say boring, list. Still, it is useful for our purposes for two reasons. First, it outlines a normative conception of poetry for consideration with regard to videogames—a medium that is often deemed to be so far from poetry

as to be irredeemably unpoetic. And, second, the list provides us with a number of concrete observations we can readily engage across medium-specific boundaries.

Of course, while the above tendencies might be useful when considering a relatively new medium like videogames in light of established poetic tradition, they are also problematic for various reasons. Despite (or perhaps because of) the extent to which ever greater varieties of poetry have been pulled into the lyric orbit in recent times, the label of "lyric" has often been viewed with suspicion or outright contempt by experimental and avant-garde poets— especially when used to conjure the kinds of poems described in the list above. Consider the outraged and sarcastic tone that permeates the introduction to *The UbuWeb Anthology of Conceptual Writing*:

> Poetry expresses the emotional truth of the self. A craft honed by especially sensitive individuals, it puts metaphor and image in the service of song. Or at least that's the story we've inherited from Romanticism, handed down over 200 years in a caricatured and mummified ethos— and as if it still made sense after two centuries of radical social change.[19]

There is good reason that many contemporary poets and theorists take issue with lyricization and with post-Enlightenment lyric norms: because those norms are often limiting, or problematic. The history of lyricization as a sexist and racist project has been pointed out by scholars like Anthony Reed, who notes that "Lyricization corresponds with the emergence of the modern, [white and male] bourgeois subject—a private individual expressing himself to other private individuals who read in quiet contemplation."[20] If we say that "all poetry" is lyric poetry, we are in one sense expanding our conception of lyric poetry, but we cannot escape the fact that we are simultaneously forcing "all poetry" to conform in some way to our

historically contingent assumptions about what lyric poetry is, has been, or should be—as well as assumptions about who lyric poets and lyric readers are—and presenting any list of "lyric characteristics" or "lyric tendencies" makes this problem all the more evident.

As such, challenging the lyric tradition is vitally important to the health of contemporary poetry, and to the health of the ongoing dialectic between the idea of "lyric poetry" on the one hand and the idea of "all poetry" on the other. Such challenges have given rise to a diverse array of poetic traditions that attempt to escape the lyric orbit in one way or another; traditions such as concrete poetry, sound poetry, language poetry, performance poetry, conceptual poetry, and digital/computational poetry, to name a few. On the poetics front, there has been pushback against the twentieth-century tendency to overemphasize the "site of the poem," and a desire for poetic practices that take seriously questions of social change and civic responsibility in the face of contemporary concerns like capitalism, sexism, racism, classism, colonialism, and ecosystem collapse—concerns that, as we have already noted, are often implicated in the history of lyric poetry and lyricization.[21]

All of this being said, lyric poetry remains a central (one might even say *the* central) point of reference for "what we talk about when we talk about poetry"—even for those seeking to challenge longstanding lyric tendencies. As poetry scholar Jonathan Culler notes, "despite contemporary poets' resistance to the idea of lyric, many contemporary poems achieve their effects by engaging the lyric tradition," which is "the poetic norm."[22] Take sound poetry or concrete poetry, for example. While these radical forms of experimental poetry are generally excluded from lyric poetry as a category, they have more in common with lyric poetry than people tend to imagine. Sound poetry, for instance, comes about by taking what Northrop Frye refers to as the "melos" interest of lyric poetry (the interest in material

sound, or "babble") to the far extreme, while concrete poetry does the same with lyric poetry's interest in "opsis" (the material image, or "doodle").[23] Some poets, like Muriel Rukeyser, go so far as to claim that these forms are experimental precisely in the tradition of "pure poetry," which is "The Lyric."[24] Or consider generative computational poetry.[25] While I would hazard that most computational poets are not overly concerned with crafting artifacts that are "lyric poems" according to nineteenth- or twentieth-century expectations, there is still a significant way in which these creators engage with Mill's idea of lyric poetry as "utterance overheard"—in this case, the interest is in overhearing the "utterance" of the computer (which takes on the role of poetic speaker and "lyric I"). But more importantly, to claim that a computer is crafting poetry in the first place is to engage the lyric, precisely because it has become so entrenched as the poetic standard: one cannot make claims about crafting "poetry" in the contemporary West without appealing to the lyric tradition in some way, either explicitly or implicitly.[26]

And that is why I have chosen to start this project by unequivocally engaging the "normative model of the modern lyric" as a reference point for videogames. Where we have many historical answers to (and disagreements about) the question, "what is a poem?" we have very few historical answers to (or disagreements about) the question, "what is a *game poem*?" Thus, it makes sense to begin such conversations by engaging the lyric norm that underpins so many of our basic assumptions about poetry.

Returning to our list of lyric characteristics and tendencies, I do not expect the list to be, in itself, of particular interest to the poetry scholar or to the practicing poet. It is certainly not "new" or "exciting." But what I hope may be of interest—to the poetry scholar and the poet, as well as to the videogame scholar and videogame creator—is my examination of how these lyric characteristics and tendencies can

function *in videogames as a medium*, in a way that has the potential to enhance our appreciation both of videogames and of poetry in turn. My hope is that this will be the beginning of a conversation, rather than the end of one, and that additional poetics frameworks (including radical, oppositional frameworks) might be brought to bear on this medium once we have firmly established that yes, videogames too can be poems.

When I refer in this book to using poetry as a "lens" for videogames, I hope that my language suggests a rather clear image. Still, I should perhaps clarify what I do and do not mean by this phrase. At a basic level, I mean simply that we will be approaching videogames with the assumption that poetry has something relevant to offer our exploration of this medium. We might call this approach looking at videogames "through" or "via" poetry (the lens image), or we might call it reading videogames "after" poetry (meaning approaching videogames after having engaged with poetry—language that also alludes to the historical trajectory of videogames as a much newer medium than words). Of course, as we have touched on in this chapter, the world of poetry is vast, and even as we rely on normative conceptions of lyric as a touchstone, we will ultimately be picking and choosing certain aspects of lyric theory to bring to this conversation.

In the following chapters, then, we will touch on what each of our identified lyric characteristics is about, and comment on how each characteristic can help us more fully appreciate certain aspects of certain videogames, including examples from my own practice. (I am a maker first and foremost, and this book has largely been fueled by questions stemming from my own creative journey.) In this process, we will consider the question of what a "game poem" might be, and why such a category might matter. I will use *Passage* (a short game that you may recall from the introduction) as a kind of through-line in this investigation—not because I "like" *Passage*, and not because

it is necessarily a Great Videogame (you can decide for yourself what you think of it), but rather because it presents a good opportunity to develop our thinking in light of a short expressive game that has been widely played and studied.[27] If you have not played *Passage* yourself, I encourage you to do so before continuing on to the next chapter: the game is free, takes only a few minutes to play through, and is readily discoverable via an internet search.

CHAPTER 2

Game Poems are Short

When it comes to lyric poetry, the fact that lyric poems are short seems as good a characteristic to start with as any and represents an easy enough concept to grasp. As with other characteristics of the lyric, brevity should not be thought of as a fixed defining quality, but rather as a characteristic *tendency*: "With a view to the majority of poems," shortness is "an obvious prototypical trait," notes poetry scholar Werner Wolf.[1] Writing in the middle of the twentieth century, literary theorist Northrop Frye goes so far as to say that the term "lyric" is simply a kind of "jargon or trade slang" for poems that are short (in contrast, again, to longer epic poems).[2] Certainly, there is some ambiguity around what "short" means exactly, but we can hazard that most lyric poems can be read through in the span of a few minutes. Celebrated American poet Mary Oliver says lyric poems are typically "sixty lines or so, and probably shorter," and that they usually have "no more than a single subject and focus and no more than a single voice."[3] Many, like Ezra Pound's famous "In a Station of the Metro," are significantly shorter:

The apparition of these faces in the crowd:

Petals on a wet, black bough.[4]

Very well: we might say that game poems, then, should generally be "short." But what of it? It is easy for this characteristic of lyric to seem like something of an inconsequential accident because we are likely to privilege narrative reading over lyric reading when it comes to literature: a short story or a long one can both have their arcs plotted out easily enough in a way that is likely to minimize any difference of length. But if we are speaking of plotting story arcs on a graph, we are in the realm of fiction, rather than lyric. Where fiction is concerned with what happens next, lyric poetry is concerned with what happens *now*. "The distinguishing features of lyric are a presence and intensity that make it, in a double sense, the *literature of moment*,"[5] notes poetry scholar Earl Miner. As we shall see presently, when it comes to lyric reading, the moment-to-moment experience of the text itself is the thing, and every detail matters. We do not ask *if* it makes a difference that lyric poems are short, but rather *how* it makes a difference.

We can start to answer this question by comparing lyric poetry to longer forms, like epic poetry and the novel. When discussing the length of these forms, we are not talking about the difference between forms such as the novel and the novella, but rather the difference between something that takes *hours* to read versus something that takes *minutes*. The contrast is striking and helps us recognize that the short length of lyric poetry, far from being accidental, plays an important part in establishing the lyric as a recognizable category: something compact and potent that can be experienced and reexperienced at short notice and surrounded with time for reflection.

Now consider videogames, and how the lens of lyric poetry allows us to look at something as unglamorous as a game's short length from a fresh perspective. Consider that from a gameplay perspective interested in notions of fun, social interaction, or flow, for example,

it's hard not to read a too-short game as anything but a rather obvious failure: there is simply not enough time to build momentum toward these kinds of gameplay goals.[6] Likewise, from the perspective of a typical game player interested in story, the short length may seem accidental, or limiting. (A sentiment clearly expressed in Marcus Richert's interactive parody of *Passage*.[7]) Narrative scholars, on the other hand, may find a game's short length to be of interest, but for a game as short as *Passage* would be hard pressed not to see the connection we are paving to lyric poetry.[8] Meanwhile, those interested in other literary lenses, like that of rhetoric, might note that a game's brevity can help its message come across clearly and potently—but such observations are often only made as afterthoughts, if at all.[9]

By contrast, read through the lens of lyric poetry, the short length of games like *Passage* or *Loneliness*, which we examined briefly in the introduction (we will consider more short games presently), is not an accident, or a failure at the level of narrative, gameplay, or entertainment, but rather an important characteristic that positions these games within a tradition of lyric works: works that want to be read not once, but many times; works that defy you to read them and not have plenty of time for reflection; works that beg you to pay attention and consider their every sound and image and interaction (a practice we will engage in shortly)—just as lyric poems have always done. As videogame scholar Lindsay Grace notes, in an echo of Mary Oliver, these kinds of games "are often engaged in the pursuit of a single idea or emotion, much like the notion of poetic theme."[10]

This is not to say that such positioning is necessarily intentional. Of course, it is possible (we might even say likely) that any short videogame, like any short piece of text, may not have been crafted to be a "lyric artifact": it may be far from the author's intention—if there is a distinct author at all—that you read the work more than once, or that you pay close attention to every one of its details. But here we see the distinction between lyric categorization and lyric reading; between

hermeneutics and poetics; between notions of authorial intent and lyric analysis.

In the following chapters, we will be less concerned with whether any given game is in some mystical way a True Lyric Work—that is left for others to decide—than with reading some games lyrically (whether they were intended for such a reading or not). While we will be working toward a loose definition that might help us to identify and discuss "game poems," the point is not primarily to properly interpret or categorize these games, or get at their True Meaning, but rather to see if a close lyric reading can enhance our *appreciation* for any given game; whether considering these games as game poems can give us something to think about, something to talk about.[11] In other words, we will be looking to answer the central question of this part of the book ("What Is a 'Game Poem'?") in a loose, conceptual way for the purpose of starting a conversation, rather than attempting to build a strict definition intended to be a conclusive or exclusive final word on the matter.

The games we will be considering as "candidate game poems" in this text have been chosen based on three criteria. (Apart from my own games, which may be seen to fit these criteria but which I discuss primarily as a matter of praxis.) First, they are all games that have, in one way or another, been *positioned* as videogames, often based on some combination of distribution channels and intentional labeling: that is, they appear in a context with other videogames and are labeled or referred to as "videogames" at sites of distribution or sites of conversation. Second, they are games that bear some amount of *family resemblance* to other videogames: that is, we can talk about specific characteristics that connect them to other videogames (e.g., a player-controlled avatar or the use of classic videogame iconography). These considerations are important, because they help to clarify what we mean by the phrase, "what we talk about when we talk about videogames" in the context of discussing unusual games in relation

to a form like poetry that has often been thought to be antithetical to videogames as a medium.

It should not be surprising that most of the games we will examine conform to some expectations for the medium (e.g., they may utilize the player-controlled avatar), while ignoring or disdaining other expectations (e.g., they may fail to provide a sense of challenge, or a clear win condition). "Videogames" is a vast category that is under significant pressure and constantly expanding, and I have no interest in relieving that pressure or slowing that expansion. As such, some of these games admittedly lie at the hazy outer edges of the videogame ecosphere—but the criteria of positioning and family resemblance always apply to some extent.

Finally, the games we will examine are ones that I have personally found to be interesting and fruitful to consider in light of poetry—that is, they are games that, in the course of my own exploration of the medium, have given me "something to think about, something to talk about." Because discussing a few select videogames in the context of a large and evolving medium can feel arbitrary ("why discuss Game X but not Game Y?"), I have also taken timeframe into consideration and chosen many of our specimens from games that were released circa ten to fifteen years ago at a point when a variety of creators (including myself) first started to refer to their game making as a kind of poetic practice and to use terms like "game poem" to describe what they were creating. I have made this choice partly because this period feels like a relevant and non-arbitrary historical moment to consider when discussing the subject at hand, and partly because videogames are an embarrassingly new medium to discuss in the context of a form like poetry, which has been around for thousands of years. Consequently, I have tried to reach back ever so slightly for examples, to forestall those who might be tempted to dismiss this whole conversation as premature or faddish. Meanwhile, I hope my discussion of (and invitation toward) present-tense practice throughout this book prevents anyone

from drawing the opposite conclusion (that game poems are relics from a however-recent past). Thanks to the advent and popularity of tiny game creation tools like Bitsy, along with accessible distribution platforms such as Itch.io, I can state without hesitation that more people are making and playing game poems today than were doing so ten or fifteen years ago. (See Appendix I for help finding recent game poem examples.)

Some of the games we will examine feature text, but in general I have focused on graphical games rather than textual or linguistic games because words have always been the natural domain of poetry, and I am interested in the poetic potential of videogames irrespective of their use of words. The games that follow are not meant to form a canon, and are not necessarily meant to be "exemplary game poems" any more than the next game that might come along. Ultimately, they are games that were simply relevant and "ready-to-hand" for the conversation with which this book is concerned.

CHAPTER 3

Game Poems are Subjective

When we say that lyric poems are subjective, we mean that the *subject* is placed at center stage: lyric poems are personal and expressive; they often involve a first-person speaker; and they often privilege an exploration of that speaker's inner life, or inner world, with "salient self-referentiality and self-reflexivity."[1] Poetry is "the spontaneous language of my heart,"[2] says Robert Burns. Or, as Hegel famously intoned when he elevated lyric poetry to the purest form of subjective expression: "it is the subjective side of the poet's spiritual work of creating and forming his material which is clearly the predominant element in his illustrative production."[3] The lyric stands in contrast here to the drama and the epic, which are concerned to different extents with "objective" outer-world relationships and meaning.[4]

Consider this stanza by William Stafford:

Some time when the river is ice ask me
mistakes I have made. Ask me whether
what I have done is my life. Others
have come in their slow way into

my thought, and some have tried to help

or to hurt: ask me what difference

their strongest love or hate has made.[5]

This poem presents a typically lyric concern with inner life and inner reality that cannot be objectively judged. As Käte Hamburger notes in *The Logic of Literature*: "The lyrical reality statement cannot be compared with any reality.... We are dealing only with that reality which the lyric I signifies as being *its*, that subjective, existential reality which cannot be compared with any objective reality which might form the semantic nucleus of its statements."[6]

While there has been much pushback against the subjective and expressive expectations attached to lyric poetry in recent times,[7] the subjective quality of lyric is an intriguing consideration when reading videogames because videogames have always been predominantly concerned with objective reality: from *Computer Space* to *Pong* to *Wii Sports* to the latest *Call of Duty* and *Grand Theft Auto* games, videogames have been nothing if not preoccupied with the idea of relating people and objects in representations of physical space: spaceships flying; spaceships and missiles colliding; rackets and balls colliding; people holding rackets; people holding guns; guns shooting enemies; enemies driving cars...on and on infinitum.[8] Against this backdrop, a videogame like *Passage* is striking for how it seeks to represent not physical objects in space, but the experience of a *subject* wandering through a metaphorically projected inner landscape of experiences, memories, and emotions.

Consider the meaning of *Passage*'s two-dimensional landscape (the navigable space we are meant to traverse with our avatar): To read this space according to established videogame convention is to read it as representing a physical space of some kind, just as we read our avatar as representing a physical body, and our pressing of arrow keys on our keyboard as representing physical movement of that physical body. But as game scholars like Nick Montfort, Noah Wardrip-Fruin,

Michael Mateas, D. Fox Harrell, Doris Rusch, and others have noted,[9] *Passage* pushes back against this reading, and we soon realize that our traversal of the game's navigable space represents not a traversal through physical space, but a traversal through *time*. And this is not meant in the sense that playing *Passage* "unfolds in time" (which is true of all videogames, since they are real-time media), but rather that *Passage* metaphorically maps a traversal of its *two-dimensional landscape* to a traversal of the player character's *lifespan*. To traverse this space is to traverse through *life*, with the various complexities and ambiguities that that word implies.[10]

How precisely *Passage* achieves this effect has been explored by many scholars[11] and will be touched on further in later chapters of this book; for now, the important point is that the effect is achieved—and that a lyric reading helps us to appreciate the effect's significance, and the game itself more fully.

With all this reference to existing scholarship, it may initially appear that we are treading old ground with our current investigation. And while it is true that many scholars have identified various layers of symbolism and metaphor present in *Passage*, it is important to note that few have analyzed the game holistically as a lyric artifact or attempted to systematically explain why many of us use words like "poetic" to describe our play experience.[12] My goal in this book is not to decry or disprove existing scholarship, so much as to build on that scholarship and trace a path to a new holistic perspective. Placing a game like *Passage* within a broad tradition of lyric works gives a larger

Figure 3: *Passage*'s play space does not represent a typical physical landscape. (Image taken by the author during play.)

context for appreciating some of the effects that scholars have noted to date, and also allows us to probe beyond them and consider other ways in which the game situates itself not just as an interesting videogame or piece of interactive media, but very particularly as a kind of lyric poem.

For the lay game player especially, the idea that a videogame might be read holistically as a poem can provide a crucial touchstone for considering why one might or might not appreciate a game like *Passage*. For the typical player, reading *Passage* as a *game* may reveal a number of different things depending on the player's preconceptions and expectations: that it is not challenging and lacks a clear goal;[13] that its basic mechanics are not novel; that there are limited interactions between its systems; that its players have limited agency; that it presents few opportunities to build flow;[14] that it is not particularly social, or very "fun."[15] Likewise, a player approaching *Passage* with a desire for a "satisfying interactive story experience" might find that the game's narrative arc is not very remarkable, or that its character development is skeletal and highly ambiguous.[16]

Such observations are understandable, but the lenses employed do little to help these players understand why some people find *Passage* to be moving and resonant. Positioning *Passage* as poetry, by contrast (that is, to consider it as a "game poem"), takes the game into an explicitly different space and can reveal a host of alternative reasons to appreciate it, from its noted use of symbolism and metaphor through to its engagement with ritual space, hyperbole, and a variety of other lyric characteristics that we will explore shortly. Returning to the lyric concept of subjectivity, we see in *Passage* an intriguing example of how videogames can move beyond the rendering of object-oriented external reality and into the realm of inner experience and subjective reality—that is, into the realm with which lyric poetry has always been most concerned. *"Some time when the river is ice ask me / mistakes I have made. Ask me whether / what I have done is my life."*

An emphasis on inner reality has characterized many of the games I've made over the last few years, and I believe a lack of useful

subject-oriented lenses outside of narrative traditions is one reason that players and critics have often found my games hard to parse. *Loneliness*, like *Passage*, utilizes simple representations and well-established mechanics borrowed from outer-world-focused videogames in order to represent inner-world realities—but in the tradition of games like Rod Humble's *The Marriage*,[17] *Loneliness* relies even more heavily than *Passage* on explicit symbol and metaphor.[18]

We can say that the squares in *Loneliness* denote people, but their movement does not really represent the movement of people through physical space; rather, to make sense of *Loneliness* one must read the movement of groups of squares that "jump" or "circle" together as indicative of various kinds of social connections or relational bonds—and not just as social connections or relational bonds, but as *subjectively perceived* social connections and relational bonds. To traverse the

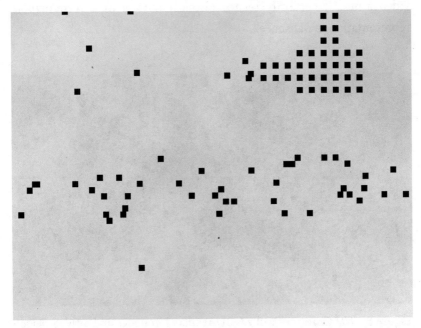

Figure 4: The movements of squares in *Loneliness* represent subjective perceptions of social bonds and interactions. (Image taken by the author during play.)

landscape of *Loneliness* is to traverse not a physical space, but the world of a subject's inner perceptions and beliefs; in Käte Hamburger's words, *"that subjective, existential reality which cannot be compared with any objective reality which might form the semantic nucleus of its statements."*[19] In my mind, such an inversion of traditional videogame expectations around objective and subjective reality is part of what makes the game resonant for some people despite its simplicity, linearity, and (in my view) lack of narrative sophistication.

As a final example, let's consider *The Graveyard*,[20] a short game by Auriea Harvey and Michaël Samyn released in 2008, in which the player guides an old woman through a cemetery. *The Graveyard* utilizes relatively realistic (if monochrome) 3D-rendered graphics, and a third-person perspective made familiar by action games like *Super Mario 64*[21] and *Tomb Raider*.[22] At first glance, then, this game appears to be concerned with objective reality in the tradition of most videogames. It certainly relates physical objects in a recognizable representation of 3D space.

Figure 5: *The Graveyard* utilizes 3D-rendered graphics and a third-person perspective typical of action games, yet presents a different kind of experience. (Image taken by the author during play.)

But rather than the smooth, fluid character movement we have come to expect in such games, moving our avatar in *The Graveyard* is a slow and excruciating process. As Piotr Kubiński notes:

> The protagonist, who walks with a cane, moves very slowly, so that getting to the bench takes her at least a minute and a half—on condition that the player decides to go straight toward the chapel. There is no real reason for him to head in a different direction, because the side streets have no actions or interactions to offer.[23]

What is the meaning of this space we see around us if we cannot interact with it? We have departed from the seemingly familiar territory of third-person action games: instead of running through the landscape and interacting bodily with the objects we see, we can only plod forward and reflect on our situation.

And that is precisely the point. Upon reaching the bench the old woman sits down, and a long folk song begins to play in her head; there is nothing at all to do in the world of objects while the song plays out. *The Graveyard* hinges on the moment of realization that the objective relationships on display are not the ones that matter here: it is the old woman as *subject* who is interesting: her inner life; her spiritual beliefs; her relationship not to the physical space of the graveyard but to the other *subjects* she has known throughout her life. Or rather: her relationship to the physical space of the graveyard is interesting *via* a consideration of her spiritual beliefs and the other subjects she has known throughout her life.

As videogame scholar Alex Mitchell points out, *The Graveyard* undermines player expectations for control to achieve poetic gameplay via a "defamiliarization" effect (Mitchell draws here on the language of Viktor Shklovsky)[24]—a process that I would argue is intertwined with the game's interest in subjective reality.[25] As with *Passage* and *Loneliness*, the inverting and recasting of the familiar objective world of videogames by *The Graveyard* is striking and thought-provoking,

and considering the game through the lens of lyric poetry—as a "game poem"—helps us pick up on this particular contrast in a way that other lenses might not.

But we are still a level removed from the game's final layer of subjectivity, because what *The Graveyard* ultimately enables the player to do is reflect upon their own life. Like the player character of *Passage*, the "player square" of *Loneliness*, and the "I" of Stafford's poem, *The Graveyard*'s old woman (while rendered at higher fidelity than our other examples) finally serves as a receptacle for the player themselves as subject. Which brings us to our next topic: poetic address.

CHAPTER 4

Game Poems Make Use of Poetic Address

As we shall see, poetic address is more complex and ambiguous than prose address. Poetry scholar Virginia Jackson points to Percy Shelley's "To a Sky-Lark" as one example, noting that the object of address in this poem is "actually the literary dissolution of the body":[1]

> Hail to thee, blithe Spirit!
> Bird thou never wert—
> That from Heaven, or near it,
> Pourest thy full heart
> In profuse strains of unpremeditated art.[2]

The foundational premise of poetic address rests on John Stuart Mill's assertion that poetry, rather than being a simple act of communication between one person and another, reads as "utterance overheard" by a third party.[3] There is often the question of who is speaking to whom (or what!), and the answer is often multifaceted: a fictional speaker may be addressing a fictional audience or object, but that fictional speaker may be speaking for the poet themselves, and the fictional audience

may in fact represent the poem's reader. Sometimes blatant apostrophe is used (addressing of an inanimate object), and sometimes a "blurred you," that gestures toward the reader, but could also be taken to be the poet themselves, or someone else. As Antonio Machado writes in his Proverbios y cantares: "The you of my song does not refer to you, partner; that you is me."[4]

Culler gives Goethe's second "Wanderer's Nightsong" as an example of this kind of indeterminacy:

> O'er all the hilltops
> Is quiet now,
> In all the treetops
> Hearest thou
> Hardly a breath;
> The birds are asleep in the trees:
> Wait, soon like these
> Thou too shalt rest.[5]

The first "thou" here can be read as an impersonal "one," "but the second, because of the command, '[wait],' is read either as self-address—the speaker too will rest soon—or, as the poem is generally interpreted because of the universality of death, as a broader address in which readers are implicated as well."[6]

Let's return to *Passage* for a moment and continue to read it as a lyric game poem. As in Goethe's poem, one of the reasons the game is interesting is for the address—the complex relationship that seems to exist between the game's creator, the player, and the work itself. When one finishes the game, one gets the distinct impression that something deeply personal is being directly expressed, but it is not so obvious what that "something" is, who is expressing it, or to whom. Echoing lyric theorists, digital media scholar D. Fox Harrell notes that the player character in *Passage* seems to "simultaneously [represent] the player and Rohrer alike as a player character."[7]

On the one hand, it doesn't seem right to read *Passage* as straightforward fiction—the author seems too much present "in the room." But neither does it seem right to say that Jason Rohrer, the game's creator, is speaking to the player directly (the game's "creator's statement" may be something closer to that[8]). What is happening, then? Is the game's creator speaking to himself? Is he speaking to the player indirectly, through the pixelated characters on screen? Is he speaking *to* one of those characters? Or is it rather that the game itself is speaking, in lieu of its creator? Does the player speak back when they play? If so, are they speaking back to the game, to its creator, or to themselves?

I would argue that all these avenues of discourse are embedded in the game, in a milieu strongly resembling historical modes of poetic address. Lyric poems are preeminently "utterances for us to utter as ours,"[9] notes literary critic Helen Vendler. Culler elaborates, saying, "we encounter lyrics in the form of…texts to which readers give voice. What we 'hear' is our own ventriloquizing of ambiguously directed address, though we may, in some cases certainly do, construe this as overhearing a distinctive poetic voice."[10] Is this perhaps what playing *Passage* feels like? Voicing the words of a poet out loud to ourselves, so that in a single moment we feel that the poet and the game are speaking to us, and also that we are speaking back to them, and back to ourselves?[11]

Compare playing *Passage* or *The Graveyard* to playing *Frogger*[12] or *Doom*,[13] games where there is no such complexity of address. The question of an author existing does not tend to surface at all in these games (games about a frog crossing the highway and a marine mowing down demons, respectively), much less the idea of an author who is attempting to speak to the player, or the question of what that author might be trying to say, or what the player might want to say in return. In some ways the frog of *Frogger* acts as an empty receptacle for the player in much the same way as the old woman of *The Graveyard*

does, but the only question of relationality that develops in *Frogger* is how "you" as the frog are positioned in relation to the objects in your environment; likewise for *Doom*. Objective reality, again. In *Passage* and *The Graveyard*, by contrast, there exists an implicit question of how "you" as the player are positioned in relation to each game's respective author(s) and the ambiguous "enacted utterance" of each game.

For longer narrative-heavy games, the question of authorship may arise more readily than for traditional action or arcade games (because we have historically ascribed authorship to narratives more so than to games). But for these kinds of games our relationship with the author tends to be fairly straightforward, as it is with most narrative works: the author is the person (or persons) who created the fiction. There tends to be less ambiguity and triangulated address at play, less question of the author being present "in the room" and speaking to the player directly in a ritual moment—which is the basic distinction made by lyric scholars between narrative address and poetic address. As with most characteristics of the lyric poetry, this distinction is important, but also subtle.[14]

How do *Passage* and *The Graveyard* present us with a kind of complex poetic address while *Frogger* and *Doom* do not? By eschewing gameplay, narrative, and literalism; by being short, ambiguous, and explicitly metaphorical—*like poems*. These are characteristics that bring forward notions of author and message while at the same time making message ambiguous and complexifying the player's relationship to the game and its various representational units. At a basic level, when we play these games, we feel compelled to ask ourselves what they are, what they're doing here, who made them, and why. Questions of author, message, and address naturally arise. Also important is the way these games suggest deeply personal expression while simultaneously touching on highly universal themes. As Culler notes of Goethe's poem, we interpret it as a broad address in which readers are implicated partly because of the universality of its central theme (death).

Another way that games can invoke poetic address is through ambiguous shifting of perspective—a technique I utilize in a few of my games, most explicitly in *Portraits of My Child*,[15] a tightly constrained PICO-8 game[16] that presents a series of short vignettes, each meant to evoke some aspect of my son's first year of life. The game presents eleven vignettes that are grouped into a roughly haiku-like structure of 3–5–3, where each set and each individual vignette are proceeded by a short line of text.

Controls, objectives, and representations are ambiguous throughout *Portraits of My Child*, but in the first set of vignettes the player has what essentially amounts to a third-person perspective on various representations of my infant son and attempts to guide him in some way through the sequence of birth, breathing, and breastfeeding. In the second set of vignettes the game's already low-resolution graphics give way to even more ambiguous blocks and washes of color: in "Hello World," the player holds down the up arrow to gradually "open their eyes" from a first-person perspective; in "First Smile," they press any key to transform a solid black screen to yellow and unleash a cheery 8-bit "bleep" sound effect. This shift seems to indicate a change in perspective from a vantage point outside my son, to my son's own vantage point, but the mechanics of player interaction complicate this interpretation. The final set of vignettes further complicates questions of perspective by including vignettes from both first- and third-person perspectives, some of which can be read as either representing my son's perspective on another person *or* another person's perspective on my son.

I employ these ambiguous perspective shifts intentionally in order to set up a kind of triangulated address between the game's player, myself as the game's creator, and the various evocations of my son. The game, in my mind, does not represent either a single perspective or a simple shifting perspective, but an ambiguous set of perspectives within perspectives designed to continuously evoke questions of how the self relates to the other and who is addressing whom. *"The you of my song does not refer to you, partner; that you is me."*

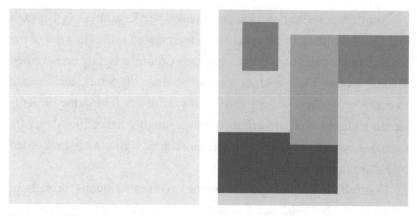

Figure 6: The vignettes in *Portraits of My Child* range from highly symbolic to slightly more concrete. (Images taken by the author during play.)

Let's turn to a final example now—*Seasonal Mixtape*[17] by dino—and consider how videogames can utilize apostrophe in addition to the "blurred you" triangulated address invoked by *Passage*, *The Graveyard*, and *Portraits of My Child*.

Seasonal Mixtape is a short Bitsy game[18] created in 2018 that presents a series of four semi-abstract vignettes, each titled after a season ("autumn," "winter," "spring," and "summer," respectively). In each of these vignettes, the player uses the arrow keys to navigate an ambiguous pixel avatar through a two-dimensional space consisting of pixelated, abstract impressionist depictions of landscapes (a corridor of autumn leaves, a bare winter forest, a boardwalk with flowering tree, a beach littered with shells). As the player moves their avatar about the space, colliding with certain groups of pixels sometimes triggers a text box to appear with some brief poetic composition related to the season (the game incorporates quotes from Ali Smith's *Seasonal Quartet*).

My interest at this juncture is not in critiquing the poetic quality of the game's text or in considering that text out of context. Rather, I'm interested in considering how the game's text, avatar presentation, visual style, and interaction logics work together to establish an intriguing mode of poetic address. Let's consider the autumn scene: the

Figure 7: *Seasonal Mixtape*, track 1: "autumn." The small cluster of pixels in the lower left is the player's avatar. (Images taken by the author during play.)

avatar is highly ambiguous here, as is the perspective on the landscape. The player seems to be directing a bit of wind, or perhaps a crushed leaf on the wind. Some of the first text we encounter appears to support this perspective, but then we read this: "You breathe in the crisp air and / wait a moment before exhaling…happiness wriggling in your / chest…the happiness of wearing // soft hoodies and jumping in rain / puddles." Are we a leaf on the wind, then? Or are we a fictional person? Or is the game's creator addressing us directly as players?

Without our avatar and the scene's interactive component, we might take the text at face value: we as readers/players are being spoken to by the poet. But in the game's context, this gets rather turned on its head—because we are a leaf, or something. So, the "you" of the text's address becomes highly ambiguous and triangulated, as does our relation to the avatar we are controlling: perhaps our peculiar avatar represents a person after all (if so, does it represent a fictional person, or does it represent us as players, or does it represent the game's creator?), or perhaps we are the leaf on the wind speaking out to a person (perhaps speaking back at the poet with the poet's own words?). This is a fascinating case of triangulated address and poetic "ventriloquism" that can only really be achieved by interactive media.

It is also an example of complex apostrophe, where as players we find ourselves uncertain about whether we are addressing a leaf on the wind (whether via text or interaction), or whether someone is addressing *us* as a leaf on the wind; either way, the game positions itself in the lyric tradition of apostrophe:

> The most blatant invocation of triangulated address is the invocation of impossible addresses, such as unseen powers: "O wild West Wind, though breath of autumn's being" (Shelley, "Ode to the West Wind"), or creatures and things unlikely to answer—a lion, a ship, death, a swan, the earth.[19]

Seasonal Mixtape's subsequent vignettes play on and intensify the triangulated address established in the game's first scene. They also bring out additional aspects of the game's poetic quality as it becomes increasingly clear that the game's creator is not relaying a fictional narrative, but attempting to say something True about life, autumn leaves, and footsteps in the snow. But now we are entering the domain of our next topic: ritual space.

CHAPTER 5

Game Poems Exist in a Ritual Space Rather Than a Narrative Space

Poetic address is one example of how lyric poems tend to exist in a kind of ritual space: they don't describe events so much as they exist to *be events*: to be performed and reperformed in what Muriel Rukeyser calls "a ritual moment, a moment of proof."[1] To engage a poem is to "*participate in a ritual* of sensitivity and self-awareness," says poetry scholar Marjorie Perloff.[2] Rather than describing a fictional scenario, the lyric poem can often be seen as a "forum for direct truth claims about the world on the part of the poet,"[3] due in part to the "existence of one seemingly unmediated consciousness or agency as the centre of the lyric utterance or experience."[4] Again, this sets the lyric apart from mimetic, narrative-first forms like fiction.[5]

We can point to Maya Angelou's "Still I Rise"[6] as a poem that offers an obvious example of this kind of truth claim positioning. The poem's nine stanzas describe a lyric "I" who is shot at, cut, pushed down, and killed by an anonymous "you," but who nevertheless proves indomitable with each invocation of the poem's haunting refrain:

"But still I'll rise." This poem presents "utterance" more than narrative, and "not fictional utterance but the real utterance of a subject of enunciation."[7] (We could also look back to Kellee Maize's "Google Female Rapper" as another example of this kind of positioning.)

Taken as a game poem, *Passage* can easily be read in this tradition of performed event, utterance, and truth claim. We have already observed that *Passage* is not particularly interesting from a narrative standpoint if read as "fiction." The game moves us, and yet if we attempt to recount the "story" of what happens in a given playthrough, we find that the recounting misses the mark; in fact, I would argue that there is nothing very interesting to say at the level of story: "I was this person, and then I think I got married to this other person, and then we collected treasure which I think was a metaphor, and then we died."[8] We are left clutching for words, and might finish with something like, "If you had been there you'd understand; if you played the game yourself, you'd get it." From a lyric standpoint, we might say that this is because *Passage* does not "describe an event"; rather, playing the game *is* an event, and it is participating in that event—a kind of ritual—that matters in this case. As Rohrer himself notes: "[None of my games] have character dialogue or cutscenes or back story.... The only way to get it is to play it."[9] As with poetry, it is not the narrative arc of *Passage* that moves us, but the moment-to-moment encounter as we read/play. Similar observations can be made about *Loneliness, The Graveyard, Portraits of My Child,* and *Seasonal Mixtape.* These kinds of games present "few narratives," reflects historian and videogame scholar Antonio César Moreno Cantano, and yet feature a notable "disregard for time."[10] A reflection that connects back to Earl Miner's observation about lyric poetry: "where narrative is distinguished by its fulfilled continuity...the distinguishing features of lyric are a presence and intensity that make it, in a double sense, the *literature of moment.*"[11]

As with most characteristics of the lyric, this aspect of ritual quality does not stand on its own but is tied in a mutually reinforcing web to

all of the other characteristics we are examining: the ritual nature of *Passage* comes out in part through its short form and the way that it shuns traditional gameplay and narrative development; this ritual nature points us, in turn, to aspects of poetic address at play, and the idea that the game doesn't seem to be concerned with telling a story, crafting a simulation, or building flow so much as with making truth claims about the world. Rukeyser could be describing my encounter with *Passage* when she writes,

> Remember what happened to you when you came to...any poem whose truth overcame all inertia in you at that moment, so that your slow mortality took its proper place, and before it the light of a new awareness was not something new, but something you recognized.[12]

Let's consider the relation between ritual space and truth claims with an example from another candidate game poem: Pippin Barr's *A Series of Gunshots*,[13] a short game from 2015 that offers the player a simple series of single-screen vignettes. The game displays some initial text asking the player to "press any key to continue," then moves on to an initial randomly chosen vignette. Each vignette presents a black-and-white illustration of a different urban or suburban scene (an apartment complex, a house), along with some ambient white noise; no instructions are given to inform the player of how to proceed. But the game's initial text is the only instruction that's needed: press any key, and the player sees a window light up, and hears the sound of a gunshot. This can be repeated once or twice, and then the current scene fades away and gives place to a new one. After a few scenes like this, the game ends.

Upon release, *A Series of Gunshots* garnered widespread attention and praise for its treatment of gun violence. Game creator and critic Paolo Pedercini called it "a minimalist gem that may be the most poignant playable commentary on gun violence to date,"[14] and game

culture website Kill Screen published an article titled "A Series of Gunshots Calls Out Senseless Gun Violence in Games."[15]

Pedercini and Kill Screen are thoughtful observers and are not precisely "wrong" in their descriptions of Barr's game. But to take their comments at face value is to fail to notice something about *A Series of Gunshots*: namely, that it is a very lyric videogame. If violence is being called out here, we should also take notice of *how* it is being called out. Kill Screen, for instance, goes into some detail on what kind of "statement" the game is making about guns—but a lyric reading would note that the game itself is not that statement. The game is not so much a statement at all, as it is an enactment and re-enactment of an ambiguous event (something that is in many ways closer to Amy Lowell's ambiguous "Circumstance" poem than it is to being a "commentary"). Why, then, do we want to read it as making truth claims?

To be clear, *A Series of Gunshots*, like most popular media, is representational, and might be thought of as making a "claim" or "statement" about the thing it is representing in a purely literal way: "guns were fired." But this is not what I am referring to. Rather, I am referring to the way we read the game as making a truth claim about the *meaning* of those fired gunshots. In other words, why do we believe the game is saying something about gun violence beyond what it depicts representationally? Why do we read it as having a "message," even though there is no text or other explicit indicator of what that message might be?

I would argue that the reason we tend to read the game this way is precisely because it is such a lyric game: short, metaphoric, hyperbolic, and ritualistic in the time-honored tradition of poetry (we will examine the lyric characteristics of metaphor and hyperbole shortly). Poems, as Culler points out, have always been forums for expressing "direct truth claims about the world." It is the fact that *A Series of Gunshots* is so poem-like that allows us to recognize that it is making truth claims—but because we lack a language that would allow us to

Figure 8: A scene from *A Series of Gunshots*. The right frame shows a window lit up by gunfire. (Images taken by the author during play.)

successfully read videogames as poems, we fail to note that the game expresses its truth claims not through statement or commentary, but by being a kind of ritual event (an "enacted" truth claim) in the same way that lyric poems have always been.

As I have already noted, many of my own games operate in the same basic ritual mode as *Passage* and *A Series of Gunshots*, but in several cases I have unintentionally blurred the line between the enacted truth claim of ritual event and the more explicit or didactic truth claim of statement or commentary. *Loneliness*, for example, presents a kind of ambiguous ritual utterance that, in the tradition of lyric poetry, attempts to say something True about my deeply personal, deeply subjective yet at the same time deeply universal experience of loneliness. But the original version of the game also presented an end screen with textual information about the game's context of creation and studies relating to loneliness in South Korea (I made the game while living and teaching in Korea). This juxtaposition caused confusion for some players, who were unsure of whether to read the game as poetry or as an educational message, or worse, as some sort of propaganda.[16] I have always thought of the game as a poem, and the original end-text

as nothing more than a bit of context, but an explicit (and forced) indication of context always carries with it the danger of diminishing a poem's ambiguity and breaking the ritual moment on which lyric poetry tends to rely. I feel this is especially true for game poems since we lack a well-developed conception of videogames as poetry, and it is an uphill battle to get players to receive a game as a form of poetic expression in the first place. Had I to do it over again, I would leave this kind of contextual information out of any games I intended as poems, or, at most, provide it in a frame that is clearly separate from the game proper. (Which is in fact what I did when I released a tenth anniversary edition of *Loneliness* in 2020, sans end screen.)

To be clear, I absolutely believe that words can be used for poetic intention in videogames (we will look at an example of this shortly in Anna Anthropy's *Dys4ia*), but such use requires careful thought and consideration. If one is not careful, it can be easy to convey an impression of didacticism, to fall into a narrative mode, or to position's one work closer to traditions of digital poetry than to videogames. Of course, none of these outcomes are inherently problematic if they are intended or desired.

Cautionary tales aside, there is a sense in which videogames as a medium lend themselves naturally to ideas of ritual space, as some scholars have noted,[17] because they are inherently interactive and performative: they must be performed to be encountered, and every performance results in something unique (which goes for everything from competitive strategy games to narrative-focused games). But, as we have just seen, that ritual dimension of play can be easily overshadowed by other aspects of the experience, particularly if we are focused on other interpretive lenses and don't have a category like "game poem" to help us consider ritual space in videogames as part of a larger poetic tradition.

CHAPTER 6

Game Poems are Hyperbolic

Some poems are explicitly hyperbolic, as when Anne Bradstreet writes:

I prize thy love more than whole mines of gold,
Or all the riches that the East doth hold.
My love is such that rivers cannot quench,
Nor ought but love from thee give recompense.[1]

But scholars note that lyric poems have an implicit hyperbolic character even when they are more reserved, due to their short form and tendency toward direct truth claims: "Like indirect address, hyperbole is a fundamental characteristic of the lyric which, when not manifest, takes the form of an underlying convention: that apparently trivial observations are of considerable significance."[2] Wolf calls this the "relative unimportance" found commonly in the lyric tradition.[3]

Whether they are making grand claims about the world, or asking you to care about a blade of grass, lyric poems hazard to animate the world, "investing mundane objects or occurrence with meaning,"[4] and constantly risk the reader responding with either a snicker or a shrug of the shoulders. "Why should I believe?" or, "Why should I care?"

As with written poetry, we can identify multiple levels at which hyperbole operates in videogames. In *Passage* we see explicit hyperbole at work in the game's technical handling of what seems to be a clear metaphor for marriage or civil union: when the player character approaches the NPC, a heart spawns between them, after which point the player character can no longer go on alone: wherever they go, the NPC goes too. It's as if the two sprites have become, effectively, a single avatar for the player to control. Because the two sprites together have a larger pixel footprint than either of the sprites alone, choosing union means that certain narrow passages between obstacles will no longer be accessible to the player to pass through. Very well: uniting with a partner may have its joys and benefits, but also means that certain life trajectories available to a single person are no longer an option—the basic metaphor at work here appears fairly obvious and has been noted by many scholars.[5] But how is this metaphor driven home? Through *hyperbole.* Consider the intractable mechanic that governs the union: the game is in effect saying that civil partnership is like being *glued* to another person; you can't even take two steps without them! As Doris Rusch points out, some players "complain that, once you run into the companion, you're stuck with her."[6] But at the same time, as players we realize that *Passage* is not making this glue-marriage claim literally; rather, it is a form of speech; it is hyperbole. As Rusch explains, "Rohrer uses simulation as a declaration of love for his wife: life is richer and more rewarding with you."[7] Or, in Bradstreet's words: "*I prize thy love more than whole mines of gold.*"

Implicit hyperbole is also at work in videogames, and in multiple ways. First, let's consider the kind of implicit hyperbole that poetry scholars point out, where mundane objects are invested with meaning, and "apparently trivial observations are of considerable significance…a leaf falls; an old man sits on a doorstep; a dog barks in the distance."[8] We see this kind of hyperbole at work clearly in Ian Bogost's game *A Slow Year* (right down to the particular image of a leaf falling).[9]

In *A Slow Year* (a game made in 2010 for the venerable Atari 2600 videogame console), the player is presented with a series of short vignettes (which Bogost actually labels as "game poems"[10]), one for each season: the first vignette is about collecting a pile of leaves from an autumnal tree; the second is about drinking coffee on a cold winter morning; the third involves timing lightning strikes on a rainy spring day; the fourth centers on a floating stick in a summer stream. Each game is difficult, slow, and enigmatic, accompanied only by a riddling haiku for instructions. The process of playing *A Slow Year* goes something like this: one starts the game and doesn't understand what to do; one searches for instructions and eventually finds the instructional haikus hidden deep within the game's accompanying *physical book*; one attempts to decipher the instructional haikus while returning to the game, and eventually, after much patience, determines that the goal of the first vignette is to painstakingly catch leaves with a basket as they fall off of the autumnal tree—painstakingly, because the wind may take them in any direction, and can only be read well with much practice.

As an example of implicit hyperbole in written poetry, we might consider "To a Poor Old Woman," one of William Carlos Williams's observational poems:

munching a plum on
the street a paper bag
of them in her hand
They taste good to her
They taste good
to her. They taste
good to her.[11]

Culler notes that in this poem we are expected to take the proposition "They taste good to her" as somehow revelatory, "a suggestion that

such simple pleasures as eating a plum that tastes good should be central to our experience of the world."[12] Similarly, in the first vignette of *A Slow Year*, we are expected to take as revelatory an interactive and computational analog of a statement to the effect of, "A leaf falls. A leaf falls. A leaf falls."

It is the pomp and ceremony, the difficulty and the enigma that surround *A Slow Year*, that make it particularly hyperbolic: the fact that you must pay attention, work hard, and decipher haikus in order to arrive at a statement/image about a falling leaf. Most striking, perhaps, is the fact that the game was painstakingly crafted in 2010 for a console that went out of fashion decades earlier—and one that is notoriously difficult to program.[13] The game as an artifact seems to practically scream at the player: *pay attention to this falling leaf! It's important!* If Williams's Old Woman poem is implicitly hyperbolic for how it suggests that something perfectly ordinary is central to our experience of the world, *A Slow Year* is even more so.

Figure 9: *A Slow Year*'s first vignette. The speed and direction of wind is indicated by an ever-shifting check pattern. (Image taken by the author during play.)

Passage is not implicitly hyperbolic in precisely the same way that *A Slow Year* is, from the perspective of content: *Passage*, after all, is about life and death, and most people will acknowledge the importance of those themes (as compared, for example, with eating a plum or observing a falling leaf). Why, then, have some people made accusations that amount to *Passage* being a kind of hyperbolic overstatement?[14]

The reason for these accusations is that *Passage* is hyperbolic for how it makes implicit claims about the place of *videogames as a medium*. It is hyperbolic not because its content is seemingly trivial, but because of the formal characteristics it brings to bear on that content: it is hyperbolic for daring to be a game about life and death while also being uncompromisingly short, lacking substantial narrative or gameplay "hooks," and being technologically backwards facing (like *A Slow Year*, *Passage* shuns high fidelity 3D visuals and sound for pixelated 8-bit era sprites and chiptune music). By essentially claiming that a short, 8-bit videogame can handle themes of the magnitude of human life and death, *Passage* is making a strong claim about the capacity of videogames as a medium, and one that could easily be perceived as exaggerated.

Returning to my own game-making practice, I see much of my work as defined by an interplay of these various kinds of hyperbole: explicit hyperbole at the level of metaphor (people "running away" from you in *Loneliness*) combined with an insistence that the mundane as well as the sacred aspects of human experience are both squarely within the purview of short expressive videogames. Consider my game *Grandmother*,[15] a short HyperCard-like game[16] in which the player clicks on a series of still images to traverse a columbarium, then navigates an ambiguous input scheme to slowly wash a headstone using a bucket and sponge.

Grandmother plays with the intersection of the mundane and the sacred along with the juxtaposition of understatement and hyperbole.

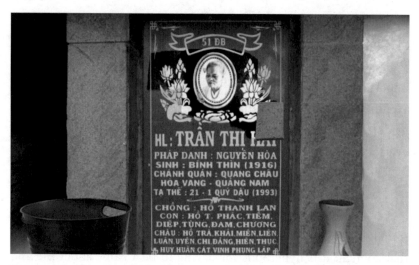

Figure 10: Cleaning the headstone in *Grandmother*. (Image taken by the author during play.)

As in *Passage*, *Grandmother*'s manifest theme of death is self-evidently important and serious, but unlike *Passage*, *Grandmother* intentionally plays down the drama and gravitas of its theme, pressing instead into the mundane nature of the player's task: there is no background music, the photos are full of ordinary objects and castoff construction materials, and the player's final act is not to die, but to squeegee a headstone and leave the space. The game is thus simultaneously understated while also being hyperbolic at the level of medium-specific claims. By implying that a contemporary gamer should take the time to play a patently ugly game about cleaning a headstone (with its dull photos, lit by a glaring midday sun, the game lacks even the retro-aesthetic draw of games like *Passage* or *A Slow Year*), *Grandmother* suggests that such mundane tasks should be "central to our experience of the world,"[17] while also claiming that videogames at their most rudimentary can and should be concerned with every aspect of that experience—much as lyric poems have always been.

The value of identifying lyric hyperbole in games is twofold: first, the ability to identify explicit hyperbole gives us room to consider that videogames—like poems—may intentionally overstate something in order to get at a certain truth. This offers an important alternative to reading any form of exaggeration as simply "unrealistic," which has been a common tack when it comes to videogames, since it is often presumed that the goal of all games is to attain higher and higher levels of indexically grounded "realism"[18] (tied to what Alexander Galloway calls mainstream gaming's "fetish for realistic gaming scenarios"[19]).

Second, the ability to identify implicit hyperbole in games like *Passage*, *A Slow Year*, and *Grandmother* allows us to situate these games relative to other forms (like lyric poetry), which have always had implicit hyperbole as part of their DNA. Positioning these games as "game poems" allows us to normalize their use of hyperbole, and to see its value as a long-utilized device that can uniquely call our attention to the surprising possibilities found in the aspects of our lives we might otherwise ignore or diminish—whether the falling of an autumn leaf, the movement of a sponge on stone, or the potential of an 8-bit videogame.

CHAPTER 7

Game Poems are Bound to Metaphor and Ambiguous Imagery

Lyric poems eschew indexical realism, literalism, and mimesis; they rely instead on metaphor and establish meaning via image, context, and comparison. "A definition of poetical style could be to say that it begins with metaphor," says Jacques Lacan.[1] Or, in Mary Oliver's words: "The language of the poem is the language of one thing compared to another thing."[2] "'Hope' is the thing with feathers," writes Emily Dickinson famously.[3] Or consider this passage from Shakespeare:

> Sleep that knits up the ravell'd sleeve of care,
> The death of each day's life, sore labour's bath,
> Balm of hurt minds, great nature's second course,
> Chief nourisher in life's feast.[4]

In these few lines, Shakespeare compares sleep to knitting, to death, to bathing, to a balm, and to the most nourishing course of a meal, in an extravagance of metaphor that one rarely (if ever) encounters in prose. In "comparing one thing to another," lyric poems create new

meaning, since every new metaphor casts a word or phrase in new light. As poetry scholar Owen Barfield notes, "Shakespeare enriched the content of 'balm' (and of 'sleep', too) when he called sleep the 'balm of hurt minds.'"[5] The lyric thus stands in contrast to prose, which tends to rely on the established "literal" meanings of words in order to be understood.

Insofar as they are tied to metaphor and image, lyric poems are also ambiguous and (to use D. Fox Harrell's language) *phantasmal*, relying on "combinations of mental imagery and ideology constructed by embodied, distributed, and situated cognitive processes."[6] "A poem should not mean / But be," writes Archibald MacLeish,[7] and his advice seems to be taken. What does it *mean* for hope to be "the thing with feathers," as Emily Dickinson writes? That hope is like a bird perhaps, but what then? Images and meanings for "hope" on one hand and "feathers" on the other will spring to mind for each reader that will necessarily be heavily tied to each reader's personal history, cultural context, inner and outer experience. There can be no appeal to dictionary definitions, because no dictionary yet holds this line's meaning: "hope" and "feathers" are being recast in relation to one another, and this recasting is necessarily ambiguous.

It is this characteristic of ambiguity that often allows poetry to speak more powerfully and universally than prose—but also makes poetry harder to explicate.[8] Where successful prose relies on being clear and unambiguous, good poetry is appreciated, in part, for lines and stanzas that can be mulled over time and again, and that continue to suggest new meanings to a myriad of readers (which connects again to the ritual aspect of poetry: an event to be performed and reperformed). "Poetic effect," writes Umberto Eco, is "the capacity that a text displays for continuing to generate different readings, without ever being completely consumed."[9]

Can videogames utilize metaphor and ambiguous imagery to provide some of the same satisfaction as lyric poems?

The answer is clearly yes, as has been demonstrated by a wide variety of scholars. (There is no shortage of interest in metaphor within game studies, though relatively few scholars have drawn a specific connection between metaphor in games and traditions within lyric poetry.[10]) Consider *Dys4ia*, an autobiographical game by Anna Anthropy about the experience of transitioning. The game presents a sequence of minigames in quick succession and overflows with metaphor in a way that recalls the Shakespeare passage above. Metaphor in *Dys4ia* works on a number of different levels, as scholars like Alexei Othenin-Girard and Noah Wardrip-Fruin have shown.[11] For the moment I would like to focus at the level of explicit metaphor derived by the game's use of text. Strategic use of text is something that "poetry-films" (films that mix words and image) have been incorporating for some time. *Dys4ia*, like a poetry film,

> expands upon the specific denotations of words and the limited iconic references of images to produce a much broader range of connotations, associations, metaphors. At the same time, it puts limits on the potentially limitless possibilities of meaning in words and images, and directs our responses toward some concretely communicable experience.[12]

Most of the minigames in *Dys4ia* force a comparison between the semantic meaning of a given word or phrase, and the interactive, representational meaning of the given minigame itself. Sometimes text appears immediately at the start of a minigame, while at other times it appears after playing for a few moments. This subtle interplay highlights the metaphorical nature of the game as it shifts the order of comparison (the "ground" and "figure" of the metaphor[13]) from minigame to minigame: sometimes the ground is the interactive, representational component of the minigame, and sometimes it is the text. Anthropy then mixes up this formula with minigames that present some text at the start, with additional text that appears during

play—thus forcing interpretation and reinterpretation of image, text, and play in quick succession, based on ever-shifting semantic cues and comparisons. It is this constant play around "one thing compared to another" that makes *Dys4ia* a game *about* metaphor as much as it is a game containing metaphor.

Consider *Dys4ia*'s first minigame (Figure 11). Here we are presented with something that appears to be a classic puzzle-game-sort-of-challenge: we must figure out how to move or reshape our avatar in order to pass through a barrier. But it quickly becomes clear that the challenge is impossible with the toolset the game provides us. As this realization hits, we are presented with the text, "I feel weird about my body." Our abstract interactive experience must now be reinterpreted in light of this text, and the text itself must be interpreted in light of the interactive experience—and in this process, abstract representation, interactive experience, and text are all "enriched," as Barfield would say. The perplexing angular shape of our avatar takes on new meaning when juxtaposed with "body," and the word "body" takes on new meaning, too. The very idea of a videogame avatar is enriched and enlivened here, as we consider that a jutting piece of a polyomino can represent not only the abstraction of a physical feature

Figure 11: *Dys4ia*'s first minigame. (Images taken by the author during play.)

of a human body—but also the abstraction of a *subjective perception* of a physical feature of a human body (objective vs. subjective reality again). Or consider how "feel weird about" is transformed, as the interactive experience suggests an urgency of frustration (even an impossibility) that the words do not. But those words are no longer the same now. For anyone who plays *Dys4ia*, the phrase "feel weird about" (especially in relation with "body") may now summon a memory of this interactive experience and the impossible challenge presented: the words themselves have been enriched and changed, along with every puzzle game puzzle.

If poetry is about enriching concepts through the process of "one thing compared to another thing," then I would hazard that *Dys4ia* is clearly a game *poem*. But regardless of categorization, the important point is that the lens of poetry again helps us better appreciate aspects of our encounter with the game.

The basic challenge of carving out rich but comprehensible metaphoric meaning is something that I have long attempted to navigate in an intentional way in my own work. In many of my games I make use of explicitly symbolic representation, relying on simple lines, shapes, and colors to represent player avatars and other aspects of the game world (the use of an abstract aesthetic involving black squares has become something of a trademark style for me[14]). My goal has never been abstraction, but rather the creation of complexity and ambiguity through metaphor: my games are about human experience and people after all—not about lines, shapes, or colors in the abstract. Of course, lines and shapes and colors can and do contain meaning "on their own," based on one's experience of these elements in the world—but without grounding (again in the sense of "ground" and "figure" when discussing the two parts of a metaphor) that meaning is often so dispersed and phantasmal that it is useless to the poet or game maker. In my experience, this is where metaphor breaks and abstraction begins: in an abstract work, a square will still be interrogated

and interpreted, but it will be interpreted in the context of its broad political, cultural, and ideological positioning, rather than any notion of intentional metaphor. I have found that establishing successful metaphoric meaning in games depends on at least one side of the metaphor being understood and "concrete" enough (we might even say "prosaic" enough) to the player that they can start to think about the comparison being made *as a comparison*, rather than as a one-sided statement (or as nonsense).

To illustrate my point: people have sometimes told me that *Loneliness* is a failure of a game because people cannot make sense of its central meaning without knowing the game's title. While the game may or may not be a failure for any number of reasons, I think such comments regarding the title are misguided because they seem to suggest that an abstract-platonic-mechanical-universal game about loneliness could exist somehow: that is, a kind of metaphoric game consisting only of figure, with no ground (or only ground, with no figure). In my mind it is the game's title that serves as the central ground for *Loneliness*'s intended meaning, producing a metaphor to the effect of, "loneliness is like *this*."[15] That grounding is what allows the subsequent experience of playing the game, with its ambiguous symbolic representations and mechanics, to be interpreted and considered in a particular light. ("If this game is loneliness, then what are these squares? What is the meaning of these movements?" etc.[16]) In other words, I believe that it is precisely *Loneliness*'s concrete title that allows it to succeed as a metaphoric game, rather than flounder as a mostly abstract one.[17]

Of course, as videogame scholar Mariam Asad reminds us, "a game does not need to explicitly incorporate language in order to be metaphorical."[18] In my game *Freedom Bridge*,[19] it is not the game's title that serves to illuminate the meaning of the player character's square avatar and the red pixels that flow behind it, so much as the square's relation to a recognizable image of barbed wire. As another example,

Figure 12: *Freedom Bridge* creates a readable metaphor by comparing a square and some red pixels to a recognizable image of barbed wire. (Image taken by the author during play.)

in *Portraits of My Child*, I rely on both text and image, as well as basic sound and color associations, to craft metaphoric meaning (this button press is a smile because of the text that precedes it, but also because of the color wash and sound effect that ensue from it).

As scholars have noted, most games feature many layers of metaphor, at different levels of explicitness and intentionality.[20] If we return to *Passage*, there is the metaphor of the compressed, pixelated play space, which we are invited to compare to some idea of "life." There is the metaphor of the avatar that represents the player character, the metaphors of the chests and obstacles the player encounters as they move around the space, and the metaphor of marriage or civil union already discussed.[21] Beyond these, *Passage* (like every videogame) has embedded within it subtle metaphors connected to pixelated representation, user input, and the most basic computational logics (things like sprite movement and collision detection): metaphors that we may take for granted and not even notice.[22] Pressing the right arrow on your keyboard is compared to the movement of a few pixels on a screen, and those pixels are compared to the image of a person, which

is in turn compared to you the player as a person—so you press a bit of plastic, and "you" move through a space that somehow represents your life. Metaphor, within metaphor, within metaphor.

It is easy to get lost here: if all meaning is established through metaphor, then what separates poetry from prose, or a "game poem" from any other kind of videogame? An investigation of this question will be a central concern of Part II of this book. For now, suffice it to say that metaphor works on a continuum ranging from common metaphors that are accepted and "literalized" as part of prose language, to metaphors that are so unexpected (or so abstract) that they risk being broken and unreadable (if we can make no sense of a given comparison). I propose that most game poems, like most lyric poems, should ideally function somewhere in the far middle ground: making new and unexpected comparisons that enrich concepts and carve out new meaning while attempting to remain conscious of meaning's breaking point.

CHAPTER 8

Game Poems Juxtapose Signified Meaning With Material Meaning

The sound of words spoken, their shape on a page—these things are of vital concern to lyric poetry, which constantly holds the tension between signified, semantic meaning, and the meaning present in the specific material incarnation of printed or spoken words: the attraction of rhythm, the effect of a line break, the significance of vibrating vocal cords. An abstract word in a dictionary is not the same thing as a word spoken in a particular context, by a particular human being, at a particular moment in time. And so Paul Valéry describes poetry simply as "a prolonged hesitation between sound and sense" ("sense" here indicating "meaning").[1] Or, in the words of Julia Kristeva: "Poetic discourse measures rhythm against the meaning of language structure."[2] This play of material vs. signified meaning lies at the heart of the lyric's fascination with metaphor (as we saw in the last chapter) and is ultimately what all the major poetic devices (rhythm, repetition, rhyme, turning of the line, etc.) attempt to explore in one way or another.[3]

Let's consider rhythm. Rhythm is the "basis of any poetic work," says poet and theorist Vladimir Mayakovsky.[4] Muriel Rukeyser agrees, positing that an attraction to rhythm lies at the heart of any first engagement with poetry.[5] But what is rhythm? It is a bodily experience of repetition and beat, a felt happening, "an event without representation."[6] And so in a poem, words with their semantic meanings are carefully and intentionally brought into contrast with this material aspect that lacks semantic meaning, but which is an undeniably significant dimension of the poem as encountered experience. "One can argue that it is the rhythm above all that makes lyrics attractive, seductive, and memorable," claims Jonathan Culler.[7]

Eavan Boland points us to Blake's "The Tyger," with its famous opening stanza:[8]

Tyger! Tyger! burning bright
In the forests of the night,
What immortal hand or eye
Could frame thy fearful symmetry?[9]

"This is a lyric that has generated a vast literature of interpretation," notes Culler, "most of which passes over its rhythmic structure, but what is most striking about it, what makes it a compelling poem, rather than a prose reflection on the power of creation, or on the threat of the French Revolution, or anything else, is its rhythm";[10] a rhythm that creates, in Northrop Frye's words, a kind of "hypnotic incantation" that connects back to lyric conceptions of ritual space.[11]

Do videogames have rhythm? Of course they do. Rhythms of sound and image, but also rhythms tied to inputs and interactions, as has been noted by other scholars comparing videogames to poetry.[12] As Lindsay Grace points out:

All of the rhythms of game verbs, and all the rests between experiences come in the form of a level. Even when level is less explicit, the stanza

reveals itself as a marker of moment. Achievements become stanzas, as progress is formed into stanza through leveling up.... In fact it is this rhythm of game play that is so essential to game experiences.[13]

Contrast the experience of playing a game like *The Graveyard* to playing Adam Saltsman's infinite runner, *Canabalt*.[14] Both of these games, like Blake's "The Tyger," contain signifying aspects that can be fruitfully considered from a hermeneutic standpoint. But as with "The Tyger," to neglect the material meaning present in each game's rhythm is to neglect a central part of our encountered experience. I would hazard that *Canabalt* is a game that, like Blake's poem, I find "attractive, seductive, and memorable" *primarily* for its rhythm: a fast, staccato repetition of sounds, images, and inputs that is nothing if not a "hypnotic incantation." *Canabalt*'s rhythm is why I keep playing it, and why the game's images stay with me long after I have stepped away from my controller. Like a hypnotic lyric poem, the game stays in my body and in my mind until I slowly start to parse questions of what it means at any number of levels[15]—but would I bother to consider this game's narrative, its politics, its systems, or other aspects of its meaning if I had not first been so completely captured by its rhythm? I think not.

The Graveyard is a different case: its rhythm is much subtler than *Canabalt*'s, but it is present in my long-press of the forward key, the soft repetition of the old woman's shuffling gait (first faltering steps, then a consistent hop that creates a "crunch, crunchy-crunch" rhythm of her shoes on the gravel), and the occasional siren passing outside the cemetery. It is a rhythm that instills a quiet reflectiveness (or boredom) in the player, in stark contrast to the effect of *Canabalt*'s high-octane tempo.

Of course, it is possible (and right) to say that all videogames contain rhythm, just as it is possible (and right) to say that all language contains rhythm. The distinction between lyric poems and most prose is the way in which lyric poems intentionally bring that rhythm

Figure 13: *Canabalt.* (Image taken by the author during play.)

to bear. Sometimes they do this by utilizing particularly striking rhythms, as in "The Tyger" (and in most metered verse). But even unmetered lyric poems shine an implicit light on their rhythm, as a byproduct of their poetic positioning and short form.[16] As we noted in Chapter 2, the fact that lyric poems are short *is not an accident, or a failure at the level of entertainment, but rather a characteristic that positions them within a tradition of lyric works, works that beg you to pay attention, to consider their every word, every line break, every sound and image.*

It is *The Graveyard*'s short form and lyric positioning that suggest the potential fruitfulness of considering the work as a game poem, which leads us to pay attention to its every detail, and consequently brings the game's quiet rhythm and intentional pacing to bear. And once we are considering that rhythm and pacing, it is easy to see what a strong effect it has on our encounter with the game. As Antonio César Moreno Cantano notes, the experience of playing games like *The Graveyard* "cannot be reduced to mere description and interpretation."[17] Imagine the old woman with any other kind of gait; imagine the bench placed half the distance away from our starting location; imagine an input

scheme that required the player to tap the forward arrow key over and over rather than simply holding it down. Each of these slight alterations would produce a significantly different experience of play, though the game's signifiers (its recognizable images and such) would remain the same. This is the juxtaposition of signified meaning and material meaning that lyric poetry (or from a reading standpoint, lyric poetics) is interested in, as it explores the question of how every material detail impacts our experience of encounter with a signifying artifact (even if we lack words to express exactly why or how)—an observation that other kinds of reading are prone to miss.

Given our foundational understanding of poetic devices—that their core function is to draw attention to the interplay of signified and material meaning present in lyric poetry—we can easily explore ways in which others of these devices might have analogs in videogames, as well as the potential of videogames to utilize new and unique poetic devices of their own. As poet and videogame scholar Jon Stone notes:

> Poetic devices such as the refrain, anaphora, epistrophe and homeoteleuton are forms of literary repetition that could be realised through the recycled surface textures, objects and player actions within the world of the game as easily as through written language.[18]

In my own creative practice, I have found that the questions I am asking constantly while making my games are questions that correlate strongly with the poet's historical interest in poetic devices and the interplay of signified and material meaning. Questions like:

1. What is the best word [mechanic] to use at a particular place in the poem [game], and why?
2. How does the rhythm of a certain string of words [inputs] create an effect that complements and heightens a poem's [game's] theme?
3. Where should the line [interactive flow] break?[19]

Consider my game *The Heart Attack*,[20] a fictional game about two disparate lives (one Vietnamese, one American) that collide in conflict during the Vietnam/American War. The game presents a kind of double slideshow that juxtaposes images of these two individuals growing up through the years: we see them with their parents, playing with friends, going to school, etc.; the player, meanwhile, must press inputs in time with a steady beat to keep two different hearts going as represented by two pulse graphs that overlay the images. Initially this is an easy task, but as the two lives are drawn into the chaos of war the racing heartbeats become ever more difficult to preserve.

The Heart Attack creates a constant, explicit rhythm that is highly intentional, because I see it is a game *about* the rhythm of daily life, and how that rhythm is broken down by war (it doesn't matter how hard the player tries: they can't keep the rhythm going). The game also utilizes a kind of visual/thematic rhyme scheme by juxtaposing images for the two individuals that are initially identical (at the embryo stage), and then consistently thematically linked; something that is not necessarily clear during play, but becomes evident when the photos are played backward together at the end of the game, and provides, I believe, an increased formal and thematic unity.

To touch briefly on two more examples from my practice: when making *The Killer*[21] (a game about a single murder during a genocide), I thought a lot about lyric building blocks like pacing, rhythm, turning of the line. There's a long, long march, then a sudden, single decision: a structure I use to try and prompt reflection, draw attention, and wake the player up. This kind of slow build toward a single "line break" or "rhythm break" or "rhyme break" moment is evident in many of my games, with subtle variations, in a way that recalls the consistent presence of these features in lyric poetry. As Mary Oliver states, "Always, at the end of each line there exists—inevitably—a brief pause. This pause is part of the motion of the poem, as hesitation is part of the dance."[22]

Figure 14: *The Heart Attack* challenges the player to keep an impossible rhythm going. (Image taken by the author during play.)

Figure 15: *The Killer* hinges on rhythm, pacing, and a sudden "turning of the line." (Image taken by the author during play.)

When Gold Is in the Mountain[23] (a "digging simulator" about the quest for gold, in dialogue with a poem from Rilke's *Book of Hours*[24]) utilizes a similar basic structure to *The Killer*, but rather than holding down a button to walk (an input scheme designed to invoke stillness and prompt reflection in *The Killer*), the player of *When Gold Is in the Mountain* must press the main input button multiple times to complete a single dig cycle with their shovel, resulting in a relentless and futile pounding of the controller designed to invoke the themes of invasion and insatiability at play. I experimented with using multiple different buttons to activate the dig cycle, rather than a single button, but found that such a scheme resulted in an input rhythm that felt like a dance, or a song, where I wanted something that evoked the pounding of a piston or drill. The question of how to map inputs in games like these—and how that mapping impacts the felt experience of the game—is not an afterthought for me, but a central concern that I see as deeply connected to lyric poetics and the historical use of poetic devices.

Figure 16: *When Gold Is in the Mountain* demands a relentless pounding of the player's controller. (Image taken by the author during play.)

CHAPTER 9
The Value of Identifying Game Poems

[By] examining moments when poetry comes close to
dissolving itself into other genres, we see how poetry
expands its range and possibilities, at the same time that it
flaunts its distinctiveness.

(Jahan Ramazani)[1]

I hope that I have begun to show that lyric poetry can be a useful lens
for videogames, one that helps us understand and appreciate certain
games and certain aspects of certain games better. As I have tried to
capture in the previous chapters, most of the lyric characteristics that
we have been examining build on and reinforce each other: short form,
poetic address, and hyperbole come together to naturally reinforce
conceptions of ritual space, for example; short form, metaphor, and
ritual space, meanwhile, lend themselves to reinforcing the exploration
of subjectivity; etc. This is only natural, since these characteristics
have been reinforcing each other for centuries throughout the
development and evolution of lyric poetry. As Muriel Rukeyser points
out, when it comes to poetry, "all the relationships within these forms

are interdependent."[2] I have attempted to examine each characteristic somewhat independently, but such an approach has its challenges.

In my experience, as poems or games feature more of these interdependent characteristics, they position themselves more and more strongly as lyric artifacts, which then encourages further lyric reading and explication (and indeed, we start to look to such artifacts to provide hints regarding what "the lyric" is all about in the first place). Because of this, it is only natural for the practice of lyric reading to turn into a kind of lyric categorization: such and such poems are *lyric poems*; such and such games are *lyric games*, or "game poems." I would argue that this kind of identification based on modes of attention/reading is inevitable, and also that it can be valuable—which is why I have titled this book *Game Poems* rather than "some lyric readings of videogames."

But before we discuss the value of identifying game poems, we should address some critics who might object that for all our lyric reading, we have yet to identify this category in a truly clear way. What precisely *is* a game poem? We have said that game poems are "like this," and "like that"—that they have various lyric characteristics—but how many of these characteristics must a game have to be legitimately and unequivocally placed in the game poem category? And what separates the category of "game poem" from related categories like digital or computational poetry? We touched briefly on digital poetry in the introduction, and its historical emphasis on linguistic sounds and symbols (words, letters, and language) and mentioned by contrast that this book's focus would be on "what we talk about when we talk about *videogames*," a category that does not necessarily share that same emphasis on words. And yet some of the games we have examined in this book do feature words. Are such artifacts game poems, then, or might they be better understood as belonging to existing traditions of digital poetry?

I think these sorts of questions are well meaning but ultimately miss the mark, because they imply the possibility of objective categorization. Following in the footsteps of literary theorist Stanley Fish, I would argue that categories like "game poems" and "digital poetry" are best thought of as related modes of *paying attention* rather than as objective taxonomical frameworks, and that every different mode of attention can offer us unique insights into the things we encounter. But let us back up for a moment and consider again the idea of "family resemblance" popularized by Ludwig Wittgenstein, an idea that we mentioned earlier in this book, and that provides a crucial touchstone for any discussion pertaining to categorization or taxonomy.

While it may be disheartening to the lover of clear distinctions, categories like "videogames" and "digital poetry" are unavoidably nebulous and expansive, much like the concept of "lyric poetry" itself. In fact, there is no hard boundary that can be drawn between conceptions of "digital poetry" on the one hand, and conceptions of "videogames" on the other—just as there are no hard boundaries that can be drawn between conceptions of "videogames" and conceptions of "digital media," or "interactive media" or "traditional games." Or between conceptions of "poetry" and conceptions of "literature," or "art." None of these categories exists as a hardened, exclusively bounded set of artifacts. Artifacts typically get classified according to these labels by resembling each other in various ways (family resemblance), and while some artifacts tend to be fairly centered in that given category, others exist at the indistinct periphery. And even those artifacts which may be said to be "centered" in a certain category (a "prime example" of the category, often used to inductively trace a category's outline[3]) generally also find themselves at home in various other categories. And those categories in which any given artifact finds itself at home tend to shift and rearrange themselves over time.

I will not, then, defend the idea of an objective game poems category based on a neatly defined set of artifacts, largely because I do not believe any category or genre can be strongly defended as such in the wake of postmodernism and poststructuralism. Discussing the idea of a lyric genre category in 1986, Ralph Cohen maintained that genre theory had already been "thoroughly discredited" at that point.[4] If we cannot defend lyric poetry as a clear, distinct, category in the twenty-first century, we cannot defend game poems in this way either. But that does not mean that we must give up on lyric poetry or game poems as loose categories defined in terms of family resemblance and artifact positioning. Indeed, drawing the rough outlines for such a conception of game poems is precisely what we have been engaged in for the last few chapters. Conceived through the lens of lyric poetry that we have been utilizing, we might say that game poems are artifacts positioned as videogames that are short and subjective, make use of poetic address, exist in a ritual space, are hyperbolic, are bound to metaphor, and juxtapose signified meaning with material meaning (keeping in mind that, as in the case of lyric poetry, all of these characteristics are simply tendencies). We might summarize such a conception of game poems as "videogames with lyric characteristics."

The value of identifying a category like "game poems," however strictly or loosely, is tied to the power of language to shape expectation and encounter. To return to where we started a few paragraphs back, Stanley Fish has posited famously that human categories and genres do not exist in any ideal or objective way, but are rather mental constructs that suggest modes of *paying attention*:

> In other words, acts of recognition, rather than being triggered by formal characteristics, are their source. It is not that the presence of poetic qualities compels a certain kind of attention but that the paying of a certain kind of attention results in the emergence of poetic qualities... categories are the very shape of seeing itself.[5]

One can draw a variety of cynical conclusions from such an assertion—for instance, that all attempts at categorization are futile—but one can also consider the positive (perhaps essential) role that mental categories play in allowing us to see and pay attention in different ways, which connects back to this book's emphasis on *appreciation*. If we posit that game poems exist, we can then start to wonder if certain games might *be* game poems, which allows us to look at those games in a new way, with a new kind of gaze and attention—which then encourages us to see and appreciate new things. I would suggest that there is a feedback loop at play here: attending in new ways (as we have been doing in this book) encourages us to propose new categories, and new categories likewise encourage us to attend in new ways. I said at the start of this book that I was more interested in lyric reading than in lyric categorization; more interested in whether a lyric lens might help us appreciate certain games than in whether any given game was "in some mystical way a True Lyric Work." And that remains true. But there is no denying that identifying new categories helps us facilitate new conversations and discover new modes of appreciation. It seems that, as Fish has emphasized, we are primed to think in terms of frameworks, categories, and genres, however imperfect these structures may be. We pay a certain kind of attention to something that we consider to be a "poem" and another kind of attention to something we consider to be a "videogame." Conceiving of an artifact as a "game poem," then, suggests new considerations, new modes of encounter, and new forms of appreciation, as I have attempted to demonstrate in the previous chapters.

Of course, this chapter should in fairness be titled "the value *and perils* of identifying game poems," since classification is always a perilous as well as a (hopefully) valuable business. If new categories can help us see and appreciate new things, old categories often make it difficult to conceive of new categories, and all new categories become old categories in time. Where every new category presents the possibility of breaking down old dichotomies, it also presents the

possibility of establishing new dichotomies—new dichotomies that are always in danger of becoming entrenched. I see a category like "game poem" as useful to the extent that it can foster new modes of encounter (and, as we will investigate shortly, new modes of creation), over and against any extent to which it might be used to establish or strengthen new or old dichotomies.

I am not primarily interested in separating "poetic videogames" from "nonpoetic videogames," for instance. I have already noted that there are several characteristics of the lyric that seem to lend themselves in a special way to videogames *as a medium* (videogames are naturally enacted, performative, and ritualistic, for instance), so it should not be unthinkable that longer games that might be focused on narrative, or traditional modes of gameplay, could still contain moments that feel lyric or poetic. Where considering short, expressive games like *Passage* and *Loneliness* holistically as game poems can give us a new angle from which to think about the value of these games and their place in the world, a lyric reading of longer, more traditional games may help increase our appreciation of some particular aspect of such games—the kind of felt effect a certain moment has, and how the game achieves that effect.

Similarly, I am not particularly interested in separating game poems at large from existing traditions of digital poetry. I have made a distinction between these categories that has been vital to the premise of this book—which is that artifacts positioned as *videogames* can be poems quite apart from any engagement with written or spoken words—but that does not mean that there are no interesting points of overlap to explore, especially when it comes to digital poetry that is computational and interactive, as game poems tend to be. If we consider creations discussed as examples of digital poetry, we can say that yes, these artifacts generally engage with words or language in some way, and that that connection is often seen as a primary feature connecting digital poetry to our long-established written and oral

poetry traditions. But there are also plenty of examples of things we might think of as digital or computational poems that play with expectations and conventions established by videogames, such as Jim Andrew's already-referenced "Arteroids"[6] (a "poetry exploder" that is certainly word-based, but borrows mechanics directly from the classic *Asteroids* computer game), or Jason Nelson's "Game, Game, Game, and Again Game"[7] (self-described as a "digital poem," "anti-design statement," and "retro-game"). There are also plenty of examples of things we might think of as videogames that play with words and/ or language, such as Gregory Avery-Weir's *Silent Conversation*[8] (a platform game where the "platforms" are made up of texts) or Daniel Benmergui's *Today I Die*[9] (a short "adventure game" in which the player must manipulate characters, objects, *and words from poems* in order to make progress through various scenes); drawing on examples we have already examined in this book, we could point to *Dys4ia*, or *Seasonal Mixtape*. While we might consider "Arteroids" to be closer to the "center" of conceptions of digital poetry than *Dys4ia* for the way it foregrounds words over any other graphical representations, we can still say that *Dys4ia* lies at the hazy outer edges of the digital poetry category because it too has an interest in words.

There are a variety of connections and continuums that might be imagined as existing between conceptions of digital poetry on the one hand and conceptions of game poems on the other, one of which (privileging a conception of poetry as grounded in words and of videogames as grounded in interaction) might be visualized like this:

Non-interactive digital poetry

↓

Interactive digital poetry

↓

Game poems featuring words

↓

Game poems featuring no words

I would submit that the labels of "digital poem" and "game poem" each suggest different modes of attention and different avenues of appreciation for artifacts like *Dys4ia* and *Seasonal Mixtape* that exist in the middle and could be judged to comfortably inhabit both categories. Indeed, it is easy to find examples of artifacts (such as "Game, Game, Game, and Again Game" and *Silent Conversation*) that have been discussed as "videogames" by videogame websites and journals and as "digital poetry" by digital poetry websites and journals. When one of these works is considered as digital poetry, the focus is often on how interaction and computation can be brought to bear on one's encounter with *words*.[10] When the same artifact is examined as a game poem, by contrast, the focus might be on how various conceptions of poetry can be brought to bear on one's encounter with *videogames*. These different modes of attention, while related, reveal different things to appreciate about the same artifact, regardless of the extent to which the artifact engages with words, or with videogame expectations, or both.

My hope is that a category like "game poem" might function as a kind of bridge between conceptions of videogames on the one hand and conceptions of digital poetry on the other, and that it might also serve to widen our conceptions of both. While a detailed investigation of the interplay between game poems and digital poetry remains outside the scope of this book, I believe it could be fascinating and fruitful to compare and contrast game poems like *Passage* or *Loneliness*, which feature few words, to established examples of digital poetry (e.g. Stephanie Strickland and Cynthia Lawson Jaramillo's "Vniverse"[11] or Nick Montfort's "Taroko Gorge"[12]) using a variety of poetics frameworks, and to consider the questions that are raised by such comparisons about the nature of poetry, the nature of computation, the nature of poetic material, the nature of poetic intervention, etc.

PART II
Making Game Poems in Practice

CHAPTER 10

What is the Material of the Videogame Poet?

So far in this book we have examined a number of small videogames and explored ways in which a poetry lens and the concept of a "game poem" can help us better appreciate many of these games. We have identified game poems as a loose category (defined by family resemblance rather than hard boundaries) of games that are generally short and subjective, make use of poetic address, exist in a ritual space, are hyperbolic and bound to metaphor, and juxtapose signified meaning with material meaning. We might say that we have laid some groundwork for a "poetics of the lyric" for videogames; that is, some groundwork for identifying and appreciating game poems.

But what if we wish to go a step further and begin making game poems in practice? The groundwork we have laid is a useful jumping off place, but I don't believe it is a sufficient foundation for the would-be game poem creator. Something is still missing, namely an understanding of precisely what the game poet's material is, and some foundational framework for conceiving of poetic purpose in crafting

that material. It is fine and well to say that poems make use of rhythm and hyperbole and metaphor, but a poet must also understand that they are working in *words*, and ideally have some vision for their art that extends beyond "include as many lyric characteristics as possible." One might conceivably be able to craft a good poem that way (by including as many lyric characteristics as possible), but I don't think it's where most poets start—and it's not where I start when making game poems in my own practice.

Let's consider the question of material. "A poet beginning to make something needs raw material, something to transform,"[1] notes poet and essayist William Matthews. It may at first glance appear obvious that the material of the videogame poet is simply "videogames," but from a creator's perspective such an assertion is less helpful than it seems, because making videogames is a very messy business. Visuals must be created, pixel by pixel, or polygon by polygon; sounds must be recorded or synthesized; code must be written, and for that purpose a programming language (or two) must be chosen, and perhaps a development environment. Basic mechanics and interactions must be crafted; narrative arcs and dialogue trees must be written and organized. Platforms must be considered, ranging from operating systems to consoles to virtual machines; hardware configurations and input devices must be taken into account.

How does one make poetry from all this? Where is the game poet meant to begin their work? Our investigation into and application of lyric poetics to this point in the book does not provide ready answers to these questions. If poets are "workers in words,"[2] then what is the precise material of the aspiring videogame poet? Is it game rules and interaction design? Is it operational logics and computational processes? Is it pixels and waveforms? Is it code? Is it the physical underbelly of transistors and circuits? Is it somehow all of these things taken together?

In *Racing the Beam*, Nick Montfort and Ian Bogost suggest that creating a "video game, a digital artwork, or a work of electronic

literature" is a "creative act that is similar in many ways to writing a poem or taking a photograph,"[3] except for some question of material:

> The creator of a computer work might design circuits and solder chips. Or, this author might write instructions for the integrated circuits and microprocessors of a particular computer, or write software in a high-level programming language, or create 3D models to be added to a virtual world, or edit digital video for embedding in a Web site.[4]

Montfort and Bogost go on to describe five levels at which videogames, due to their complexity, might be considered and analyzed, ranging from reception/operation to interface, form/function, code, and platform. They then give a fascinating account of the expressive constraints and affordances of the Atari VCS (an early videogame console that you may recall from Chapter 6) but leave the question of the material of the videogame poet (and how it might differ from the material of the "digital artist" or writer of "electronic literature") hanging tantalizingly in their introduction.

This question of material should not be essentialized any more than the question of the true nature of poetry, but it is nonetheless an important question to consider. The point is not to separate True Videogame Poets from impostors (as if this were a discussion we could even attempt at the present time), but rather to give a starting place to those who might desire to approach videogame creation as an intentional poetic practice but feel that they are missing a crucial touchstone, that being a clear perspective on the material they are working with—which is not a trivial concern. If we know one thing about poets, it is that they care for their material very dearly, very particularly: every word, ever punctuation mark, every line break is chosen with care.[5] (As Oscar Wilde is said to have said, "A poet can survive everything but a misprint."[6])

Should our aspiring videogame poet, then, show this same kind of care as they write the code their programs are composed of, paying

careful attention to every *if-then-else* statement and every variable name? Should they focus more broadly on the interactive or procedural nature of what they are crafting? Should they be as particular as possible, and aspire to craft the hardware their creations are played on? And what of "details" like graphics and sound? Are these core concerns, or peripheral matters?

From the perspective of creative practice, it quickly becomes clear that it is impossible to speak meaningfully about fashioning anything like a game *poem* if we cannot identify the core of the material we aspire to work with. As Montfort and Bogost point out, there are lots and lots of ways one can start to craft a videogame, and it is easy to get lost on any number of levels.

Let's start at the bottom of our messy videogame heap and consider a few analogies with written poetry that might help us narrow our focus. (Note that the analogies I will share here are neither complete nor intended to be exclusive; they simply reflect some thoughts that I have found to be helpful for clarifying this question of material in the context of my own practice. As always, I welcome alternative analogies and perspectives from other practitioners.)

In my practice, I tend to see the programming languages, the IDEs, the frameworks, and the engines as vaguely analogous to poetic forms: some (like free verse) provide few formal constraints, while others (like the villanelle or haiku) are tightly bound and limited, with finished poems/games in the latter case bearing a strong family resemblance because of the shared constraints.[7] Because I tend to make mostly simple 2D games that can be easily ported between systems, in practice I feel like I am writing free verse much of the time. Java? GameMaker? ActionScript? Python? Unity? Processing? Phaser? The choice of programming language or game engine generally makes little difference to me, and I often port my games between engines for the sake of distributing on new platforms. Tightly constrained engines like PICO-8, PuzzleScript, or Bitsy are a different matter, though: these

engines make me feel like I'm writing a villanelle or a haiku; I move to them when I am tired of free verse and wish to work within tighter constraints. (Which, in my opinion, has resulted in some of my most fruitful labor. I have found T.S. Eliot's reflection that limitations aid creativity to be largely true.[8]) As with poetic forms, those adept with these confined engines can make them do amazing, unpredictable things, but one is still likely to recognize the resulting efforts based on the constraints that birthed them—which is why we can speak somewhat categorically of "Bitsy games" or "PICO-8 games."[9] (We will discuss the value of highly constrained game engines further in Chapter 14.)

If programming languages and game engines function as formal constraints for the videogame poet, then is code itself the poetic material we are searching for? Writing code is *writing* after all (assuming one does not use a visual scripting language, God forbid[10]) and written or compiled code is essential to any videogame. As with the words that make up a poem, a videogame's code can be poured over and written out line by line, and the end result can be messy, or it can be elegant. But these parallels belie the fact that at the code level we are actually fairly distant from the expressive realm with which poetry is most concerned, which is the realm of *felt experience*: that which the reader sees, hears, perceives, and imagines.[11] And here is the issue for game poems: when it comes to instantiated code, there are many ways to create nearly identical felt experiences for the player, who generally has no ability to discern whether an *if–then–else* statement or a *switch* statement is used to craft any given effect they encounter during play— much less whether a visual scripting language was employed. This isn't to suggest that code does not matter or does not have meaning—code leaves a material trace that is deeply entangled with many layers of meaning, which is the suggested basis for critical code studies[12]— but only that it is not the chief concern of the *videogame poet* who is working with code.[13]

From the videogame poet's standpoint, we might draw an analogy from a game's code to the ink that marks the page as a traditional poet writes down a poem on paper. The ink matters: it leaves a material trace that is relevant to the nature of poetry, and the words themselves cannot exist on the page without it; beyond this, the ink is deeply entangled with important questions of politics, economics, and ideology: where did it come from, how was it attained, what ideological structures are embedded with it on the page?[14] These things can be fruitfully studied and expounded upon, and some poets address them directly—but they are not the major concern of most lyric poets, who might write out what they consider to be the same poem in red ink or in blue.[15] In fact, lyric poems are often said to exist in the poet's head, or in an oral recitation, without being contingent on being written down at all[16]— and this is a crucial idea for game poems (that the core of the poem can exist in the mind of the poet before anything is instantiated in code), because it helps narrow our material focus.

In my own game-making practice, I often find myself caring rather obsessively about the elegance of the code that underpins my game poems; but rather than believing that this represents an essential aspect of my work, I tend to feel that spending too much time and atten- tion crafting elegant code takes away from what I consider to be the "real work" of making the game poems themselves (much as I would consider that too much attention given to calligraphy or papermaking could take away from a poet's central work of writing poems). Again, this is not to say that elegant code and beautiful calligraphy are not important or meaningful, but only that I see these things as adjacent but different kinds of work to the poet's (I wouldn't know how to begin to compare the meaning or importance of beautiful calligraphy to that of a finished game or poem). At the end of the day, when working on game poems, I generally force myself to focus on the *games as they are experienced* instead of the code that underpins them, and many of my finished game poems are consequently built on a mess of code (or visual scripting) that feels like it was scrawled out on a wrinkled restaurant

napkin. And despite my aversion to wrinkled restaurant napkins, I can live with this because in my mind the *poem* is the thing—not the paper or the ink or the quality of my handwriting.[17]

If the videogame poet's material is not code, then what is it? To help us answer this question, let's jump to the other end of our messy "videogame heap" and consider the devices and platforms a videogame is released on. I would suggest that these things are in many ways analogous to where a poet might choose to distribute or publish their work. One might write a poem on a napkin or piece of scratch paper for a friend (as Emily Dickinson was wont to do[18]), or send it out in an intimate newsletter, or publish it in a well-established journal or in a bound book. Again, the questions involved in distribution and publication are far from irrelevant: they change not only the poem's audience but also its material manifestation, how and where letters and words appear on a physical surface. These details matter to the poet—for some poets and some poems they are non-negotiable—but still we are at the periphery of our art, since the crucial part of most lyric poems can survive a transcription (if they could not, then my copy of *The Complete Poems of Emily Dickinson* contains no poetry at all, in which case we are lost).

Of course, the question of transcription is more complicated for game poems than it is for traditional poetry, due to the nature of technology and technological obsolescence. Where written and oral poems can be passed down rather easily from one generation to the next for hundreds or even thousands of years, videogames are built on a complex stack of technology that often becomes obsolete within decades, if not sooner. Unlike a traditional poet, a videogame poet is obliged to engage in the work of re-creation and re-publication on a continual basis if they want their game poems to remain playable by *anyone at all*.[19] In many ways, making game poems feels more like writing a poem in the sand with one's finger than it does like writing with traditional paper and ink: the waves wash the words away quickly, and the poem must be written in the sand over and over again if it is to

be available for continued encounter. Given this reality, game poems bear some amount of resemblance to ephemeral art, and crafting them becomes a potentially stubborn act that connects rather strikingly to the romantic themes of mortality and transcendence that have been so bound up in the history of lyric poetry and lyricization (see Chapter 1).

These sorts of observations help bring to light important ways in which the practice of making game poems differs from the practice of writing poetry, but they do not change my belief that the central core of most game poems, like the central core of most traditional poems, can exist in the mind of the poet separately from the technology that underpins any particular instantiation of any particular poem. As we have observed, the basic concept of a lyric poem breaks down if we say that it is composed fundamentally of physical materials like paper/ink or code/computer. Because the important thing for poetry is the felt experience of the reader/player, I believe that most game poems, like most traditional lyric poems, *can* survive a transcription (which is what we call "porting" in the context of software and computing environments). While such transcription is often a laborious and imperfect process, I have already mentioned that I frequently port my game poems between engines/platforms for the sake of preservation and reaching new audiences—and I don't consider that I am crafting a fundamentally new game poem each time I engage in this work.[20]

As significant as questions of devices and platforms are, then, to the maker of videogames, I cannot see these things as describing the fundamental material of the videogame poet. I would say, rather, that the core material of videogames as far as the poet is concerned must lie somewhere between questions of programming languages/frameworks/engines and code on the one side and questions of devices and platforms on the other. To go deeper than this, we will need to take a step back and consider the poet's interest in not just words, but also *language*.

CHAPTER 11

Thinking in Terms of Language and Signifiers

It is helpful to remember that when we say the material of lyric poetry is words, this statement should be understood in the context of language. One *line* is the basic gesture of a poem, says Robert Hass: not one word, but multiple words in context, words together signifying something.[1] Poetry is "*language* in a state of dreaming," says Gérard Genette.[2] Or Julia Kristeva again: "Poetic discourse measures rhythm against the meaning of *language structure*."[3] In the tradition of the language poets, then, I see poetry as a form that explores the tension between signified meaning and material meaning present in a given context, and works to recast words in order to create new meaning—that is, I see it as a particular kind of intervention in language.[4] As poet and language theorist Lyn Hejinian states in her introduction to *The Language of Inquiry*:

Poetry [is a] dynamic process...that can turn language upon itself....
Language is nothing but meanings, and meanings are nothing but a
flow of contexts. Such contexts rarely coalesce into images, rarely come

to terms. They are transitions, transmutations, the endless radiating of denotation into relation. Poetry, to use William James's phrase, "is in the transitions as much as in the terms connected."[5]

Such a conception of poetry may at first glance seem to exclude videogames as a medium from poetic consideration (as has often been the case when it comes to conceptions of digital poetry, as we have already touched on). But, on the contrary, "language" broadly defined is not limited to written or spoken words. Every medium has its language, and its vernacular—a conventional network of signs and signifiers that becomes established and prosaic over time. This kind of broad conception of language (or semiotics, if we wish to be more precise) is the basis for fields of study ranging from visual semiotics[6] and cognitive semiotics[7] to specialized disciplines like the semiotics of film[8] and photography[9] (and even the semiotics of comics, as explored creatively by Scott McCloud[10]). In a move that is particularly relevant to videogames, scholars like D. Fox Harrell have made proposals for how existing semiotic frameworks might be usefully applied to computational media.[11]

I will examine the question of what I mean by the "language of videogames" in more detail presently but must note that a thorough investigation of semiotic theory is beyond the scope of this book, and I will consequently be standing on the shoulders of the many theorists who have laid the groundwork for a broad conception of language as operating within all kinds of media.[12] If Christian Metz can say that cinema functions as a "specific language,"[13] I would like to be bold and make a similar claim for videogames. I would then like to go one step further and suggest that this language of videogames (that is, the web of essential *signifying facets* within the medium) is the core material of the videogame poet. This claim is still broad and ambiguous, and consequently may not seem like a helpful step forward, but it allows us to make a few important observations.

For starters, the videogame poet cannot discount the visual or auditory components of games (those "old territories" shared with other mediums), because these components form a key part of the established language of videogames: the network of signifiers through which games mean what they mean.[14] As a creator or theorist, it is easy to dismiss these representational aspects of videogames in favor of their more "unique" and "exciting" interactive and computational dimensions. For example, when discussing the popular *Lara Croft* videogame franchise, videogame scholar Espen Aarseth has famously said that "the dimensions of Lara Croft's body, already analyzed to death by film theorists, are irrelevant to me as a player, because a different-looking body would not make me play differently."[15] While a sharp focus on the unique interactive nature of games can certainly yield much fruit (as many game scholars have demonstrated), from the perspective of the videogame poet it is wrong-headed to say that a videogame's graphics and sound represent old territory that has already been trod by other mediums like music, painting, photography, or cinema—and the reason why it is wrong-headed largely comes down to the poet's interest in specific language over abstract form.

If we take the visual component of games, yes, we can say that painting and photography and cinema all feature flat surfaces that can be filled with various visual patterns and shapes, which is also true for videogames; but if we consider the question of *visual language*, we can see that each of these mediums has overlapping but unique patterns of established semiotic conventions. Put another way, the established visual language of painting and photography are not precisely the same, even if visual representation in both mediums relies on the same building blocks of color, shape, and line, and even if any individual painting can look very much like any individual photograph. In fact, a painting that looks like a photograph is a perfect example to consider, because while the basic visual elements will be nearly identical in each, photorealism in painting *means* something very different from

photorealism in photography. In photography, photorealism is simply an assumed (we might say "vernacular" or "prosaic") mode of visual representation. In painting, on the other hand, photorealism requires careful and laborious technique and is pregnant with questions about the ultimate purpose of art and what it means to be "real," as well as meta-questions about the nature and value of painting specifically in relation to another specific artform (photography).

Now consider videogames. The nature and meaning of various visual styles (pixel art, cartoon graphics, photorealism, etc.), as well as the meaning of particular visual representations (a pixel, a crate, a gun, a woman), are different in videogames than in cinema, or in photography, or in painting. Which is not to say that the meaning is entirely disconnected (of course videogames draw on traditions of visual representation and semiotics established in those older mediums), but it is certainly not identical: each of these mediums has its own set of visual conventions.

I would suggest that the videogame poet's particular interest in a game's graphical representations is not so much an interest in shape and color and line per se (like it might be for a formalist painter[16]), but rather in the way that particular shapes and colors and lines—certain visual styles, signs, and symbols—have come to mean certain things *in videogames as a medium* over time, and in interrogating and recasting those signifiers (or introducing new signifiers) in order to intervene in the established language of the medium.[17]

Consider Figure 17. This screenshot says a lot about the nature of Yacht Club Games' 2014 action-platformer *Shovel Knight*[18] before we ever start to interact with the game itself. After seeing this screenshot, an experienced game player could likely start playing this game in their head, even if they have never encountered it before. How is this possible when videogames are interactive computational experiences that unfold in time? Couldn't *anything* happen when we start to play this game? Technically, yes. But the vernacular language of videogames

Figure 17: A platform game. (Image courtesy of Yacht Club Games.[19])

has been so established over the last few decades that a simple screenshot like this comes laden with a significant number of specific expectations; the visual signifiers here are numerous and substantial, and they operate very differently in videogames than they would in any other medium. As Harrell notes in *Phantasmal Media*:

> Signs come in *systems*: signs become signifiers in new systems and are incorporated within other signifiers. In other words, the differences in meaning of the signs reveals phantasms—each meaning involves shared epistemic and image spaces and each meaning can be revealed by contrasting different phantasms.[20]

We could say similar things with regard to sound in games. The sound of a "bleep" or a "chirp" or a shotgun reloading all have significant connotations in games, and those connotations are different in videogames than they are in other mediums like film or music. Consider a game that opens with a simple black screen and the sound of a shotgun reloading. The meaning of this sound in videogames is so entrenched that the overwhelming expectation for such a game is

that it would fade in to reveal the trappings of a first-person shooter (FPS). Our experienced game player may hear such an opening and automatically position their hands on their keyboard and mouse (or gamepad) in a way that corresponds to typical inputs used in such games, and may even have ideas in mind for how the game will look, and what the first few seconds of gameplay will entail.[21] Videogames have established visual and auditory vernaculars that are ripe for poetic intervention; as such, for the videogame poet, these aspects of games form a crucial part of the material they are working with.

Let's move on now from image and sound to consider the computational and interactive nature of videogames. If we consider our hypothetical player's reaction to a game that opens with the sound of a shotgun reloading, this reaction reveals the extent to which the various layers of signification and convention in videogames are entwined: aside from whether they are correct in their prediction of a first-person shooter game, our imaginary player is only able to grip their gamepad in a particular way, only able to imagine how an FPS game will look and how it will play, because the language of videogames broadly speaking (and FPS games specifically, in this case) is deeply entrenched and highly predictable, from the visual and auditory levels down to computation, interaction, and interface logics, and each layer of expectation is attached to and built on top of the others. To put it another way, the player imagines not only what they will see and hear as they begin to play our hypothetical game, but also how the interactive and computational dimensions of the game will unfold; that is, how the game will respond to their input, etc.

For the aspiring videogame poet, it is crucial to realize that the clusters of computation and interaction that are built into games can act as signifiers and establish a kind of vernacular language just as much as words, images, and sounds can.[22] Scholars like Janet Murray, Ian Bogost, Noah Wardrip-Fruin, and Michael Mateas have laid the groundwork for a linguistic-poetic approach to interactive

computational systems with their discussion of concepts like procedural authorship, unit operations, procedural rhetoric, and operational logics, respectively. Each of these concepts has its own framing and scope, but the important point that each of them has in common is the idea that computation and interaction logics (loosely speaking: "if this happens, then this happens") can be bundled together in consistent ways and tied conventionally to certain meanings and interpretations—that is: that they can form the basis for a kind of *language*. Ian Bogost's "unit operation" is the most abstract and general of these concepts, describing a "conceptual frame for discrete, compressed elements of fungible meaning" that can, in theory, be applied to *any* medium (though Bogost's focus is on computational media).[23] It is a useful concept for considering how units of meaning can operate at a foundational level across media but is somewhat broad and abstract for our purposes.

On the other hand, Bogost's concept of procedural rhetoric, which builds on Janet Murray's discussion of procedurality in connection with authorship,[24] is far less abstract, and describes the basic idea that interactive systems mount claims about the world through the *procedures* that govern those systems (apart from specific considerations of *content*). This basic concept can be applied to videogames at a number of different levels, though Bogost's focus in *Persuasive Games* is the rhetoric of procedural systems taken together as a whole. Gonzalo Frasca's well-known political game, *September 12th: A Toy World*,[25] is an example of a rather simple system that can be seen to contain a clear rhetoric about the War on Terror.[26] In this game, the player controls a reticle with their mouse and clicks to launch missiles at a Middle Eastern-looking village, ostensibly to wipe out "terrorists" who can be seen running around in the village carrying guns. When innocent citizens are inevitably killed by the missile's blast radius, more terrorists are spawned, and this cycle continues until the player chooses to quit the game. In Bogost's words:

The interface between missile, terrorists, and citizens works, insofar as it produces a result in the game world. However, the result it produces is undesirable, the converse of claims that long-range precision warfare is "surgical." Thus *September 12* claims that this logic of counterterrorism is broken; no one is made any safer by following it, and in fact many more innocent lives are lost.[27]

September 12's procedural message is so strong that some, like Doris Rusch, have posited that it's "impossible to not get the message when playing the game."[28]

The basic concept of procedural rhetoric, while somewhat imprecise, is highly accessible, and can be easily applied to any number of videogames. For example, *SimCity*,[29] the famous city simulator, contains procedural systems that can be said to make claims regarding how best to deal with challenges like crime, traffic,

Figure 18: A missile lands in *September 12*. (Image taken by the author during play.)

and pollution in real-world urban environments ("do $X + Y + Z$, and traffic will improve").

Procedural rhetoric is a highly useful idea for advancing an understanding of how interactive computational systems operate as a kind of language, which is important for our purposes. Rhetoric, however—that is, "the art of using language effectively so as to persuade or influence others"[30]—is not precisely the aspect of language that poets are most concerned with.[31] Rhetoric makes use of vernacular language in order to mount arguments, where poets are generally interested in the core of vernacular language itself: the weight, sound, and meaning of words and phrases in various contexts, and how that meaning can be explored and interrogated.[32] (Of course one can interrogate rhetorical arguments by making counter-arguments, but this is the realm of debate rather than of lyric poetry.)

Noah Wardrip-Fruin's concept of an "operational logic"[33] offers something much more analogous to an individual *word* in spoken language. Operational logics can be divided into various domains (graphical logics, resource logics, character state logics, etc.) and are concerned with the meaning of such basic things as collision detection, avatar movement, and resource counters: essential procedural elements that, like words, can be used and reused in a variety of games, in a variety of contexts.[34] Operational logics "connect fundamental abstract operations...with how they are understood at a human level,"[35] which is very similar to something we might say of words in the context of language (that they connect fundamental abstract markings or sounds with how they are understood at a human level).

For a concept as basic and conventional as sprite movement or collision detection, we might wonder what there is to say about its meaning: isn't the meaning obvious? What could collision detection mean apart from the notion that two objects collide in space? But as Wardrip-Fruin and Mateas remind us, "processes, on their own, have no intrinsic representational power."[36] The basic computational logic of

pixels on a display overlapping and triggering a further process does not inherently represent two physical objects colliding in space any more that the letters making up the word "c o l l i s i o n" do. Our understanding of collision detection has been built up subtly and consistently over time as videogame after videogame, dating back to *Spacewar!*[37] and *Pong*,[38] have utilized metaphors that reinforce this meaning. Though some videogames have offered up alternative metaphors (collision detection as used to indicate Pac-Man eating, for instance, which is hard to interpret purely as a collision of two physical objects[39]), the fact that it is generally hard to imagine alternative meanings for collision detection is a sign of just how established and prosaic the language of procedural signifiers in videogames has become—and how relatively few game poems there are to help us reimagine the meaning of these basic "words." How and why does a basic computational operation like collision detection come to mean certain things in videogames, and how might one intervene to question or recast that meaning? This is precisely where the poet's interest lies (game poems like *Passage* and *Loneliness* both attempt to recast collision detection, for instance), and we will investigate these kinds of questions in more detail shortly.

To conclude our discussion of material, I will repeat my central thesis: that the core material of the videogame poet is the *language* of videogames: a vast tangled web of visual, auditory, and procedural signifiers, with all of their established ways of signifying (both denotatively and connotatively) in relation to one another and to the world at large. This perspective admittedly leaves us with an immense, complex, and ever-shifting material,[40] but it also serves to distinguish the perspective of the game poet from that of other practitioners working in videogames and allows for some possibility of "getting down to business," as we will explore in the next chapter.

CHAPTER 12

One Vision of Poetic Intervention

We have now sifted through our messy "videogame heap" from Chapter 10 and identified one perspective that the aspiring game poet might take toward their material, namely that their material is the vast, tangled, and ever-shifting web that constitutes the "language" of videogames. But we have only touched briefly on the question of how poetic intent might be brought to bear with regard to this material. That is, the question of what the game poet's *purpose* is in crafting a game poem beyond the tongue-in-cheek proposal that they include as many lyric characteristics as possible.

What separates the specific purpose of the videogame poet from that of other creators working in videogames? Consider the roles of game designer, software engineer, level designer, narrative designer, pixel artist, sound engineer, and animator: at a broad level, all of these people are "making videogames," but at a more specific level they all have very different goals and purposes: the level designer seeks to design a good level, where the pixel artist seeks to paint a good sprite, and the narrative designer seeks to tell a good story. What is the foundational purpose of the poet working in games? Our discussion of material in the previous chapter provides an entryway for considering this question:

if the game poet's material is the language of videogames, then surely their purpose must relate in some way to crafting that language. But where we might say that a level designer's purpose is to design a "good level," it doesn't seem right to say that a videogame poet's purpose is to craft "good language." If the language of videogames consists of "a vast tangled web of visual, auditory, and procedural signifiers," then doesn't "good language" translate broadly to "good videogame"? And now we've lost the thread of poetry.

There are two important realizations to be had here. First is that the poet's interest in videogames is indeed broader than the interest of the software engineer, level designer, narrative designer, or pixel artist: the videogame poet is in some way interested in the "whole package" of videogames (at least all those parts involving sensory stimuli and signification).[1]

The second realization is that the poet's task is not to craft "good language," but rather, as we have already hinted at in the previous chapters, to intervene in language—to craft good *poetic interventions*. This sets the purpose of the videogame poet apart from the purpose of the "game designer" broadly speaking, in much the same way that we might separate the purpose of the traditional poet from that of the "writer," broadly speaking. Still, to use the word "good" with regard to poetic intervention is both lazy and useless. Given some set of criteria, we might speak of virtue or quality or artistry when it comes to either poetic intervention or poetic language (as critics have done throughout history), but for now I want to set these notions aside. The question of what makes a "good" game poem is a question we can tackle another time (if we have the inclination to do so), when we have built up the language and criteria necessary for such judgment; for now, our interest is more basic: what does poetic intervention look like, and how might such intervention translate to videogames?

This is, in some ways, where the "rubber meets the road" for the would-be videogame poet. As with perspectives on the poetic

material of videogames, the question of what it means to intervene poetically in games demands many answers from many videogame poets, just as we have had many historical answers from many historical poets of what it means to intervene poetically in oral and written language.[2]

My own answer to this question begins with a vision for poetry that has been expressed in one way or another by many poets, perhaps most famously by Percy Shelley in *A Defence of Poetry*, where he writes that poetry "lifts the veil from the hidden beauty of the world, and makes familiar objects be as if they were not familiar."[3] Julia Kristeva gives voice to a similar perspective a century later in "The Ethics of Linguistics," when she notes that poetic language carries on the struggle against the "death" of a world where rhythm and felt experience have been lost.[4] I have found the language of Owen Barfield, a somewhat obscure poet-philosopher, to be particularly clear and resonant when it comes to expressing this vision for poetry. Echoing Shelley, Barfield writes in *Poetic Diction* that poetry is about intervening in vernacular language to recast that language and make it new—in order to help us see the world itself anew.[5]

Language, notes Barfield, relies fundamentally on metaphor: words are cast in relation to physical objects first, and then in relation to other words whose meaning has become established.[6] He postulates that new words start out with an explicitly metaphoric quality: everything is "like" something else, and no word can be thought of as having a "literal" meaning—all is image, comparison, and contrast.[7] But gradually, as early metaphors are used over time and become part of vernacular language, their meaning becomes prosaic and literalized; the ambiguous power of the original metaphor is lost, and we start to read some words as having a specific, *literal* meaning.[8] This development of literal meaning is part of what allows vernacular, prose language to work as an effective tool for communication, but that communication comes at the expense of an appreciation for the

uncertain metaphors and ambiguous felt experience at the heart of all language. We gradually lose an appreciation for the sound and rhythm of familiar words and for the way they first helped us see the world in a "new and strange light"[9] by arousing "cognition of the unknown."[10]

Poetry, then, is about recasting familiar words, often via the use of new metaphors. It is about reviving language, making it fresh, and mysterious, and concrete once more—and simultaneously reviving our stale conception of the world. As Muriel Rukeyser notes, language is never static, and poetry is part of "a process, in which motion and relationship are always present—as a river in whose watercourse the old poetry and old science are both continually as countless pebbles and stones and boulders rolled."[11] Thus, as we observed in Chapter 7, Shakespeare was able to enrich existing words and change established language when he crafted a new metaphor by calling sleep the "balm of hurt minds" in act II of Macbeth.[12]

Can we imagine this kind of poetic intervention taking place with regard to the established language of videogames?

This question is of particular interest because videogames have long been enamored with literalism. If I write a sentence in the hope that it can and will be understood in precisely one way, that is literalism; that is prose (at least, a prosaic perspective on prose). It is not hard to read the history of videogames as an infatuation with literalism: the desire to achieve ever higher fidelity in graphics, sound, and physics rendering in order attain a kind of hyperrealism that has no use for metaphor.[13] As Merritt Kopas notes:

> Games have a photorealism problem—mainstream games in particular have become so focused on emulating film that the industry has come to believe the highest calling of video games is to visually reproduce reality perfectly.[14]

In one version of the dream of virtual reality, no conscious semiotic interpretation will have to take place in the mind of the player: the

spaceship is a spaceship; the sword is a sword; the hand you see is *your hand*. There is no need of or desire for metaphor in such a world; every representation is simply taken, literally, for the thing represented. And many videogames are fast approaching this dream. Most commercial FPSs, for instance, rely on indexical-inspired representation and established conventions so heavily that there is little if any conscious semiotic interpretation going on for those well trained on the genre: you are this person, running through this environment, carrying this gun…that is that.

The established conventions are of course key. Metaphoric language and literal language are both a negotiation between writer and reader (or speaker and listener) and are mitigated by context (as noted by Saussure, Peirce, and others, and emphasized by Harrell[15]). Established meanings are built up over time, and something that begins its life as strongly metaphoric (press these buttons to move this perspective on the screen) can take on established prosaic meaning over time for a given group of people, which is what allows some players to start up an FPS game and use the arrow keys and mouse to move "themselves" around without even thinking about it.

Videogames can work outside of the literalist paradigm by seeking to make the familiar unfamiliar after the fashion of poetry. Drawing on the work of Viktor Shklovsky, Alex Mitchell has noted the connection between poetic gameplay and the use of "defamiliarization" effects in games like *The Graveyard* and Brendon Chung's *Thirty Flights of Loving*:[16]

> Shklovsky's notion of defamiliarization involves encouraging the reader
> to see the familiar in an unfamiliar way, not for its own sake, but as a way
> to break out of the tedium of everyday life and see what we see everyday
> in a new, fresh light…. Similarly, the techniques I have identified through
> my close reading of *Thirty Flights of Loving* require some effort on the
> part of the player, an effort that results from the conceptual distance
> between what the player expects to encounter in a first-person shooter,
> and what she encounters in this game.[17]

Contrast a game that relies on easily accepted literal meaning to
a game like *Passage*, with its backward-facing aesthetic and dense
use of metaphor. To begin with, in a world where photorealistic 3D
environments are increasingly the norm, a 2D side-scrolling game
takes on a certain metaphoric quality from the get-go: after playing a
photorealistic first-person shooter, it is not quite as easy to accept that
the pixelated avatar in *Passage* is *you* in the same way as your player
character in the FPS: rather than "you are this character," we are met
with something like, "let this avatar stand in for you *in some way*"
(much as someone might have reacted to their square avatar when first
playing *Adventure*[18] back in 1980) and are consequently primed for
metaphoric meaning before we even start playing the game.

It should be noted that even as high budget mainstream games
continue to pursue cutting-edge photorealism, the emerging
popularity of indie games in recent years has simultaneously given
rise to the normalization of what might be called a "retro-chic"
aesthetic. I would argue that this retro aesthetic generally tends to
rely on metaphor more explicitly than photorealistic rendering, but
its normalization over time can still serve to break down a player's
need to "work" for semiotic interpretation—requiring new modes of
poetic intervention. This kind of development reflects the constant
evolution of vernacular language, and the need for evolving strategies
of poetic intervention. Navigating this landscape requires careful
intentionality on the part of the poet, who must constantly balance
a desire to push back against literalism and prosaic language with a
cognizance of meaning's breaking point (as we noted when discussing
metaphor in Chapter 7).

Consider that even as it eschews representational realism, *Passage*
still relies on convention and some amount of established semiotic
meaning—if it did not, the game would come across as gibberish,
much like a poem concocted only of words that had never been used
before or words completely out of order.[19] Thanks to *Adventure*,

The Legend of Zelda,[20] and many other classic videogames, we understand the basic conceit of a 2D game with a user-controlled avatar. But, importantly, rather than simply embracing established conventions in a way that would encourage literal reading, *Passage* pushes back against those conventions in a denial of literalism, and an explicit invocation of metaphor, as we began to examine in Chapter 3.

In *Phantasmal Media*, Harrell provides a framework that he calls "polymorphic poetics" for reading the many layers of metaphor present in *Passage*—a framework that can also serve as a strategic guide for creators looking to imbue their games with this kind of metaphoric meaning. Harrell's language is dense but seeks to rigorously investigate the basic question of how one might start to think of "mapping" metaphors like *life is a journey* into a videogame's semiotic space.[21] *Passage* succeeds in being a richly metaphoric game, in Harrell's view, because of the way it effectively translates broad phantasmal concepts like "life journey," "past, present, and future," and "death" into the language of videogames (or in Harrell's terms, the "semiotic space" of videogames) via the use of ambiguous medium-specific signs: a pixelated play space, a maze, an avatar, compressed "past" and "future" areas, the image of a tombstone, etc.[22]

Whether understood through the lens of polymorphic poetics or another framework, the important point is that the meaning of *Passage*'s two-dimensional landscape (to take one example) is better read as a metaphoric representation of "life" than as the representation of a physical landscape (a point we began to consider in Chapter 3). The idea of navigable space in videogames is being recast here, being given new and ambiguous meaning. It was understood to mean one thing (physical space—the old, established metaphor that has become prosaic), but now it can somehow also mean "your life." This power to recast the world and help us see things anew is the power of poetry. Because of *Passage*, *Adventure* and *Zelda* are not the same anymore. *Adventure* and *Zelda* defined the conventions that allow us to read

Passage, but *Passage* alters those conventions in a way that redefines our reading of *Adventure* and *Zelda*: the play spaces, the avatars, the visual icons, and the operational logics of those older games have become visible anew, and bear within them more potential meaning. As Noah Wardrip-Fruin notes:

> What makes *Passage* remarkable is how it works with common meaning-making strategies of video games—in particular, how it takes them apart and reassembles them so that they are active both in traditional and in new ways, making them visible to us again.[23]

Notice how Wardrip-Fruin's language seems to echo that of Percy Shelley, who speaks of making "familiar objects be as if they were not familiar."[24]

It is my belief that this kind of intervention in the established language of videogames can be pursued with intention, and that we might consider such work (for lack of other present alternatives) the special domain of the videogame poet, and the game poem. The titles of "videogame poet" and "game poem" are certainly less important than the work itself, but the titles are not *unimportant* if they can help us to identify and distinguish a mode of creative engagement with videogames that has generally been minimized or overlooked.

CHAPTER 13

Recasting the Language of Videogames

In Part I of this book, we developed a loose definition for the category of "game poem" centered around lyric tendencies and family resemblance. We identified game poems, broadly speaking, as games with lyric characteristics. We can now add to this framework the concept of poetic intervention in the language of videogames, an idea we touched on indirectly in the first part of the book—all of the games we examined in Part I can be seen to craft various kinds of interventions in the language of videogames, often by bringing lyric characteristics or lyric devices to bear—but that we have now defined explicitly.

At this juncture it may be helpful for me to return to my own experience making game poems and provide some additional notes "from the trenches," as it were. It should come as no surprise by now for me to say that I consider the core of my game-making practice to be the intentional pursuit of exactly the kind of poetic intervention that we have been discussing in the last couple of chapters: from the visual and auditory levels down to input mappings and operational logics,

I seek to carve out new metaphors, recast established signifiers, and open avenues for new meaning. At the visual level, one of the reasons I use abstract symbolic representation in much of my work is to challenge the longstanding trend toward literalism and photorealism in videogames (which suggests that the visual representation of a square can only stand for a box or a crate, for example), and to create room for more subtle and ambiguous visual meaning.

Consider my games *Loneliness*, *Freedom Bridge*, and *A Brief History of Cambodia*,[1] for example. In *Loneliness* and *Freedom Bridge* I attempt to remind the player that in addition to being a box or a crate, a square in a videogame could just as well be a person—returning to the convention established by *Adventure* in an era when symbolic representation was commonplace. (Barfield notes that returning to "archaic language" is a common technique for poetic intervention.[2]) Then, in *A Brief History of Cambodia*, I push this metaphor out further: in this game the player is presented with a single screen that shows some black squares floating up and down on an abstract sea; there is also a hand cursor icon familiar from operating systems and web browser interfaces. With some experimentation, the player discovers that they can move the hand cursor with their mouse and use it to grab hold of the squares and toss them about in various ways. They can also hold the squares underwater, which results in violent jerking along with ambiguous underwater noises and the release of air bubbles; if the square continues to be held underwater the jerking eventually stops, and the square falls slowly to the bottom of the screen and disappears. (It is a grim game in dialogue with a grim history.)

We could say that the squares represent people here, much as in *Loneliness* or *Freedom Bridge*. But read in light of its title, *A Brief History of Cambodia* suggests that each of its squares represents not a single person, but rather a multitude of people—or a single person standing in for a multitude. Through this kind of use of explicit and shifting symbolism, I attempt to enrich and enliven depictions

Figure 19: The squares in *A Brief History of Cambodia* do not represent individual people as such. (Image taken by the author during play.)

of squares in videogames (they can no longer be read automatically as crates or boxes)—but more importantly: to enrich and enliven depictions of simple lines and shapes in general, and to suggest that any game, at any time, could be using visual representation in symbolic and ambiguous ways.

Many of my games make use of less symbolic, more representational 8-bit-style graphics, but in these cases I still attempt to challenge and overload conventional videogame representations rather than simply recreate nostalgic iconicity. Sometimes I seek to recast a specific representation (as in the case of the visual representation of a square, above), and sometimes I seek to broaden the expectations that exist around a particular *mode* or *style* of representation (such as pixel art or photorealism in games). *Walking with Magnus*[3] may look vaguely like a classic 8-bit-era side-scroller, for example, but instead of shooting or collecting things, the player's "objective" is simply to take a long walk with an infant in a stroller. The game thus challenges and expands expectations tied to this

Figure 20: *Walking with Magnus* is not a typical 8-bit-era side-scroller. (Image taken by the author during play.)

visual style and genre. Likewise, *Grandmother* attempts to expand expectations around photorealism in games (through its use of actual photographs): instead of shooting photorealistic bullets from a photorealistic gun, the player of *Grandmother* uses a photorealistic sponge to clean a photorealistic headstone.

As we have noted in the previous chapters, the various layers of signification and convention in videogames are tightly entangled, from the visual and auditory levels down to computation, interaction, and interface logics, and I have found that my attempted interventions are typically likewise entangled. In *Loneliness*, for example, my use of abstract shapes to represent people primes the player to look for symbolic meaning within the game, which sets up further interventions at the level of operational logics, where the game attempts to recast basic logics tied to sprite movement and proximity detection. As we have noted, these are logics that, historically, have most often been used in videogames to represent the movement and interactions of physical

objects in space: a spaceship flying, a tank moving and shooting, etc. But in *Loneliness*, these logics represent something very different. We can say that the squares represent people, but as we discussed in Chapter 3, they do not represent physical bodies in space so much as subjective perceptions of people, as tied to subjective perceptions of social connections and relational bonds. If the circular movement of certain groups of squares in *Loneliness* does not represent circular movement of bodies in space, then it follows that approaching a group of squares with your player avatar and watching them flee cannot represent people literally running away from you as you draw physically near to them. What does this proximity detection indicate, then? Like the symbolic visual image of the squares themselves, drawing close to other squares as determined by proximity detection logics in *Loneliness* is an explicitly symbolic metaphor, and the resultant movement of these squares away from your avatar is likewise an explicitly symbolic metaphor.

Rather than having "clear and obvious" meanings as we think of these logics as having in videogames ("a spaceship is moving through space; when it gets too near to an asteroid it crashes"), the meanings of these logics in *Loneliness* are thus figurative and highly ambiguous: perhaps the circular movement of a certain group of squares together represents people playing boardgames with friends, or perhaps it represents people getting coffee at work; perhaps drawing near to them represents an attempt to engage a particular social group, or perhaps it represents only an *imagined* attempt at such an engagement, or a *memory* of the last such attempt. By breaking with established conventions and proposing new metaphors, *Loneliness* attempts to forge new meaning onto these established logics in the way that Owen Barfield would speak of poets forging new meaning onto words.

There is no shortage of potential examples I could offer in this regard. *A Brief History of Cambodia* attempts to overload and shift the meaning present in the input logic of a mouse click, for instance. In videogames we are used to the click of a mouse button often being

tied to the pull of a trigger and a spray of bullets, but here that same click is recast to mean the shooting and drowning and clubbing of multitudes—without necessitating any depiction of bullets or human beings or blood. *Portraits of My Child* attempts to recast things as basic as a button press, a solid wash of color, and the sound of a "bleep" by suggesting that these things can hold within them some connection to a newborn's first cry, or first smile. *The Heart Attack* attempts to enrich the possible meanings of rhythm, collision detection, and sound in relation to rhythm game conventions.

Always it is my hope that after playing one of my games a player's experience of some aspect of the world is enriched and enlivened (that they see another's smile in a fresh light, for instance, after playing *Portraits of My Child*) and also that their experience of other videogames is enriched and enlivened because the basic building blocks of the medium have been endowed with little bits of new potential: that a simple shape bears more possibility, that a "bleep" is richer, that a sprite's movement on screen is more pregnant and interesting than it was before—even if ever so slightly. This, for me, is what the question of making game poems is all about.

Which brings me to a last point regarding the importance of framing and positioning when making game poems. (Something we touched on in Chapter 2, and again in Chapter 9.) People have sometimes asked me why I choose to position the things I make as "videogames." Why not show the work in gallery spaces and simply call it "art"? The reason is that I see myself not simply as an artist, but also as an aspiring poet whose *medium is videogames*. My desire is to intervene in the language of a particular, established medium—an intervention that becomes ineffectual if the medium in question is not clearly defined. Which is not to say that I or other game poem creators should not show our work in art spaces (which I sometimes do), but only that if the thread connecting what we make to videogames becomes too thin, the work ceases to be an intervention in the language of this specific medium.

A case in point is found in the various possible framings of my *Stations of the Cross*[4] triptych. *Stations of the Cross* is an interactive installation project in dialogue with traditions of spirituality, pilgrimage, and contemplation, as well as historical artworks like Barnett Newman's *Stations of the Cross* series of paintings.[5] The installation consists of three enclosed booths, or "stations," each of which presents an abstract, contemplative touchscreen experience that can be encountered in the space of a couple of minutes or over a longer time frame, depending on the pace and inclination of the player. As with historical Stations of the Cross images, each game is presented as an object available for contemplation, spiritual reflection, and aesthetic encounter, centered around the core theme of suffering.

Framed as a videogame installation, *Stations of the Cross* intervenes forcefully in the medium of videogames at a number of levels, recasting expectations around what videogames can do and be, in addition to crafting specific interventions at the level

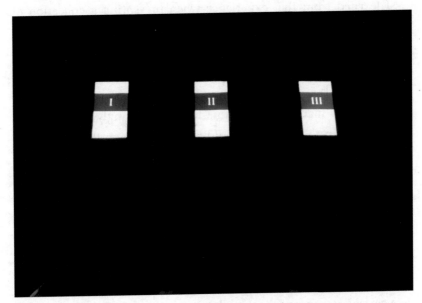

Figure 21: My *Stations of the Cross* installation, with all three stations open and revealed. (Photo taken by the author.)

of representations and operational logics. (It extends the work of *Loneliness* and *A Brief History of Cambodia*, for example, by suggesting that a square in videogames can represent such ambiguous concepts as "death" or "the weight of the world.") These interventions are forceful partly because *Stations of the Cross* is so far from being a typical videogame. And yet *because* it is so far from being a typical videogame, any positioning in relation to videogames risks being lost without adequate context and framing—in which case the medium-specific interventions go from being forceful to non-existent. This is what happened when I showed the work in an art space in 2017:[6] the context of the work and the work itself were so far from viewers' mental conception of "videogames" that for many the piece failed to register as relating to videogames in any way whatsoever. For this particular installation I didn't necessarily mind the dissociation,[7] but it was an interesting lesson to observe, and one that I think is highly relevant to discussions of game poems, and what it means to intervene in the established language of a given medium.

I learned from that experience when presenting a collection of five game poems at another art exhibition.[8] Because this was again an arts context rather than a videogame festival (where the framing of "videogames" is generally strongly enough entrenched that any presented work is automatically assumed to relate to videogames in some way),[9] I made sure to frame my work strongly in relation to videogames so that viewers would be able to make the connection and hopefully perceive the interventions I was attempting for the medium (even if subconsciously). In my mind, this kind of intentional positioning is a large part of what separates the practice of creating game poems from a more general interactive art practice.[10]

During the exhibition, people asked me why I chose to use a stock *Dance Dance Revolution*[11] dance pad as an input device for a game poem about walking with my infant son—why not paint the pad to be less garish? My answer: because I see my work as relating not just to

Figure 22: In my "Videogames After Poetry" art installation, I made use of unadorned videogame controllers (including a garish dance pad) as one means of positioning my work clearly in relation to videogames. (Photo taken by the author.)

the art world, but also explicitly to videogames as a medium. Because I want players to see that dance pad and recognize it as a dance pad and consider that the controllers and technologies we've been using in videogames for a long time, for certain kinds of expressive ends, can also be used for other kinds of expression. Because I want players' next experience of playing *Dance Dance Revolution* to be altered ever so slightly. *Because this thing you're engaging with isn't just an Art Object—it's also a Game Poem.*

CHAPTER 14

Making Game Poems in Practice: A Beginner's Guide

My hope for this book is that it might be useful not only to the videogame scholar, but also to the practicing game maker. Consequently, from the first chapters I have attempted to ground our discussion in practical examples from a variety of game poems, as well as case studies from my own work. Indeed, much of our discussion has emerged from and centered around questions directly related to practice. Still, our examination of creative *process* has been limited to this point in the book. "Game poems are such and such"; "Poetic intervention in videogames involves such and such." But what about the blank sheet of paper? How does one actually begin this work and carry it through to some kind of completion? I will turn now from theory and scholarship to the building blocks of daily practice. What follows will be a highly personal account of how I spend my days, and what I've found to be helpful in the process of making game poems: a kind of creator's handbook with hints of manifesto. Some parts will be specific to game poem creation, but other parts will likely apply broadly to many types of creative practice. If you are looking for

advanced guidance, I'm afraid you will have to look elsewhere—this is a beginner's guide, because I am a beginner. I include it here in the hopes that it might be useful to some other beginners, since I have found there to be a dearth of guidance on this particular topic.

Start by Making

> Our real illiteracy is not the ignorance to read and write…but the inability to create.
>
> (Friedensreich Regentag Dunkelbunt Hundertwasser)[1]

There are creators (including some very good poets) who will tell you to begin your creative journey by reading. That is to say, if you want to make game poems, begin by playing other game poems, reading poetry, etc. But I disagree. Or rather, I think that if you're reading this chapter, you've probably already played a game poem or two, and there's a good chance you might have some little image, some little idea, some little inkling for a game poem of your own. If you have that image, if you have that idea, if you have that inkling, I urge you to start by making something. Even before the image is clear. Even before you have a good grasp of what you are trying to do. Even if you've never made a game before. Even if you don't know how to program. There are tiny little game engines out there that anyone can learn to use in a matter of hours, which work great for making game poems. You don't need to know how to program or have any previous experience with game design. Go search for "how to make a game in Bitsy"[2] and make a tiny terrible game poem before the sun goes down. Or maybe your tiny game poem will be great. I don't know. But allow it to be terrible. It's fine if you decide to throw it away.

I believe in reading (we'll get to that shortly), but I also agree with Hundertwasser that making is the hard part. Inertia is the hard part.

Self-doubt is the hard part. Which is why I'd urge you to start by making something—even, in fact, if you don't have any idea or any inkling. Open a book and point to a word, then make a tiny game poem about that word. Not inspired? Point to a different word. Or use an image as a prompt, or a color, or a feeling. Anything you like. *A blue circle moves across a blank screen, finds a sunflower, and the world turns yellow: bleep bleep.* That's a game poem. Or even simpler: *a blue circle resists movement, then moves.* That's a game poem that expresses something about my experience in the world today; let's call it "My Day So Far." With a bit of effort, you could make this game poem (or something like it) right now, using a tool like Bitsy, whatever your previous experience (or lack of experience) in game creation. Start with a shape, add a color, add a verb. Can you express something with that? People like to talk about (and decry) the number of amateur poets out there in the world writing what are presumed to be bad poems, but

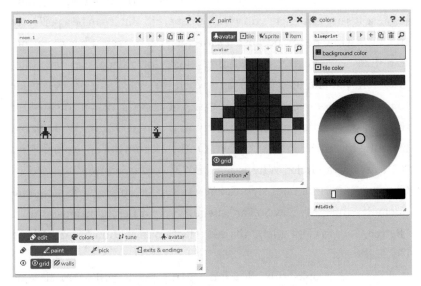

Figure 23: Bitsy: one example of an accessible and tightly constrained game engine. (Image taken by the author.)

I personally believe all those amateur poets and all those bad poems are the lifeblood of poetry. The most important thing for poetry is this: we need poems to be *written*. Similarly, we need game poems to be *made*. Yet, while the amateur poetry scene can be viewed as relatively healthy, there aren't too many people making game poems "out there in the world." If you have any interest in pursuing this journey, you have plenty of time for reading, practicing, getting better—but if you don't start making now there's a chance you never will. So start by making something tiny and terrible, just to get it out of the way. Then come back here; I'll wait. Fight inertia.

Start Small

Okay, so you've made your tiny game poem? Great. The thing about game poems is, we care about all the little parts, and simplicity is fine, ambiguity is fine. "My Day So Far" can't be a traditional videogame, because it's not fun, there's no winning, etc., etc. But it can be a perfectly fine little game poem, because it's an image, it evokes, it has meaning. It utilizes the most basic building blocks of videogames (a sprite, avatar movement, user input), and when presented as a poem (rather than as an incomplete game prototype), it asks the reader to consider those basic building blocks explicitly, and in a new light. What is the meaning of a sprite in this context? Or the meaning of an avatar? Why is the avatar a circle? Why is it blue? Of course, as we discussed in Chapter 7, the title does significant work for a simple, abstract game poem like this. "My Day So Far" suggests very different meanings than "Betina Goes to Get Lunch," than "Perfection in Motion," than "A Blue Circle Moves."

To some people, this idea for a game poem will seem silly or absurd. ("It doesn't mean anything"; "it's whatever you want it to be"; "all the meaning is in the title.") But that's simply because it is a

poem, and little poems like this have always seemed silly or absurd to some people. Consider Strickland Gillilan's famous short poem, "Lines on the Antiquity of Microbes" (also known as "Fleas"), which simply reads:

Adam
Had 'em.

This poem is so tiny that changing its title, or changing a single word, changes everything. To the poet, rather than seeming silly, or absurd, a tiny poem like this presents a fascinating study in meaning-making—and we could say the same of our tiny blue circle game poem. From a poet's standpoint, a game poem like "My Day So Far" can be viewed as a fun little sandbox, a chance to play with meaning. By changing the title, or the avatar's shape, or the input mechanisms, we can interrogate the meaning of words on the one hand, and the meaning of interacting with a little blue sprite on the other. This is not to suggest that what we have here is a great game poem. So far as described it is haphazard, highly ambiguous, thrown together, and abstract. When compared to a poem like Strickland's "Fleas," it lacks the cohesion, intentionality, and directness that make that poem "work." But it is still a game poem, and that's my point: you can begin here, in this little sandbox, just experimenting with basic shapes and movement and interactions and asking what kind of title might allow a simple but resonant metaphor to emerge. (Or you may find it more natural to work in the other direction: think of a title for your game poem and ask yourself what sorts of basic shapes and interactions allow a resonant metaphor to emerge.)

Consider my game poem *First Smile*,[3] the simplest, tiniest game poem I've ever made, about my infant son's first smile: the player is presented with a gray screen, and when they hit the right key—"bleep!" and the screen turns yellow. (I've distributed this game poem on its

own, though it is also exists as a vignette within *Portraits of My Child*, as already mentioned.) This game poem is utterly simple, but it is cohesive and direct, and it still makes me grin. At an only-slightly-more-complex level, *Loneliness* is another example of where this kind of play with basic shapes and movement and interaction can lead. To make game poems, you must be willing to be playful, open, and interested in the most basic building blocks of videogames, of language, of metaphor, of meaning. Rather than finding tiny, minimalistic games to be silly or absurd, look for what might be interesting, and press in there. Then be willing to be silly and absurd yourself as you play and create. Try things out, experiment, and realize that some people may look at you strangely and speak derisively about your creations. That's okay. Welcome to the world of poetry.

Embrace Constraints

As you continue experimenting and making, embrace smallness, embrace constraints. As with writing a poem or painting a picture, a blank sheet of paper or a blank canvas can often feel daunting. Start with the most accessible, most constrained game engine that you can find. (See Appendix I for a list of recommendations.) Rather than looking at constraints as a hinderance, try to see them as an asset, as many poets have advocated.[4] Constrained game engines resist literalism and naturally lend themselves to symbolism and metaphor, which are useful features for a poet (see Chapter 7, Chapter 13) because they force you to consider how you might express your idea using simple comparisons and the most basic elements of interaction and representation. If you struggle to know what to make game poems about, you can continue to use the technique suggested above: open a book and point to a word;[5] or make use of an online prompt generator;[6] or join a game jam like Ludum Dare[7] and make a game poem in forty-eight hours based on a provided idea.

This may seem like a haphazard approach to creation, but the initial goal in making game poems, as with writing poetry or developing any creative skill, is not to produce high art, but to *practice.* While playing other game poems can help you identify effective techniques and gain an understanding for how poetic devices operate in videogames, it is only by making game poems yourself that you begin to learn how to achieve the techniques you wish to achieve in your own games—so that when you have an image in your mind, you are able to manipulate pixels and code to bring that image to life. This is fundamentally no different from learning the technical craft that underpins any artform: a painter must learn to paint what they see int their mind's eye; a composer must learn to write down what they hear in their mind's ear. Sometimes the technique required is simple: my vision for *Loneliness* required that I be able to make black squares move on a 2D canvas. Sometimes it is more advanced: Jason Rohrer's vision for *Passage* required a method for graphically compressing a large play space in order to present a compelling visual metaphor.

Of course, the sky is the limit when it comes to technical mastery in programming and in making games generally, which is another reason that I recommend beginning with constrained game engines and development frameworks. If you are new to programming (and/or to poetry), don't start by making a sloppy game poem in a relatively unconstrained engine like GameMaker, Unity, or Unreal. You will find yourself overwhelmed with possibilities and with

Figure 24: *Passage* utilizes a graphical compression technique to make the game's entire landscape visible at all times. (Image taken by the author during play.)

things to learn, and your creative energies will end up dispersed. Instead, make a tight and focused little game poem in a tight and focused little engine like Bitsy or PICO-8. Test the boundaries of these constrained systems and learn to work within their limits to achieve a variety of effects.

If you find yourself struggling to fit your vision into the constraints of the engine you are working with, remember that poetry has long been valued as an art form that strips away everything inessential[8]—and a constrained game engine can help you to do just that. Ask yourself what your game poem is about at its core and try to imagine what that core experience might look like given the constraints you have to work within. (It makes for an interesting study to take an existing game poem like *Passage* and ask how one might reproduce some of the felt experience of the game using a more constrained engine like Bitsy, Twine, or PICO-8.) When you feel that you are ready, you can seek out new engines and frameworks that allow you more freedom—but I encourage you to delay this step for as long as possible.

Embrace Imitation and Appropriation

In her *Poetry Handbook*, Mary Oliver dedicates the entirety of an early chapter to imitation, stating:

> You would learn very little in this world if you were not allowed to imitate. And to repeat your imitations until some solid grounding in the skill was achieved and the slight but wonderful difference—that made you *you* and no one else—could assert itself.... I think if imitation were encouraged much would be learned well that is now learned partially and haphazardly. Before we can be poets we must practice; imitation is a very good way of investigating the real thing.[9]

And I am inclined to agree. All creators know that there is no such thing as truly original art: everything builds on and extends something that came before. What you can offer is that "slight but wonderful difference" that makes your creations your own. Imitation is a great place to start with making, particularly before you have much idea of what defines your own style and voice. That will come. But in the meantime you can practice, you can play and explore, you can build technical skill and learn craft, you can take existing works and change little things and see what kind of difference those little changes make.

One place to start is by copying other game poems outright to build technical skill. But don't stop with a carbon copy: try changing the game in various ways both subtle and overt, to observe what the impact is on the felt experience of play. (The goal of copying existing games is to practice and gain technical skill; needless to say, such copies should never be released under the guise of original work.) Next try making a game in the style of another game poem, but about something else entirely: a game poem that evokes *Passage* but that, rather than being a memento mori, is a reflection on the joys and struggles of childhood; or a game poem in the style of *Loneliness*, but that is about friendship and connection. Or you can try flipping this idea on its head and making a game poem that attempts to capture the themes of *Passage* or *Loneliness*, but does so using different mechanics, or in a different style entirely. One of my favorite exercises, already mentioned above, is to take an existing game poem and try to capture something of its core (that is, to reproduce something of the felt experience of play) using tighter constraints: to attempt to reproduce *Passage*, for example, using a tiny game engine like Bitsy, or PICO-8. There is no end to imitative exercises that might be imagined, especially if you expand your subject matter. Imitate other game poems, but also: imitate written poems, imitate life, imitate everything.

A related idea to imitation is that of appropriation, which can have a similar meaning, but which I tend to think of as less about copying and more about utilizing existing work in the context of making new work. Consider found poetry, or conceptual poetry, for example, which often use the words of existing poems as a kind of conceptual tool and creative constraint in the context of producing something that is materially bound to those existing works while also being an original creation in its own right. Some critics, like Marjorie Perloff, have pointed to appropriation as one of the most important and relevant techniques in contemporary poetry.[10] Be that as it may, my interest at this juncture is less about finding the cutting edge of contemporary poetry practice, and more about the extent to which appropriative techniques can serve as useful constraints to get one's creative juices flowing (as anyone who has ever written a piece of blackout poetry[11] knows).

When it comes to game poems, the concept of appropriation can be applied in a variety of ways. You can start with an existing game poem and appropriate its parts to make a new game poem that says something about the first game poem's themes, or something about the nature of game poems in general, or something about that first game poem in particular. Marcus Richert's *Passage in 10 Seconds* is an example of this kind of work: it appropriates *Passage* in order to be a game poem *about Passage*, about game poems in general, about the nature of art. You can also appropriate more traditional videogames, an idea that I would argue lies close to the heart of any poetic game-making practice since game poems are inherently connected to videogames as a medium and, in my view, are always attempting to reframe or recast expectations connected to that medium (see Chapter 12, Chapter 13). Adam Saltsman's *Fathom*[12] is a great example of a game poem that appropriates games in the Metroidvania genre in order to comment on those games and present what is ultimately a very different kind of gameplay experience.

Figure 25: *Fathom* appropriates aspects of famous action-platformer games in order to prime expectations and ultimately offer a different kind of experience. (Images taken by the author during play.)

Read Widely

Now that we've gotten our hands dirty, let's return to the idea of reading/playing existing work. I would repeat my advice to start making first, because of inertia, but I would also urge you to read/play existing work as you go. Play some of the game poems discussed in this book, then go in search of others. (Again, see Appendix I for some resources to help you on your way.) Play game poems first without overthinking them, to get an impression of the felt experience of playing. Allow the experience to sit with you for a moment (or a day), then start processing the first level of encounter. What does it feel like to play the game? What images are evoked and what themes are at work? Does the game poem resonate with you, or not? Does it illicit a strong emotional response? Does an enjoyment of the game poem come naturally, or is it something you have to reach for? Is playing the game difficult or easy? Is the rhythm jarring or smooth? Does interacting with the game feel like sandpaper, or like velvet, or like something else entirely?

After you've processed the initial encounter, play the game again, this time reading closely, and try to identify how the game *achieves* this felt experience of play. How does the game poem attain that staccato-like rhythm that stays in your body? That "aha" moment of realization? That feeling of lightness or heaviness? That subtle invocation of everyday beauty? You are looking now for techniques and devices to bring to your own work for exploration or explosion. How does the game poem make use of its little building blocks of interaction, computation, graphics, and sound? How does it acknowledge or resist expectations for what a videogame is or should be, and how does this affect your experience? Likewise, how does it acknowledge or resist expectations for what a poem is or should be? These kinds of questions were the focus of Part I of this book, and you can use those chapters as a kind of template in this investigative process, but don't rely on them as complete or canonical: there are more techniques and devices at play in game poems than can possibly be explored in one short book.

Play traditional videogames as well, when you can. Especially historically important videogames. Especially popular videogames. Become an expert on the things that make videogames tick: on genres and tropes and cliches, and all the expectations that have been built into this medium over the last few decades. You need to know what videogames are in order to use and recast their language effectively (see Chapter 10 to Chapter 13).

I recommend that you read poetry, too, if you aren't doing so already. As we explored in Chapter 1, the concept of a "game poem" can only have meaning in relation to long-established ideas about what poetry is and has been. Read lyric poems, read concrete poems, read language poems and digital poems. Find poets you like and focus there, because the point is to find inspiration rather than to press on for the sake of obligation. Read poetry handbooks and poetry theory if you have a mind to. Look for poetry everywhere: watch poem films and film poems; spend time with music, with paintings, with photographs.

Look for connections between mediums. Feel out the poems, study their techniques, and learn how they work. Pay special attention to the poems that resonate with you: consider why they resonate and consider whether the answer might be relevant in some way to the game poems you wish to make. Read, read, read. Study, study, study. And yet... don't get lost here. There is no end to reading, and you cannot read everything if you are to leave any time for making. Inertia. Always come back to making.

Play With Videogame Expectations

Remember Johan Huizinga's conception of poetry as play, from the introduction? Game poems are videogames that play with and push back against typical videogame expectations. Seek out a copy of the nearest game design textbook,[13] find a list of all the things a game "needs to have in order to be a game" (rules, goals, challenge, a clear winner, some notion of fun, etc.), and throw the list out. Or rather, try going down the list one requirement at a time and making a game poem that specifically rejects that requirement. Try making a game poem that rejects *all* the requirements. Is it possible?[14] Investigate the building blocks of videogames and ask how they might be interrogated and recast, how you might get players to look at those building blocks and experience them in a new way (to paraphrase Percy Shelley).

Lean in toward symbolism and metaphor. Reject literalism and easy interpretation; push back against gaming's "photorealism problem" and "fetish for realistic gaming scenarios."[15] Videogames have always loved objective reality, so make game poems about subjective reality: those things that are real but that don't show up in a photograph, or a 3D-render. ("Why does death so catch us by surprise, and why love?"[16]) Don't be afraid to require something of your players; don't be afraid to make them work for meaning. Let them know that they will have to work for meaning.

Make game poems with words, and game poems without words, game poems with titles, and game poems without titles. Play with words, play with language, play with sound, play with image, play with computation, play with interaction, play with expectations tied to different gaming platforms and frameworks. Investigate how felt experience and poetic effect work in videogames. Investigate how poetic devices operate, and how they can be put to use. Consider devices that have analogs in traditional poetry, as we explored in Chapter 8 (rhythm, repetition, rhyme, turning of the line, etc.), as well as devices that may be more unique to videogames as a medium (devices specifically tied to computation or user interaction, for instance).

You may also wish to celebrate ways in which you can undermine videogames' historical entanglement with capitalist values. Critics have noted that videogames are often about "solving, clearing, managing, upgrading, collecting, estimating and so on,"[17] and we all know that videogames make more money today than any other entertainment media. So, make game poems that undermine these expectations, from the level of gameplay mechanics to the levels of sale and distribution: if you can make your game poems free, make them free; if you can make them open source, make them open source. Play with conceptions of value, play with distribution channels, play with the marketplace.

Just remember, in all of this play and experimentation, not to lose the thread of videogames. Game poems are game poems as long as they maintain that thread, as long as they work to intervene in videogames as a medium. So appropriate recognizable elements from existing games (even if that's something as simple as a user-controlled avatar) and position your game poems next to other videogames on gaming platforms like Steam, Newgrounds, and Itch.io. Call your game poems "videogames," call them "game poems," call them "games," call them "notgames"…but find a way to keep the thread.

Figure 26: PICO-8: another example of an accessible, constrained game engine. (Images courtesy of Roman Petrov and Lexaloffle Games.)

Make Game Poems About Everything

Make game poems that are intimate and personal, about your deepest fears, struggles, hopes, and dreams; game poems about the things you love, and the things you hate.

But also: make game poems about the things you find yourself feeling indifferently towards; game poems about the most mundane, everyday things in your life.

Make game poems that explore unusual topics and complex emotions.

But also: make game poems that explore usual topics and straightforward emotions.

Make game poems about your inner life.

But also: make game poems about your outer life.

Make game poems about universal things.

But also: make game poems about specific things.

Make game poems that attempt to wake the player up, give pause, prompt reflection.

But also: make game poems that aren't afraid to put the player to sleep.

Make game poems about the power of moment, that resist the idea of a nice narrative arc.

But also: make game poems that play with the idea of narrative arc.

Make quiet game poems, and stoic game poems.

But also: make loud game poems, and outraged game poems.

Make game poems about yourself and game poems about the other.

But also: make game poems that attempt to bridge the chasm between self and other.

Make game poems rooted in the present, game poems about current events.

But also: make game poems rooted in deep history, game poems about lost events.

Make game poems about truth and game poems about myth.

But also: make game poems about the relationship between truth and myth.

Make game poems inspired by literature and art and poetry.

But also: make game poems inspired by the toilet.

Make game poems about capitalism and technology.

But also: make game poems about God and unfathomable mystery.

Make game poems about racism and sexism and colonialism.

But also: make games about the kindness of strangers.

Make game poems about our latest obsessions and fetishes.

But also: make game poems that are able to see beyond our latest obsessions and fetishes.

Make game poems about being young.
But also: make game poems about growing old.

Most of all: make game poems about what you really know, rooted in "that time of night, lying in bed, thinking what you really think."[18]

Most of all: tell the truth.

Most of all: make game poems about everything.

Embrace Mystery

The Prince of Lu said to the master carver:
"What is your secret?"
Khing replied: "I am only a workman:
I have no secret. There is only this:
When I began to think about the work you commanded
I guarded my spirit, did not expend it
On trifles, that were not to the point."[19]

Throughout this book, I have attempted to focus on the pragmatic side of poetry theory and poetry creation, but one can only carry such a perspective so far. It suits the scholar to an extent; it suits the creator less. When it comes to the day-to-day process of writing poetry or making game poems, there are some practical pointers that can be given, but there is much that is hard to write about, much that risks sounding like gibberish. I have tried to focus this chapter on the practical pointers—on what I know of the *craft* of making

game poems—but I cannot bring myself to ignore the mystical side of creation entirely, because I believe the mystical and pragmatic aspects of creation are tightly bound up together. Indeed, some piece of advice that may sound mystical or nonsensical to one reader may strike another as imminently practical. Consider this pointer from American poet Kathleen Norris:

> Once, when I was asked, "What is the main thing a poet does?" I was inspired to answer, "We wait."[20]

Here is the core of the process of writing poetry, according to Norris: waiting. Is this a mystical suggestion, or a practical pointer of the kind one might find in an Alpine hiking guide? I would suggest it is both. The connection between waiting and writing poetry may not be immediately apparent, and some may shrug off the advice, but still: one can do it.

I quote this tidbit from Norris because I find her process resonant. Or rather, I cannot seem to escape it. (The necessity of waiting, that is.) When I consider making a game poem, I am pressed by questions such as these: How do I make a game about the little moment of fleeting beauty and existential longing encountered on an empty soccer field on my last day of teaching at a countryside middle school? How do I make a game that captures something of what it feels like to walk through the Choeung Ek killing fields of Cambodia, and all the overwhelming emotions that are stirred up? How do I make a game about the inexplicable sacredness found in the mundane task of caring for the gravesite of a deceased loved one? How do I make a game that captures something of the crushing loneliness I've experienced during periods of deep depression? How do I make a game that expresses the wonder of encountering strangers in a strange land who would take me into their home and treat me like family? How do I make a game that captures a fraction of how joyful and how tired I've been every day since my first child was born?

The answer—to all of these questions—is that I don't know. One can talk about craft and technique, but there is no technique for capturing mystery in a bottle. While these are all game poems I have attempted to make, my process always begins with the same simple realization: *I don't know how to make these games.* So, what do I do? I take my advice from Norris and other poets who seem to know what they're doing. I try to stay present. I try to keep my eyes open. I try to hold onto the experiences and encounters that change me. I keep those encounters in the back of my mind, and they sit there and bump around, and I take a shower, and I work at my day job, and I play with my kids, and the days go by. I take long walks when I can. Sometimes I sit under a tree. The tree bit sounds romantic, but only if you're a great poet, and I'm not a great poet. Mostly I shower, and work at my day job, and play with my kids. And mostly stuff bumps around in the back of my mind, and nothing comes of it. But once in a while, every once in a long while, I'll be taking that shower, and something will come to me. An image, a thought, an idea for a game mechanic. And most of the time the idea's no good, and I throw it away. And sometimes the idea's good, but I don't act on it, and the idea is lost. But occasionally I grab the idea, and I think, "yes, that's it," and I sit myself down in front of my computer, and I make the game. This is my "process" of writing poetry, this is my "process" of making game poems. Trying to stay present. Trying to stay awake. Mostly waiting.

I risk this detour into mystery because it has become plain to me over the years that this is where the real work lies—at least for me. Your experience may differ, but for me it's the staying awake and waiting that's difficult. Having the patience. Holding on to those encounters. Making space in my life for silence and solitude. Not giving up on making things despite long periods of overwhelm or creative drought. Once an idea for a game comes to me, and it's the right thing, the making itself is the fun part, and relatively easy: some pixels here, a bit of code there. That's what the practice is for, why I work at this craft. So that I can be ready. When I made *Loneliness*, I had a prompt, and

I had my experience, and I walked around and mulled ideas over for two days. Then I sat down and made the core of the game in a little over two hours. When I made *The Killer*, I had been wandering around Cambodia for a month, slowly becoming overwhelmed by its history, trying to make a game out of what I was learning but getting nowhere. I had no idea how to make a game out of the intense feelings of shock and horror that were racking my body. I lay in bed every night listening to Jónsi's "Tornado" on repeat. Then one night as I was listening to that song, an image came to me: two stick figures walking, one with a gun. And that was it. Most of my game poems are made like this. In the waiting and stillness that come after some kind of experience, some kind of encounter.

The quotation at the top of this section is from a retelling of an ancient Taoist story in which a woodcarver, Khing, produces an amazing work of art (a bell stand), and everyone wonders how he did it (at first the people say it "must be the work of spirits"). Khing replies that he waited, he fasted, he guarded his spirit. Then he had what he describes as a "live encounter" with a particular tree from which the bell stand emerged. "If I had not met this particular tree there would have been no bell stand at all,"[21] he says. Waiting. Guarded spirit. Live encounter.

I have never produced a work of art that has been ascribed to spirits, but I believe in this process—or rather, I can't seem to escape it. The mystery of poetry is that it wants to be about something True. But not in a science and engineering sort of way (I happen to have an undergraduate degree in physics, strangely enough). This isn't bridge building. There can be no real case study for how to write a poem, or how to make a game poem. "Even if you try to take notes or write memoranda on why you are choosing, you can't cover even half of what you do when you make something," says poet Rachel Blau DuPlessis, "It's uncalibratable."[22] So how to proceed? Well, you can think a little bit about rhythm, about rhyme. You can watch the stream and listen to

its babble. You can think a little bit about language. You can daydream and play. You can suffer and be human. You can try to stay awake. You can open yourself to the possibility of live encounter. You can play with words or with images or with operational logics. You can doodle. You can attempt to make space in your life for silence and solitude. You can try to tell the truth.

I'm a beginner, and I would never claim that any of my game poems are more than trifling doodles. I realize that talking about grand mysteries risks making my doodling sound grandiose, but I don't personally think it's possible to attempt to make poetry without getting tangled up in these things. So, for what it's worth, that's my "process."

Make Creation a Practice

The flip side of the mystery of making is the *practice* of making. I don't believe one can predict, or control, or fully understand the mysteries associated with inspiration and creation and poetry. But I do believe one can work to make the act of creation an active practice in one's life. And I find that inspiration is much more likely to visit me when I am practicing making than when I have let that practice go dormant. What do I mean by practicing making? I mean all the things that we have talked about in this chapter: sitting down with prompts, joining game jams, imitating other game poems, etc. You don't have to wait for inspiration to strike in order to pick up a game engine, to doodle, to sketch, to practice. And as I said, inspiration loves practice. I have often found that ideas that have been bouncing around in the back of my mind for weeks or months or years are sometimes ignited by a seemingly random prompt or constraint at a seemingly random game jam that I *happen to be taking part in*. This is how *Loneliness* came to be, as well as several of my other game poems.

If you want to make game poems, my best advice to you is this: make making game poems a practice in your life. Sit down for an hour a

day, whether you feel inspired or not, pick up a little game engine, and doodle. Or take a few hours on the weekend. But be consistent. This is the same advice that has been passed around for years (probably for generations), attributed to a variety of sources, as some variation on the colorful phrase "ass in chair." Stephen King expresses the relationship between inspiration and "ass in chair" nicely:

> Your job is to make sure the muse knows where you're going to be every day from nine 'til noon or seven 'til three. If he does know, I assure you that sooner or later he'll start showing up…and making his magic.[23]

As many creators can attest, this is a real phenomenon. I've gone through many different periods of varying productivity making game poems over the last ten-plus years, and I can tell you without hesitation that my most productive periods of creation correlate strongly with "ass in chair," questions of inspiration notwithstanding.

So: make, make, make. And while you're making, remember to play. Try various styles and techniques. Experiment. Hold your art lightly. Abandon things that aren't working (or put them on hold) and push in when something clicks. It's okay to sketch, it's okay to throw things away. I've released a lot of game poems, and abandoned many, many more. Get people to play your game poems and observe their experience—but be cautious accepting feedback. The goal is not to derail or soften your creative vision (there are plenty of people who simply won't like the things you make), but rather to note the experience of those who encounter your games in case you want that experience to be different.

Give thought and time to revision. In many ways, revision is the most practical aspect of game poem creation. Unlike initial inspiration, revision is mostly contained, mostly controllable: you can make a small change and note the effect that change has.[24] Is a certain moment in your game poem having a weaker or stronger impact than you desire? Could the rhythm be altered to better reflect the theme

of the game? Would the player's agency be impacted in a positive or negative way if the controls were changed like this or like that? For the most part you can lean here on language that people have been using in poetry workshops for generations: this image feels stronger, this juxtaposition feels more evocative, this metaphor feels richer; this sequence feels less repetitive; this control scheme feels more elegant; these timings feel less manipulative; etc. Always consider any poetic interventions you are attempting to craft (as we discussed in the last few chapters) and attend to the details. As with a written poem, the details are everything to a game poem. The feel of a button press, the volume of a beep, the precise timing of a fade—these are the kinds of things I pour over for hours.

So: sit down in that chair. Make, make, make. Play, play, play. Revise, revise, revise. Tell the truth. Hold nothing back.[25] I said at the start of this chapter that my suggestions for making game poems would not necessarily be specific to game poem creation, and that has proven to be true. As with most creative endeavors, it turns out that if one wants to make game poems, the hard part isn't really perfecting craft and technique, but rather sustaining a consistent creative practice.

How to make a game poem?

1. Stay awake.
2. Make space in your life for silence and solitude.
3. Make creation a practice.

Finally:

4. Follow your own voice, forge your own path. Decide what game poems are for yourself, determine your own poetic purpose, construct your own poetics, establish your own praxis, and write your own guide for how to make a game poem.

I'm a beginner, and that's my advice. Take what's useful, leave the rest. The important thing is this: make some game poems.

CHAPTER 15

Why We Need Game Poems:
A Brief Conclusion

What are videogames? How do they operate, and how do they move us? Where does their meaning lie, and how is that meaning conveyed? Why do we make them, why do we play them, and why do we keep coming back to them?

We have had many answers to these questions offered up through the centuries. Jacques Derrida has said famously that he calls a videogame "that very thing that teaches the heart, invents the heart."[1] Mark Strand and Eavan Boland say of videogames that "the subtlety, elegance, and hunger of the human spirit is obvious everywhere [in videogames], neither constrained by nor separable [from the interactive components, bounding boxes, and digital assets] that shelter them."[2]

Videogames, says Mary Oliver, "are not [games], after all, but fires for the cold, ropes let down to the lost, something as necessary as bread in the pockets of the hungry."[3] Renowned videogame scholar Dylan Thomas says that videogames are "what [in a videogame] makes you laugh, cry, prickle, be silent, makes your toenails twinkle, makes you want to do this or that or nothing, makes you know that you are alone

in the unknown world, that your bliss and suffering is forever shared and forever all your own."[4]

I could go on. Alice Walker says that videogames are "the lifeblood of rebellion, revolution, and the raising of consciousness";[5] Rainer Maria Rilke writes that videogames are works of art that have "grown out of necessity";[6] and Nobel laureate Czesław Miłosz says that he has defined videogame creation simply as a "passionate pursuit of the real."[7] Why are we playing videogames, asks Annie Dillard, "if not in hope of beauty laid bare, life heightened and its deepest mystery probed?"[8]

But I suspect my game is up (if it was ever on to begin with): these are not quotations about videogames, but quotations about poetry. I choose to end my book with these adapted quotations because they present a kind of enigma that is entangled with my reasons for writing this book. As a game player and creator, I find these quotations resonant and evocative, but also exceedingly strange. They seem to describe a flying pig, as it were: try as I might, I can't square them with what I know about videogames. The shoe just doesn't fit.

But why not?

The answer may initially seem simple: that videogames and poetry have been on very different paths since their respective beginnings.[9] Videogames are entangled with technology and capitalism, while poetry can appear to be the opposite of these things. The two mediums have different ideas of what's real and of what's valuable, so of course quotations about poetry sound strange when applied to videogames— how could they not? "Is not the juxtaposition of poetry with video games a confusion of orders? An outrage against decorum?" asks Piotr Kubiński.[10] Certainly, there's some insight to be found if we pursue this line of inquiry, but I don't think it tells the whole story—because we can find plenty of examples of videogames and of poetry that operate outside of these historical tendencies: games like the ones we have been examining in this book, which intentionally undermine

techno-capitalist expectations, and poems that press right into those expectations.[11]

I think the more significant reason that these adapted quotations feel dissonant and strange is that we lack a depth of language and frameworks for conceiving of videogames as capable of being poetic. Partly this is because much videogame theory operates under the assumption that videogames are a subset of traditional games, which obscures their poetic potential, and partly it is because the literary lenses that have most often been used for videogames tend to focus primarily on their narrative or rhetorical potential[12] at the expense of their poetic potential. The last few years have seen a spate of fruitful scholarship around videogames, much of which operates outside of traditional dichotomies, but the question of how one might fruitfully apply a poetry lens to games has remained largely unexplored. We continue to need more points of reference for thinking about all kinds of meaning in videogames, and that is why I have written this book. But more than that, I have written this book because I believe that we need more game poems in the world—and it is easier to make something when we are able to acknowledge and talk about what we are making.

Why do we need more game poems in the world? Let me return to the quote from Derrida, above. Derrida asks the question, "what is poetry?" and answers: "I call a poem that very thing that teaches the heart, invents the heart, that which, finally, the word heart seems to mean."[13] It is a striking image. For Derrida, a poem is that which gives rise to the desire, the dream, of learning by heart. "So: your heart beats, gives the downbeat, the birth of rhythm.... [There can be] no poem that does not open itself like a wound."[14] Rhythm, ritual, incantation, truth, mystery. As I mentioned in Chapter 1, I chose lyric poetry as a lens for videogames in this book partly because the modifier of "lyric" adds a bit of grounding to the word "poetry," and avoids some of the more mystical connotations that that word carries with it. But in the

end, we cannot avoid the mysterious, mystical dimensions of poetry. Because whatever poetry is, it is more than words on a page; it is more than poetics; it is more than technique; it is more than theory; it is more than praxis. In truth, when I think about my own practice of making videogames, it is the adapted poetry quotations above that resonate with me most strongly: these are the games I want to make; these are the games I want to play. "Poems are not words, after all, but fires for the cold, ropes let down to the lost," says Mary Oliver.[15]

I would suggest that we need game poems in the world for the same reason that we need poetry in general: because we are cold, and we need videogames that are fires. We need videogames born of waiting, silence, and deep listening. We need videogames that speak the language of our contemporary lives, yet are able to hold themselves above our lives' monstrous current. We need videogames that are able to see beyond our latest obsessions and fetishes to the truths that connect us across time and space. We need videogames about God and intractable mystery. We need videogames that call out oppression and injustice in all their myriad forms. We need videogames that remind us of what it means to be human in the face of the posthuman and the inhuman. And we need videogames that remind us that we still have the capacity to love, and the capacity to forgive. In short, we need videogames that embody "the subtlety, elegance, and hunger of the human spirit," as Mark Strand and Eavan Boland write. We need videogames that, in the words of Dylan Thomas, are able to make our "toenails twinkle."

I choose to close my book with these adapted quotations because for me they represent—*in poetry*—a vision for what game poems might be. They represent a paradox, a tension, an itch that I want to scratch. They represent what I see as a hole in videogame theory and practice: a lack of language and frameworks for thinking about videogames as capable of being poetic, and a lack of practical guidance for those wishing to pursue poetic videogame creation.

Unfortunately, I don't believe it's possible to write a book on how to craft game poems that make one's "toenails twinkle" or that are "fires for the cold." I don't believe it's possible to write a book on how to make videogames the way Emily Dickinson or Czesław Miłosz write poetry. But then, I don't believe it's possible to write a book on how to craft those kinds of poems, either. What we *can* do, for videogames just as well as for poetry, is start to talk a little bit about poetics, a little bit about technique, a little bit about poetic praxis—so that little by little we build up a vocabulary, build up some frameworks that help us conceive of videogames as a medium capable of poetic expression, so that we can better appreciate the poetic videogames in front of our faces, and better attempt to make more of those games.

That is what I have endeavored to do in this book: to explore some tensions that have come out of my own creative practice and lay some little bit of groundwork for discussing and making game poems. (Following gratefully in the footsteps of a plethora of other scholars and creators.) By tackling the topic of poetic videogames in such a broad and multifaceted way, I leave myself open to charges of spreading myself too thin. But considering that so little work has been done in this particular domain, a broad and accessible approach seemed warranted. This book does not aim to be the end of a conversation, but the start of one, and my hope is that it might act as a springboard for those who care to dive deeper or to add additional perspectives on this topic.

Thanks for reading. Now go make some game poems!

APPENDIX I

Tools and Resources for Finding and Making Game Poems

Finding Game Poems

Game poems can be a little bit tricky to find. Here are some resources to help get you started on your way.

PoeticVideogames.com

https://www.poeticvideogames.com

A website that I maintain that acts as a "bucket for poetic videogames." The games collected here are not meant to form any kind of canon, but rather to serve as a springboard for exploration and discovery.

Meditations.games

https://meditations.games

"Meditations," a 2019 project envisioned by indie game creator Rami Ismail, is a collection of 365 small games, each accompanied by a short text, which were created by hundreds of different game designers as "meditations" inspired by a particular day of the year. I would call the end result a wonderfully varied collection of game poems.

Bitsy Games

https://itch.io/games/made-with-bitsy

Bitsy is a tiny, constrained game engine that lends itself naturally to the creation of small, personal games that juxtapose limited gameplay elements with snippets of text, and I would classify many of the resulting games as game poems. You can find a large collection of Bitsy games of all varieties hosted on Itch.io at the URL above.

Itch.io

https://itch.io

Itch.io is a widely used and relatively open distribution platform that hosts interactive creations of all kinds. Because it is widely used and so accessible to creators, it is a great place to search for small, unusual videogames. Searching its collection of "poem," "game poem," or "poetic videogame" yields a treasure trove of interesting artifacts to explore.

ELMCIP Knowledge Base

https://elmcip.net

The ELMCIP (Electronic Literature as a Model of Creativity and Innovation in Practice) Knowledge Base is a great place to explore artifacts that lie at the intersection of conceptions of videogames and conceptions of digital poetry. While it can be somewhat hard to uncover the more "videogamey" artifacts in its collection, searching the database for "game poem" or simply "videogame" yields many fruitful results.

ELO Directory

https://directory.eliterature.org

The ELO (Electronic Literature Organization) Directory is another good place to look for hybrid digital poetry / videogame creations.

Following Creators

Creators who make one game poem often make another. Finding and following game poem creators is thus one way to keep abreast of new work in this space. But try not to get trapped in a small pond. (I will not provide a list of creators here, since any such list, even more than a list of individual game poems, risks being far too exclusionary.)

Recommended Game Engines for Making Game Poems

I highly recommend choosing a small, constrained game engine as a starting place for making game poems, regardless of how much experience you have (or don't have) programming and making games. (See Chapter 14 for discussion of why constraints are useful to the game poem creator.) Many of the engines listed here have tutorials and documentation readily available at their home pages, but you can also search the internet for "how to make a game in X" to get started.

The engines listed here represent only a few possibilities among hundreds of options you can explore. I have focused on engines that are constrained, accessible, popular, cross-platform, free, and open source. (All of the engines on this list are both free and open source, with the exception of PICO-8.)

Bitsy

https://bitsy.org

Bitsy is a tiny, accessible game engine that runs in a web browser, which anyone can begin to use in a matter of hours. The engine is tightly constrained and naturally lends itself to juxtaposing limited gameplay elements with small snippets of text, which works great for crafting metaphors.[1] This is the engine I typically recommend as a starting place for making game poems.

(Bitsy was used to make the game poem *Seasonal Mixtape*, discussed in Chapter 4.)

PuzzleScript

https://www.puzzlescript.net

Like Bitsy, PuzzleScript is a very specialized little game engine, in this case designed to make tiny puzzle games with minimal fuss (no programming knowledge required). Can it be used to make tiny game poems as well? I'll leave that for you to decide.

Twine

https://twinery.org

Twine is an extremely accessible game-creation tool that differs from most of the engines on this list in that it is a text-based framework designed for creating interactive hypertext experiences. While it may be more readily aligned with digital poetry creation than graphical game poem creation, it can easily be used to manipulate simple graphics (or emojis) in addition to text, and has been utilized to create a wide variety of games, stories, and poems.

Scratch

https://scratch.mit.edu

Scratch is a general-purpose 2D game engine created at MIT that uses a visual "puzzle piece" scripting system and is designed to be accessible to non-programmers. (It is marketed toward children and classroom use but is a perfectly fine general-purpose engine for anyone learning to code, or anyone who prefers a visual scripting system to traditional text-based programming.) The fact that you can see changes that you make to your games in real-time while you code is one of many factors

that make Scratch a good choice for beginners who want to move beyond specialized engines like Bitsy and PuzzleScript to something more general-purpose.

(Scratch could be used to make or imitate most of the 2D game poems discussed in this book.)

PICO-8

https://www.lexaloffle.com/pico-8.php
https://www.pico-8-edu.com

PICO-8 is currently my favorite general-purpose game engine for making game poems. (I like it well enough to include it as the only non-open-source engine on this list.) It is less specialized than Bitsy, which means that it can be used to make almost any kind of game, but is still very tightly constrained compared to most popular general-purpose game engines (it refers to itself as a "virtual console" and is designed to mimic some of the constraints of early 8-bit era videogame consoles). You will need to learn to program to use this engine, but the scripting language that it utilizes (LUA) is widely considered to be accessible and beginner friendly. Though the main version of the software is paid, there is also a free, web-based, educational edition available.

(PICO-8 was used to make the game poem *Portraits of My Child*, discussed in Chapter 4.)

TIC-80

https://tic80.com

A free and open-source alternative to PICO-8, designed to mimic similar constraints (though not quite as strictly).

Phaser

https://phaser.io

Phaser is a popular and flexible general-purpose 2D game framework built on top of one of the most prevalent programming languages in the world (JavaScript). An excellent open-source option for making easily distributable 2D games of all kinds, and a good alternative to Scratch for those looking for a more traditional text-based coding system.

(Phaser could be used to make any of the 2D game poems discussed in this book.)

Godot

https://godotengine.org

Godot is a powerful general-purpose game engine commonly seen as an open-source alternative to the wildly popular but closed-source Unity engine, which can be used to create essentially any type of 2D or 3D game you can imagine. Not a good starting place for making game poems, as there are so few constraints, but a good engine for games requiring an open possibility space, or a 3D environment.

(Godot could be used to make a 3D game poem like *The Graveyard*, discussed in Chapter 3, or any of the game poems discussed in this book.)

Additional Tools and Resources for Making Game Poems

As with game engines and frameworks, when it comes to making game poems, I recommend searching out tools that are accessible and that provide interesting creative constraints, rather than simply vacillating toward whatever appears to be the most powerful tool

available for a given job. Here are a few recommendations to get you started on basic tasks like image creation and sound production. Bear in mind that game engines like Bitsy and PICO-8 come with their own development environments and provide everything you need to create a full game from scratch—making the use of additional tools entirely optional.

(Unless otherwise noted, all the recommendations on this list are once again free and open source.)

Image and Animation Tools

GrafX2

http://grafx2.chez.com

GrafX2 is a bitmap paint program that began life in 1996 on MS-DOS but has since been ported to a variety of platforms. While the interface is anything but modern and can take some getting used to (I recommend tracking down a video tutorial to get started), the program remains a very pure, constrained, and capable 256-color pixel editor.

Aseprite / LibreSprite

https://www.aseprite.org
https://libresprite.github.io

Aseprite is a popular and well-maintained pixel art and animation editor that started out as free software but has since become paid. It is a modern and full-featured pixel editor that offers a potentially happy medium between a more constrained option like GrafX2 and a general-purpose image editor like GIMP. The source code is publicly maintained but not free to license; those looking for a fully open-source alternative can investigate LibreSprite, a community-driven fork of Aseprite launched in 2016.

GIMP

https://www.gimp.org

The GNU Image Manipulation Program (GIMP) is the gold standard in general-purpose open-source bitmap image editors and offers much of the same functionality as Adobe's proprietary Photoshop. In my opinion it is not the best program for composing and animating basic pixel art, since the constraints are few and the interface can be overwhelming, but it is a powerful tool for painting or manipulating large, complex raster images.

Inkscape

https://inkscape.org

What GIMP is to raster images, Inkscape is too vector graphics: the gold standard in open-source vector graphics editors.

picoCAD

https://johanpeitz.itch.io/picocad

If you are interested in utilizing 3D models in your game poems, I highly recommend starting your 3D modeling journey with picoCAD: a wonderfully constrained little program for building and texturing 3D models that is designed to be "fun, easy, and accessible by focusing on the bare essentials."

Blender

https://www.blender.org

If your 3D graphics require more detail and nuance than picoCAD is able to provide, you can turn to Blender: by far the most popular open-source program for general-purpose 3D modeling and animation.

Audio Tools

ChipTone

https://sfbgames.itch.io/chiptone

ChipTone is a free (though not open source) browser-based tool for generating synthesized sound effects (think beeps, chirps, zaps, etc.), inspired by the popular but now somewhat defunct (because Flash-based) Bfxr.[2]

Bosca Ceoil

http://boscaceoil.net

Bosca Ceoil is an accessible and fun-to-use tool designed to let anyone create and edit simple music tracks within a matter of minutes.

MilkyTracker

https://milkytracker.org

MilkyTracker is one of the most popular open-source music trackers among chiptune composers.

Audacity

https://www.audacityteam.org

Audacity is a powerful and accessible general-purpose audio editor that can be used to easily change a sound clip's volume, remove background noise, add effects like reverberation, etc.

Searching Out Additional Tools

Itch.io

https://itch.io/tools

Of course, game development tools are not limited to image and sound editors. There are a plethora of open source (and closed-source) tools available for assisting game designers with everything from platform game level creation to the procedural generation of medieval city maps. Itch.io hosts a large number of tools of all varieties, which can be easily filtered by platform, type of tool (e.g. pixel art tools, audio tools, map editors, procedural generators), and price.

GitHub

https://github.com/ellisonleao/magictools
https://github.com/Kavex/GameDev-Resources
https://github.com/Calinou/awesome-gamedev

There are several popular lists of game development tools hosted on GitHub. I provide three popular lists here, and others are easily discoverable via search.

Finding Inspiration: Constraint Generators and Game Jams

As with any creative practice, a blank sheet of paper (or blank screen) and an infinite possibility space can sometimes be a game poem creator's worst enemy. If you are struggling to know what to make a game poem about, or how to start your approach, I suggest that you go in search of a prompt or constraint to help you on your way. You can use a handy book for this purpose, or an online "game idea generator."

I have found joining game jams (physical or virtual gatherings where participants make a videogame from scratch, often in a short time frame, often with shared constraints) to be particularly helpful for getting my creative juices flowing.

When it comes to prompts and constraints, remember to think playfully and consider unusual interpretations as you seek inspiration. (The prompt that partially spurred me to create my game poem *Loneliness* was "island.")

Constraint Generators

Game idea generators often focus on traditional modes and genres of gameplay that may not necessarily align with game poem creation. Still, I have often found it helpful, when beginning work on a game poem, to take one or two constraints from these kinds of generators and interpret them in unexpected ways in the context of a theme or idea I am wanting to explore.

BAFTA Game Idea Generator

https://ygd.bafta.org/resources/game-idea-generator

Generates: environment, goal, genre, rules, wildcard ("a random feature")

Example: "At Home" (environment) + "Rescue" (goal) + "Racing" (genre) + "One Life Only" (rules) + "Fairy Tale" (wildcard)

Let's Make a Game Idea Generator

https://letsmakeagame.net/game-idea-generator

Generates: genre, rule, setting, theme.

Example: "Real-Time Strategy" (genre) + "Safe in the Dark" (rule) + "Dystopia" (setting) + "Lost Love" (theme)

Firith Studio Game Idea Generator

https://firith.studio/game-idea-generator

Generates: genre, theme, mechanic.

Example: "Graphic Adventure" (genre) + "Alternative History" (theme) + "Dancing" (mechanic)

The Game Gal Word Generator

https://www.thegamegal.com/word-generator

Choose a common party game and a category, and this tool will generate a word or a question for you. Example: "Get to Know You" (game) + "Questions for Youngsters" (category) = "What is something that scares you?" Also available as a mobile phone app.

Reach for a Book

As mentioned in Chapter 14, one simple way to generate a prompt or constraint is to open a book and point to a word or two. Of course, you may need to repeat this exercise a few times to arrive at a resonant set of words, and some books are better suited to this exercise than others. I particularly recommend a book like the already mentioned *Book of Symbols* for this purpose,[3] where each page presents a salient archetype or image for consideration.

Game Jams

This short list includes some of the most popular and longest-running game jams, though it should be noted that game jams have exploded in popularity in recent years (both online and in-person varieties), and there are now far too many regular jams to list here. Fortunately, Itch.io hosts a comprehensive game jam calendar (see below), which is the best resource available to the would-be game jammer.

Ludum Dare

https://ldjam.com

One of the most popular and longest-running game jams, Ludum Dare is a 48-hour game-making jam and "competition" (participants vote on their favorite games) that started in 2002 and typically takes place three times a year. For each Ludum Dare, participants vote on a theme that serves as the central constraint (in addition to the tight time frame and the directive to make a complete game from scratch).

Weekly Game Jam

https://weeklygamejam.itch.io

As the name suggests, Weekly Game Jam is a popular weekly game jam that is hosted by Nekomatata games and takes place on Itch.io. A new theme is released every Friday, and participants have one week to create a game and then vote on their favorite submissions.

Global Game Jam

https://globalgamejam.org

Another game jam that is partially described by its title, Global Game Jam is a popular and well-funded (though not-for-profit) global game jam that takes place once a year, typically at the end of January. With

thousands of participants at hundreds of physical sites, GGJ calls itself "the world's largest game creation event taking place around the globe." Like Ludum Dare, it is a 48-hour, theme-driven jam, but somewhat unusually, GGJ encourages physical interaction over online-only engagement, and collaborative game development over solo creation.

Game Maker's Toolkit

https://gmtk.itch.io

Another popular yearly game jam that takes place online in June or July. Once again, there is a 48-hour time limit to make a game around a provided theme and participants vote on their favorite submissions using on a variety of metrics.

Glorious Trainwrecks

https://www.glorioustrainwrecks.com

The Glorious Trainwrecks community has been around since 2007 and has traditionally hosted game jams where anyone and everyone is encouraged to try to make some kind of game (a "glorious trainwreck") in just two hours. While the community is not as active as it once was, I have always valued their "just put it out there" ethos, and they still host occasional game jams.

Itch.io Game Jam Calendar

https://itch.io/jams
http://www.indiegamejams.com

Many game jams are hosted online at Itch.io, which consequently also hosts the most comprehensive list available of ongoing and upcoming jams. (A similar list can be found at the second URL given, indiegamejams.com.)

Notes

Introduction Why Poetry as a Lens for Videogames?

1 Jason Rohrer, *Passage*, Windows, MacOS, Linux (2007). http://hcsoftware. sourceforge.net/passage/.
2 Jason Rohrer, "What I Was Trying to Do with Passage," *SourceForge*, November 2007, http://hcsoftware.sourceforge.net/passage/statement.html.
3 Noah Wardrip-Fruin captures something of my experience when he calls *Passage* a "strange and powerful game" ("Beyond Shooting and Eating: Passage, Dys4ia, and the Meanings of Collision," *Critical Inquiry* 45, no. 1 (2018): 139).
4 Not a long time—though, in terms of videogame chronology, that takes us a quarter of the way back to *Pong*!
5 A longstanding dichotomy within videogame studies, theoretically separating those who would emphasize the "ludo" (i.e., interactive gameplay) dimension of videogames from those more interested in games' narrative dimension. Note that this dichotomy has largely been broken down within game studies (something I will get to in a moment), though the lenses of "gameplay" and "narrative" continue to be of significant interest to game designers and game players. See Gonzalo Frasca, "Ludology Meets Narratology: Similitude and Differences Between (Video) Games and Narrative," *The Video Game Theory Reader*, edited by Mark J. P. Wolf and Bernard Perron, 1st ed., 221–35 (New York: Routledge, 2003); Markku Eskelinen, "The Gaming Situation," *Game Studies* 1, no. 1 (2001): 68; Michalis Kokonis, "Intermediality Between Games and Fiction: The 'Ludology vs. Narratology' Debate in Computer Game Studies: A Response to Gonzalo Frasca," *Acta Universitatis Sapientiae, Film and Media Studies* 9, no. 1 (January 1, 2014), https://doi.org/10.1515/ausfm-2015-0009; Noah Wardrip-Fruin and Pat Harrigan, eds, *First Person: New Media as Story*

(MIT Press, 2004), chaps. 1–2; Janet H. Murray, "The Last Word on Ludology v Narratology in Game Studies," in *Proceedings of the 2005 Digra International Conference: Changing Views: Worlds in Play* (DiGRA, 2005), https://www. researchgate.net/publication/251172237_The_Last_Word_on_Ludology_v_ Narratology_in_Game_Studies.

6 Videogame design as a discipline has likewise been framed almost exclusively as a new form of *game* design (see popular textbooks such as: Katie Salen and Eric Zimmerman, *Rules of Play: Game Design Fundamentals* (MIT Press, 2004); Chris Mark Bateman and Richard Boon, *21st Century Game Design* (Charles River Media, 2006); Tracy Fullerton, *Game Design Workshop: A Playcentric Approach to Creating Innovative Games* (2nd edition; Amsterdam: Morgan Kaufmann, 2008); Jesse Schell, *The Art of Game Design: A Book of Lenses* (CRC Press, 2008); Simon Egenfeldt-Nielsen, Jonas Heide Smith, and Susana Pajares Tosca, *Understanding Video Games: The Essential Introduction* (Routledge, 2015)).

7 Jordan Magnuson, *Loneliness*, browser, NecessaryGames.com, 2010. https:// www.necessarygames.com/my-games/loneliness.

8 See Fullerton, *Game Design Workshop*, chap. 2, for one such list. Other textbooks feature similar lists.

9 "Mechanics as Metaphor—I: How Gameplay Itself Tells a Story," *YouTube*, November 2, 2003, https://www.youtube.com/watch?v=4QwcI4iQt2Y. For additional examples of this kind of narratological reading of *Loneliness*, see Rachel Elizabeth Meyers, "In Search of an Author: From Participatory Culture to Participatory Authorship," master's thesis (Brigham Young University, 2014), 17; "Literary Analysis: Art Games," *YouTube*, December 15, 2014, https://www.youtube.com/watch?v=l0OQQtIeEKI&list=PLgd64Tsovv 9l15p9klJCOqSz3BsxBhFQH&index=9&t=7s.

10 A kind of "folk wisdom" test in the vein of Janet Murray's "did it make you cry?" (See Murray, "Did It Make You Cry? Creating Dramatic Agency in Immersive Environments," in *International Conference on Virtual Storytelling*, 83–94 (Springer, 2005).))

11 I resonate with Antonio César Moreno Cantano's description of my games as "brief, direct, with few narratives" ("Soledad y memoria en la obra de Jordan Magnuson," in *La vida en juego: la realidad a través de lo lúdico*, edited by Alberto Venegas and Antonio César Moreno Cantano (AnaitGames, 2021), 83).

12 In bringing up old perspectives like ludology/narratology, it is not my intention to dwell on old debates and frameworks, but rather to convey something of my experience as a game creator "out in the world" and the lenses that I most often see applied to my own games. For practitioners such as myself, perspectives on videogames stemming from longstanding debates can still sometimes seem omnipresent—as when critics continue to suggest that it is the narrative potential of my games that makes them resonant, or when major publications continue to publish articles on these topics (however intentionally provocative; see for example Ian Bogost, "Video Games Are Better Without Stories," *The Atlantic* 25 (2017)). In my experience, these kinds of debates are often considered "dead" in academia long before they lose their influence in the broader ecosphere.

13 Ian Bogost, *Persuasive Games: The Expressive Power of Videogames* (MIT Press, 2007); Noah Wardrip-Fruin, *Expressive Processing: Digital Fictions, Computer Games, and Software Studies* (MIT Press, 2009); D. Fox Harrell, *Phantasmal Media: An Approach to Imagination, Computation, and Expression* (MIT Press, 2013).

14 Murray, *On Video Games.*

15 Gonzalo Frasca, "Simulation versus Narrative: Introduction to Ludology," in *The Video Game Theory Reader,* edited by Mark J. P. Wolf and Bernard Perron, 1st ed., 221–35 (New York: Routledge, 2003); Matthew Wilhelm Kapell and Andrew B. R. Elliott, *Playing with the Past: Digital Games and the Simulation of History* (Bloomsbury Publishing USA, 2013).

16 P. David Marshall, "Technophobia: Video Games, Computer Hacks and Cybernetics." *Media International Australia* 85, no. 1 (November 1997): 70–78, https://doi.org/10.1177/1329878X9708500111; Bill Nichols, "The Work of Culture in the Age of Cybernetic Systems," *Screen* 29, no. 1 (Winter 1988): 22–47. https://doi.org/10.1093/screen/29.1.22.

17 Bogost, *Persuasive Games*; Steve Holmes, *The Rhetoric of Videogames as Embodied Practice: Procedural Habits* (Routledge, 2017); Jason Hawreliak, *Multimodal Semiotics and Rhetoric in Videogames* (Routledge, 2018).

18 Grant Tavinor, *The Art of Videogames* (John Wiley & Sons, 2009); Andy Clarke and Grethe Mitchell, *Videogames and Art* (Intellect Books, 2007); Chris Bateman, *Imaginary Games* (Zero Books, 2011).

19 Pat Harrigan and Noah Wardrip-Fruin, *Second Person: Role-Playing and Story in Games and Playable Media* (MIT Press, 2010); Daniel Homan and Sidney Homan, "The Interactive Theater of Video Games: The Gamer as Playwright, Director, and Actor," *Comparative Drama* 48, no. 1–2 (2014): 169–86, https://doi.org/10.1353/cdr.2014.0000; Shyba, "The Spontaneous Playfulness of Creativity: Lessons From Interactive Theatre for Digital Games," in *Situated Play: Proceedings of the 2007 DiGRA International Conference* (University of Tokyo: Authors & Digital Games Research Association (DiGRA), 2007).

20 Susana Ruiz, Benjamin Stokes, and Jeff Watson, "Mobile and Locative Games in the 'Civic Tripod': Activism, Art and Learning," *International Journal of Learning and Media* 3, no. 3 (July 2011), https://doi.org/10.1162/ijlm_a_00078; Aaron Oldenburg, "Abstracting Evidence: Documentary Process in the Service of Fictional Gameworlds," *Game Studies* 17, no. 1 (July 2017): 18; Cynthia Katherine Poremba, "Real|Unreal: Crafting Actuality in the Documentary Videogame," PhD thesis (Concordia University, 2011).

21 Nick Montfort, *Twisty Little Passages: An Approach to Interactive Fiction* (MIT Press, 2005).

22 A. Gazzard and A. Peacock, "Repetition and Ritual Logic in Video Games," *Games and Culture* 6, no. 6 (November 1, 2011): 499–512, https://doi.org/10.1177/1555412011431359; Rachel Wagner, *Godwired: Religion, Ritual and Virtual Reality* (Routledge, 2012); Sun-ha Hong, "When Life Mattered: The Politics of the Real in Video Games' Reappropriation of History, Myth, and Ritual," *Games and Culture* 10, no. 1 (January 2015): 35–56. https://doi.org/10.1177/1555412014557542.

23 Raph Koster, *Theory of Fun for Game Design* (O'Reilly Media, 2013); Marc Prensky, "Fun, Play and Games: What Makes Games Engaging," *Digital Game-Based Learning* 5, no. 1 (2001): 5–31.

24 Brendan Keogh, *A Play of Bodies: How We Perceive Videogames* (MIT Press, 2018).

25 Katherine Isbister, *How Games Move Us: Emotion by Design* (MIT Press, 2017); Aubrey Anable, *Playing with Feelings: Video Games and Affect* (University of Minnesota Press, 2018).

26 Ian Bogost, "Videogames Are a Mess," keynote address presented at the Digital Games Research Association (DiGRA) conference (Uxbridge, UK, September 2009), http://bogost.com/writing/videogames_are_a_mess; José P. Zagal et al., "Towards an Ontological Language for Game Analysis," in *Proceedings of DiGRA 2005 Conference: Changing Views – Worlds in Play* (Authors & Digital Games Research Association (DiGRA), 2005).

27 Ian Bogost, *How to Do Things with Videogames* (University of Minnesota Press, 2011); Diana Gagnon, "Videogames and Spatial Skills: An Exploratory Study," *Educational Technology Research and Development* 33, no. 4 (December 1985): 263–75.

28 Harry J. Brown, *Videogames and Education* (Routledge, 2014); James Paul Gee, *What Video Games Have to Teach Us About Learning and Literacy* (Palgrave Macmillan, 2004); Kurt Squire, "From Content to Context: Videogames as Designed Experience." *Educational Researcher* 35, no. 8 (2006): 19–29; Scott A. Gibson Dodd, "Not-Games in Secondary English Language Arts," master's thesis (University of Alberta, 2014).

29 Jane McGonigal, *Reality Is Broken: Why Games Make Us Better and How They Can Change the World* (Penguin, 2011); Mark D. Griffiths, "The Educational Benefits of Videogames," *Education and Health* 20, no. 3 (2002): 47–51.

30 Braxton Soderman, "Intrinsic Motivation: FlOw, Video Games, and Participatory Culture," edited by Rebecca Carlson, *Transformative Works and Cultures* 2 (March 15, 2009), https://doi.org/10.3983/twc.2009.097; Jesper Juul, "Fear of Failing? The Many Meanings of Difficulty in Video Games," in *The Video Game Theory Reader 2*, edited by Mark J. P. Wolf and Bernard Perron, 237–52 (Routledge, 2009), https://www.jesperjuul.net/text/fearof failing/.

31 Derek Burrill, "Queer Theory, the Body, and Video Games," in *Queer Game Studies*, 25–34, (University of Minnesota Press, 2017), http://www.jstor.org/stable/10.5749/j.ctt1mtz7kr.6; Naomi Clark, "What Is Queerness in Games, Anyway?," in *Queer Game Studies*, 3–14 (University of Minnesota Press, 2017), http://www.jstor.org/stable/10.5749/j.ctt1mtz7kr.4; Bonnie Ruberg and Adrienne Shaw, *Queer Game Studies* (University of Minnesota Press, 2017); Bonnie Ruberg, *Video Games Have Always Been Queer* (New York University Press, 2019).

32 See for example N. Katherine Hayles, *Electronic Literature: New Horizons for the Literary* (University of Notre Dame, 2008); C. T. Funkhouser, *Prehistoric Digital Poetry: An Archaeology of Forms, 1959–1995* (University of Alabama Press, 2007); *New Directions in Digital Poetry* (A&C Black, 2012); Paola Trimarco, *Digital Textuality* (Macmillan International Higher Education, 2014); Scott Rettberg, *Electronic Literature* (John Wiley & Sons, 2018).

33 Mariam Asad, "Making It Difficult: Modernist Poetry as Applied to Game Design Analysis," master's thesis (Georgia Institute of Technology, 2011), 4. See also Diğdem Sezen, "Narrative Explorations in Videogame Poetry," in *Interactive Digital Narrative: History, Theory and Practice*, edited by Hartmut Koenitz et al., 227–40 (Routledge, 2015), 230–31.

34 An extensive examination of the boundaries and overlap between "what we talk about when we talk about *digital poetry*" vs. "what we talk about when we talk about *videogames*" could yield much fruit—and has been touched on

by scholars like Funkhouser and Sezen (see Funkhouser, *New Directions in Digital Poetry*; Sezen, "Narrative Explorations in Videogame Poetry"), but lies beyond the scope of this book. Here my focus will be squarely on "what we talk about when we talk about *videogames*." (Though I will touch on the interplay between game poems and digital poetry in Chapter 9.)

35 Film's historic relationship to poetry is another topic which lies outside the scope of this book, but suffice it to say that there have been a variety of perspectives on the subject, many of which eschew the notion that film poems must rely on verbal language as their means of being poetic. See Dziga Vertov, *Kino-Eye: The Writings of Dziga Vertov* (University of California Press, 1984); Redell Olsen, *Film Poems* (Les Figues Press, 2014); William C. Wees, "Poetry-Films and Film Poems," *Film Poems' Programme Notes* (1999); Susan McCabe, *Cinematic Modernism: Modernist Poetry and Film* (Cambridge University Press, 2005); Robert Scott Speranza, "Verses in the Celluloid: Poetry in Film from 1910-2002, with Special Attention to the Development of the Film-Poem" PhD thesis (University of Sheffield, 2002); see also Muriel Rukeyser's discussion of film in *The Life of Poetry* (Paris Press, 1996).

36 Funkhouser, *Prehistoric Digital Poetry*, 251. It should be noted that Funkhouser later softened his position when considering games like Jim Andrews's *Arteroids*—though *Arteroids* is a prime example of a game that positions itself strongly in relation to digital poetry traditions through its use of linguistic signs and symbols. See Funkhouser, *New Directions in Digital Poetry*; Jim Andrews, *Arteroids: The Poetry Sploder* (Vispo.com, 2017).

37 Johan Huizinga, *Homo Ludens* (Routledge, 1949), 132.

38 See Jordan Magnuson, "[AGBIC] Walk or Die (Open Source) [FINISHED]," TIGForums, July 26, 2010, https://forums.tigsource.com/index.php?topic=14085.

39 Sarah Larson, "Jason Rohrer and the Art of the Video Game," *The New Yorker*, June 23, 2016, https://www.newyorker.com/culture/culture-desk/jason-rohrer-and-the-art-of-the-video-game.

40 Auriea Harvey and Michaël Samyn, *The Graveyard*, Windows, MacOS (Tale of Tales, 2009).

41 Tale of Tales, "The Graveyard" (accessed December 13, 2017), http://tale-of-tales.com/TheGraveyard.

42 Nina Freeman, interview by Asher Penn. *Sex Magazine*, Summer 2014, http://sexmagazine.us/articles/nina-freeman.

43 Daniel Benmergui, Road to the IGF: Daniel Benmergui's Today I Die, interview by Kris Graft, Gamasutra, February 2, 2010, http://www.gamasutra.com/view/news/117979/Road_To_The_IGF_Daniel_Benmerguis_Today_I_Die.php; Ian Bogost, *A Slow Year: Game Poems* (Open Texture, 2010); Nathan Altice, "Diving Bell by Nathan Altice," browser, HTML5 (2021), https://ex-writer.itch.io/diving-bell.

44 Ian Bogost offers what might be the most substantial of these creator reflections in his printed companion to *A Slow Year*, but follows Huizinga's basic approach of comparing the two forms on the idea that traditional poetry feels "very gamelike" (Bogost, *A Slow Year*, 142).

45 See for example Jason Fagone, "The Video-Game Programmer Saving Our 21st-Century Souls," *Esquire*, November 20, 2008, https://www.esquire.com/features/best-and-brightest-2008/future-of-video-game-design-1208; Edward Champion, "The Video Game as Art," *Reluctant Habits* (blog), January 21, 2008, http://www.edrants.com/the-video-game-as-art; Nate

Trans, "Video Game Poetry," Video Game Expressionism, January 25, 2011, http://mr-wonderful.blogspot.com/2011/01/video-game-poetry.html? q=video+game+poetry; Clive Thompson, "Poetic Passage Provokes Heavy Thoughts on Life, Death," *Wired*, April 21, 2008, https://www.wired. com/2008/04/gamesfrontiers-421/.

46 Fagone, "The Video-Game Programmer Saving Our 21st-Century Souls."

47 Raph Koster, "The Gametrekking Omnibus," Raph's Website, September 25, 2012, https://www.raphkoster.com/2012/09/25/the-gametrekking-omnibus/.

48 See for example: Michael Mateas, "A Preliminary Poetics for Interactive Drama and Games," *Digital Creativity* 12, no. 3 (September 1, 2001): 140–52, https://doi.org/10.1076/digc.12.3.140.3224; Peter Mawhorter et al., "Towards a Theory of Choice Poetics," in *Proceedings of the 9th International Conference on the Foundations of Digital Games* (Ft. Lauderdale, FL, 2014), http://www. fdg2014.org/papers/fdg2014_paper_19.pdf; Georg Lauteren, "The Pleasure of the Playable Text: Towards an Aesthetic Theory of Computer Games," in *Computer Games and Digital Cultures Conference Proceedings* (Tampere University Press, 2002); Sonny Sidhu, "Poetics of the Videogame Setpiece," master's thesis (MIT, 2013); Soraya Murray, *On Video Games: The Visual Politics of Race, Gender and Space* (I.B. Tauris, 2017), chap. 1.

49 Harrell, *Phantasmal Media*, chap. 4.

50 Piotr Kubiński, "Micropoetics and Video Games, or a Minimalistic Encomium to Short-Sightedness," Forum Poetyki (Forum of Poetics), 2017, http://fp.amu.edu.pl/micropoetics-and-video-games-or-a-minimalistic-encomium-to-short-sightedness/, 65.

51 Kubiński, "Micropoetics and Video Games, or a Minimalistic Encomium to Short-Sightedness," 69.

52 Sezen, "Narrative Explorations in Videogame Poetry," 237.

53 See Eva Müller-Zettelmann and Margarete Rubik, *Theory into Poetry: New Approaches to the Lyric* (Rodopi, 2005), 99; Virginia Jackson and Yopie Prins, eds., *The Lyric Theory Reader: A Critical Anthology* (JHU Press, 2014); Jonathan Culler, *Theory of the Lyric* (Harvard University Press, 2015); Eva Müller-Zettelmann, *Lyrik Und Metalyrik* (Winter, 2000).

54 Montfort, *Twisty Little Passages*.

55 Asad, "Making It Difficult."

56 Thomas J. Papa, *Poetic Videogames: A Haiku Perspective* (Mimicry Games, 2014).

57 Lindsay D. Grace, "The Poetics of Game Design, Rhetoric and the Independent Game," in *Proceedings of DiGRA 2011 Conference: Think Design Play*, 2011, https://www.researchgate.net/publication/262250050_The_Poetics_of_ Game_Design_Rhetoric_and_the_Independent_Game.

58 Alex Mitchell, "Making the Familiar Unfamiliar: Techniques for Creating Poetic Gameplay" (2016); Alex Mitchell, Yuin Theng Sim, and Liting Kway, "Making It Unfamiliar in the 'Right' Way" (2017); Alex Mitchell, "Antimimetic Rereading and Defamiliarization in Save the Date" (2018).

59 Astrid Ensslin, *Literary Gaming*, illustrated edition (The MIT Press, 2014).

Chapter 1 Thinking in Terms of Lyric Poetry

1 See among others Gérard Genette, *The Architext: An Introduction* (Quantum Books, University of California Press, 1992); W. R. Johnson, "On the Absence

of Ancient Lyric Theory," in *The Lyric Theory Reader: A Critical Anthology*, edited by Virginia Jackson and Yopie Prins, 91–103 (JHU Press, 2014); Seth Lerer, "The Genre of the Grave and the Origins of the Middle English Lyrics," *Modern Language Quarterly* 58, no. 2 (June 1, 1997): 127–61, https://doi.org/10.1215/00267929-58-2-127; Heather Dubrow, "Lyric Forms," in *The Cambridge Companion to English Literature, 1500–1600*, edited by Arthur F. Kinney, 178–99 (Cambridge Companions to Literature; Cambridge University Press, 1999), https://doi.org/10.1017/CCOL0521582946.009; Virginia Jackson and Yopie Prins, eds, *The Lyric Theory Reader: A Critical Anthology* (JHU Press, 2014); Virginia Walker Jackson, *Dickinson's Misery: A Theory of Lyric Reading* (Princeton University Press, 2005); Gillian White, *Lyric Shame: The "Lyric" Subject of Contemporary American Poetry* (Harvard University Press, 2014).

2 Aristotle does not actually give much attention to lyric poetry in the *Poetics* and conceives of the distinction between lyric, epic, and drama as one based primarily on *mode of address* rather than questions of *genre* as currently conceived: drama is acted out, epic poetry is spoken, and lyric poetry is sung, accompanied by a lyre (which is where we get the term *lyric*, and also why we refer to the words of songs as "lyrics"). See Johnson, "On the Absence of Ancient Lyric Theory."

3 William Wordsworth and Samuel Taylor Coleridge, *Lyrical Ballads: 1798 and 1802* (Oxford University Press, 2013).

4 Julia Ward Howe, *Words for the Hour* (Ticknor and Fields, 1857).

5 John Stuart Mill, "Thoughts on Poetry and Its Varieties," *The Crayon* 7, no. 5 (1860): 123–28, https://doi.org/10.2307/25528049.

6 This short paragraph is necessarily a drastic oversimplification of the history of lyric and of lyricization. For a thorough investigation of these topics see Jackson, *Dickinson's Misery*; Jackson and Prins, *Lyric Theory Reader*; White, *Lyric Shame*.

7 Alex Preminger, Frank J. Warnke, and O. B. Hardison, Jr., *Princeton Encyclopedia of Poetry and Poetics* (Princeton University Press, 2015), 826. Emphasis added.

8 While the most radical forms of contemporary experimental poetry—sound poetry and concrete poetry, for example—are generally excluded from lyric poetry as a category, some poets, like Muriel Rukeyser, actually claim that these forms are experimental in the tradition of "pure poetry," which is "The Lyric" (*The Life of Poetry* (Paris Press, 1996), 115). In any case, much poetry that was once considered "experimental" (or not poetry at all) is now considered lyric, including such prominent examples as the poems of Emily Dickinson (see Jackson, *Dickinson's Misery*).

9 "XVIII," in William Shakespeare, *Shakespeare's Sonnets* (American Book Company, 1905), 59, ll. 1–4.

10 Amy Lowell, "Circumstance," quoted in Mary E. Galvin, *Queer Poetics: Five Modernist Women Writers* (Praeger, 1999), 29.

11 *Google Female Rapper—Kellee Maize* (2012), https://www.youtube.com/watch?v=VhhdXG5UM2o. For additional discussion of rap as poetry see Alexs Pate, *In the Heart of the Beat: The Poetry of Rap* (Scarecrow Press, 2009);

Adam Bradley, *Book of Rhymes: The Poetics of Hip Hop* (Basic Books, 2009); Jonathan Culler, *Theory of the Lyric* (Harvard University Press, 2015), 172.

12 What Jackson and Prins call "the normative model of the modern lyric that twentieth-century literary criticism has bequeathed to us" (*Lyric Theory Reader*, 575).

13 Jackson and Prins, *Lyric Theory Reader*, Introduction.

14 One need only compare two popular anthologies of poetry theory to notice what a difference the "lyric" label can make. While Jon Cook's *Poetry in Theory* (Blackwell, 2004) and Jackson and Prins' *Lyric Theory Reader* are similar in size and cover roughly the same period of history (mostly twentieth-century theory), the essays in Cook's anthology tend to be highly mystical in their conceptions of poetry (poetry as True Art), while those in Jackson and Prins' collection are much more concerned with discussing the kinds of forms, structures, devices, and inclinations that may or may not define lyric poetry as a category (even if mystical questions about the nature of True Art are still present in the background).

15 Eva Müller-Zettelmann and Margarete Rubik, *Theory Into Poetry: New Approaches to the Lyric* (Rodopi, 2005), 21.

16 See Werner Wolf, "The Lyric: Problems of Definition and a Proposal for Reconceptualisation," in *Theory Into Poetry: New Approaches to the Lyric*, edited by Eva Müller-Zettelmann and Margarete Rubik, 21–56 (Rodopi, 2005). As a reminder, the basic notion of "family resemblance," as popularized by Ludwig Wittgenstein, is predicated on the idea that it can often be more fruitful to consider categories as nebulous groupings defined by multiple overlapping similarities between artifacts, rather than as hard bounded sets defined by some single defining feature. See Ludwig Wittgenstein, *Philosophical Investigations* (John Wiley & Sons, 2010).

17 When it comes to poetry scholarship, I will be drawing on the work of Virginia Jackson, Yopie Prins, Jonathan Culler, Eva Müller-Zettelmann, Margarete Rubik, Jeanne Heuving, Tyrone Williams, and Werner Wolf, among others. I will be relying particularly heavily on Jackson and Prins' *Lyric Theory Reader*, which provides detailed insight into historical conceptions of the lyric and the development of "the normative model of the modern lyric that the twentieth century has bequeathed to us" (575). I will also draw heavily on Culler's *Theory of the Lyric*, which, besides being an authoritative text, is at once impressive in scope and refreshingly pragmatic in approach. Culler has developed a strong theory of lyric poetry as a history-spanning genre (even if grounded in post-Enlightenment norms) and presents many examples of lyric characteristics that can be convincingly traced from ancient times through the present day.

18 Relevant citations supporting each of these points will be provided in the following chapters. Note that this is not meant as a comprehensive list of all possible lyric characteristics (Müller-Zettelmann and Rubik present essays noting additional characteristics and tendencies, for instance, in their *Theory Into Poetry*), but it is a list that I have found to be fruitful. My project here is neither to develop a new theory of the lyric nor to systematically aggregate and transcribe existing lyric theory to videogames, but rather to consider how some aspects of existing lyric theory might be useful when approaching videogames.

19 "U B U W E B:: Anthology of Conceptual Writing" (accessed March 9, 2022), https://www.ubu.com/concept/.

20 Anthony Reed, "The Erotics of Mourning in Recent Experimental Black Poetry," *The Black Scholar* 47, no. 1 (January 2, 2017): 23–37, https://doi.org/10.1080/00064246.2017.1264851. See also Sarah Dowling, "Ethos and Graphos," in *Inciting Poetics: Thinking and Writing Poetry*, edited by Jeanne

Heuving and Tyrone Williams, 121–36 (University of New Mexico Press, 2019); Aldon Nielsen, "White Mischief," in *Inciting Poetics: Thinking and Writing Poetry*, edited by Jeanne Heuving and Tyrone Williams, 137–54 (University of New Mexico Press, 2019); White, *Lyric Shame.*

21 See Jeanne Heuving and Tyrone Williams, eds, *Inciting Poetics* (University of New Mexico Press, 2019), for a good overview of recent topics in contemporary poetics.

22 Culler, *Theory of the Lyric*, 32, 76.

23 See "Rhetorical Criticism: Theory of Genres" in Northrop Frye, *Anatomy of Criticism: Four Essays* (Princeton University Press, 2020).

24 Rukeyser, *The Life of Poetry*, 115.

25 Computational poetry is poetry that makes use of computation in some way, often (in the case of "generative" computational poetry) by being generated by a computer based on programming instructions written by a human being—or another program.

26 Consider that even as Anthony Reed proposes a "post-lyric" form of poetry in "The Erotics of Mourning," he admits that the lyric is not avoidable as a point of reference, and even that post-lyric poetry will ultimately end up "belonging" to lyric poetry: "even if one is, as one must be, unfaithful to this genre [lyric] it's not avoidable as a point of reference, even if it just signifies a rejected gatekeeping mechanism of literary culture. The 'post-lyric' names one heterodox way of belonging to that misnamed genre, 'the' lyric. It is a critical intervention into the broader processes of lyricization" (27).

27 There is no five-minute game that I know of that has been more widely played and studied than *Passage*. See D. Fox Harrell, *Phantasmal Media: An Approach to Imagination, Computation, and Expression* (MIT Press, 2013), 165: "Passage is a critically acclaimed game"; Diğdem Sezen, "Narrative Explorations in Videogame Poetry," in *Interactive Digital Narrative: History, Theory and Practice*, edited by Hartmut Koenitz et al., 227–40 (Routledge, 2015), 231: "Since its release in 2007, Jason Rohrer's Passage has garnered special attention, both from the critics and the public." One need only search the game studies literature to easily confirm these kinds of claims. *Passage* is also one of only a handful of videogames to have been inducted into the Museum of Modern Art's permanent collection ("Jason Rohrer. Passage. 2007 | MoMA" (accessed September 24, 2022), https://www.moma.org/collection/works/145533).

Chapter 2 Game Poems are Short

1 Werner Wolf, "The Lyric: Problems of Definition and a Proposal for Reconceptualisation," in *Theory Into Poetry: New Approaches to the Lyric*, edited by Eva Müller-Zettelmann and Margarete Rubik, 21–56 (Rodopi, 2005), 38.

2 Northrup Frye, "Theory of Genres," in *The Lyric Theory Reader: A Critical Anthology*, edited by Virginia Jackson and Yopie Prins, 30–39 (JHU Press, 2014), 26.

3 Mary Oliver, *A Poetry Handbook* (Houghton Mifflin Harcourt, 1994), 84.

4 Ezra Pound, "In a Station of the Metro," *Poetry* 2, no. 1 (1913): 12.

5 Earl Miner, "Why Lyric?," in *The Lyric Theory Reader: A Critical Anthology*, edited by Virginia Jackson and Yopie Prins, 577–89 (JHU Press, 2014), 585. Emphasis added.

6 See Doris C. Rusch's comments about player complaints when playing *Passage* in *Making Deep Games: Designing Games with Meaning and Purpose* (CRC Press, 2017), 39; Marcus Richert, *Passage in 10 Seconds*, browser, Kongregate. com, 2010, https://www.kongregate.com/games/raitendo/passage-in-10-seconds; Mihaly Csikszentmihalyi's prerequisites for flow in "Toward a Psychology of Optimal Experience," in *Flow and the Foundations of Positive Psychology*, 209–26 (Springer, 2014).

7 Richert, *Passage in 10 Seconds*.

8 *Passage* is so short when compared to most narrative videogames that it strongly recalls, from a literary perspective, the striking difference in length between lyric poems and most works of narrative fiction (something to be experienced in *minutes* rather than *hours*). Again, this is an order of magnitude beyond the difference in length between say, a novel and a novella (or a "long videogame" and a "medium length videogame"). It is hardly surprising, then, that those narrative scholars who point out the significance of *Passage's* short length are often the ones most interested in situating the game in relation to poetry. See Diğdem Sezen, "Narrative Explorations in Videogame Poetry," in *Interactive Digital Narrative: History, Theory and Practice*, edited by Hartmut Koenitz et al., 227–40 (Routledge, 2015).

9 See for example Ian Bogost, *Persuasive Games: The Expressive Power of Videogames* (MIT Press, 2007). While Bogost examines many short games for their rhetorical emphasis, the brevity of such games is rarely brought up as a central concern.

10 Lindsay D. Grace, "The Poetics of Game Design, Rhetoric and the Independent Game," in *Proceedings of DiGRA 2011 Conference: Think Design Play* (2011), https://www.researchgate.net/publication/262250050_The_Poetics_of_ Game_Design_Rhetoric_and_the_Independent_Game, 2.

11 In this approach we will be following in the footsteps of lyric poetry scholars like Culler, who emphasize *appreciating* lyric poems for the effects that are at play over attempts to grasp a poem's "true meaning." Culler contends that this difference in emphasis is the basic distinction between poetics and hermeneutics, but admits that the two pursuits will always be intertwined. See Jonathan Culler, *Theory of the Lyric* (Harvard University Press, 2015), 5–6.

Chapter 3 Game Poems are Subjective

1 Werner Wolf, "The Lyric: Problems of Definition and a Proposal for Reconceptualisation," in *Theory Into Poetry: New Approaches to the Lyric*, edited by Eva Müller-Zettelmann and Margarete Rubik, 21–56 (Rodopi, 2005), 39.

2 Robert Burns, *Reliques of Robert Burns: Consisting Chiefly of Original Letters, Poems, and Critical Observations on Scottish Songs* (Bradford and Inskeep, 1809), 200.

3 Georg Wilhelm Friedrich Hegel, *Aesthetics: Lectures on Fine Art* (Clarendon Press, 1998), part 3, section 3, chapter 3.

4 A long-discussed distinction within poetry theory. See Virginia Jackson and Yopie Prins, eds, *The Lyric Theory Reader: A Critical Anthology* (JHU Press,

2014), for detailed exploration of this topic. Also Eva Müller-Zettelmann's discussion of subjectivity as a distinguishing tendency of the lyric in *Lyrik Und Metalyrik* (Winter, 2000); Jonathan Culler, *Theory of the Lyric* (Harvard University Press, 2015), 2; Wolf, "The Lyric," 39.

5 William Stafford, excerpt from "Ask Me" from Stafford, *Ask Me: 100 Essential Poems of William Stafford.* Copyright © 1977, 2014 by William Stafford and the Estate of William Stafford. Reprinted with the permission of The Permissions Company, LLC on behalf of Graywolf Press, Minneapolis, Minnesota, www. graywolfpress.org.

6 Käte Hamburger, *The Logic of Literature* (Indiana University Press, 1993), 276–77, 285.

7 See again Chapter 1; Jackson and Prins, *The Lyric Theory Reader*; Jeanne Heuving and Tyrone Williams, *Inciting Poetics* (University of New Mexico Press, 2019).

8 There is an interesting way in which this focus on objective reality mirrors our historical literary interests as well. As scholars like Gérard Genette have shown, our current fascination with lyric poetry and inner reality is a relatively recent phenomenon compared to our longstanding fascination with objective forms like epic and drama, and the "centuries-old exclusion applied to everything that is not 'an imitation of men in action.'" (W. R. Johnson, "On the Absence of Ancient Lyric Theory," in *The Lyric Theory Reader: A Critical Anthology*, edited by Virginia Jackson and Yopie Prins, 91–103 (JHU Press, 2014), 22).

9 See Nick Montfort, "PvP: Portal versus Passage," *Grand Text Auto* (blog), February 24, 2008, https://grandtextauto.soe.ucsc.edu/2008/02/24/pvp-portal-versus-passage; Michael Mateas and Noah Wardrip-Fruin, "Defining Operational Logics," in *Breaking New Ground: Innovation in Games, Play, Practice, and Theory; Proceedings of DiGRA 2009* (DiGRA, 2009); D. Fox Harrell, *Phantasmal Media: An Approach to Imagination, Computation, and Expression* (MIT Press, 2013), chap. 4; Noah Wardrip-Fruin, "Beyond Shooting and Eating: Passage, Dys4ia, and the Meanings of Collision," *Critical Inquiry* 45, no. 1 (2018): 139; Doris C. Rusch, *Making Deep Games: Designing Games with Meaning and Purpose* (CRC Press, 2017), 38–39.

10 While *Passage* is in many ways an ambiguous game, it should be noted that it is also biographically grounded and can be seen to align itself with certain notions of social and chrono-normativity when it comes to questions of domestic partnership, adulthood, and gender and race expectations. The degree to which the game expresses these things per se when read apart from Rohrer's biographical creator's statement is a complex question, but of course the creator's statement is itself an important part of the game's contextual place in the world. Normative conceptions of lyric speaker and lyric reader are a central concern of contemporary poetics, as we discussed in Chapter 1, and rightly problematize any discussion of lyric subjectivity in game poems like *Passage*. To what extent, for instance, might the game correspond to the emergence of the "modern, bourgeois subject" that scholars like Reed interrogate? (See "The Erotics of Mourning in Recent Experimental Black Poetry," *The Black Scholar* 47, no. 1 (January 2, 2017): 23–37, https://doi.org/10.1080/00064246.2017.1264851).

11 See Chapter 3: note 9.

12 See Introduction: note 45.

13 See Wardrip-Fruin, "Beyond Shooting and Eating," 139.

14 See Mihaly Csikszentmihalyi, "Toward a Psychology of Optimal Experience," in *Flow and the Foundations of Positive Psychology*, 209–26 (Springer, 2014).

15 See Doris Rusch's comments about player complaints when playing *Passage* in *Making Deep Games*, 39.

16 See again Marcus Richert, *Passage in 10 Seconds*, browser, Kongregate.com (2010), https://www.kongregate.com/games/raitendo/passage-in-10-seconds.

17 Rod Humble, *The Marriage*, Windows, 2007, https://www.rodvik.com/rodgames/marriage.html.

18 See the Introduction for a description of *Loneliness*.

19 Hamburger, *The Logic of Literature*, 276–77, 285. Emphasis added.

20 Auriea Harvey and Michaël Samyn, *The Graveyard*, Windows, MacOS (Tale of Tales, 2009).

21 Miyamoto, Shigeru, Yoshiaki Koizumi, Takashi Tezuka, and Nintendo EAD et al. *Super Mario 64*. Nintendo 64. Nintendo, June 23, 1996.

22 Gard, Toby, and Core Design et al. *Tomb Raider*. Sega Saturn, PlayStation, MS-DOS. Eidos Interactive, 1996.

23 Piotr Kubiński, "Micropoetics and Video Games or a Minimalistic Encomium to Short-Sightedness," Forum Poetyki (Forum of Poetics), 2017, http://fp.amu.edu.pl/micropoetics-and-video-games-or-a-minimalistic-encomium-to-short-sightedness/, 66.

24 Alex Mitchell, "Making the Familiar Unfamiliar: Techniques for Creating Poetic Gameplay" (2016); Alex Mitchell, Yuin Theng Sim, and Liting Kway, "Making It Unfamiliar in the 'Right' Way" (2017).

25 Mitchell's discussion of defamiliarization in videogames is highly relevant to any consideration of games as poems, and something we will return to in the second part of this book.

Chapter 4 Game Poems Make Use of Poetic Address

1 "In the romantic ideal of lyric affect, bird-poets would have no bodies" (Virginia Walker Jackson, *Dickinson's Misery: A Theory of Lyric Reading* (Princeton University Press, 2005), 188.

2 Quoted in Jackson, *Dickinson's Misery*, 188; See also "To a Skylark," in *The Complete Poetical Works of Percy Bysshe Shelley*, edited by George Edward Woodberry (Houghton, Mifflin Company, 1901), 381, ll. 1–5.

3 John Stuart Mill, "Thoughts on Poetry and Its Varieties," *The Crayon* 7, no. 5 (1860): 123–28, https://doi.org/10.2307/25528049. See also how Northrop Frye builds on Mill's conception of poetic address in *Anatomy of Criticism: Four Essays* (Princeton University Press, 2020).

4 "Con el tú de mi canción, non te aludo compañero; ese tú soy yo" (Philip G. Johnston, *The Power of Paradox in the Work of Spanish Poet Antonio Machado (1875–1939)* (Edwin Mellen Press, 2002), 78. Rough translation mine.

5 Goethe, "Wanderer's Nightsong II," translated by Henry Wadsworth Longfellow in *The Complete Poetical Works of Henry Wadsworth Longfellow* (Houghton, Mifflin and Company, 1920).

6 Jonathan Culler, *Theory of the Lyric* (Harvard University Press, 2015), 195.

7 D. Fox Harrell, *Phantasmal Media: An Approach to Imagination, Computation, and Expression* (MIT Press, 2013), 164.

8 Jason Rohrer, "What I Was Trying to Do with Passage," *SourceForge*, November 2007, http://hcsoftware.sourceforge.net/passage/statement.html.

9 Helen Vendler, *The Art of Shakespeare's Sonnets* (Harvard University Press, 1999), 18.

10 Culler, *Theory of the Lyric*, 187.

11 Of course, the problem of normative lyric subject rears its head again here. To what extent are questions of sex, gender, and race implicated in one's ability to identify with the "lyric I" that *Passage* presents?

12 Robert Papas and Konami et al., *Frogger*, Arcade, Sega, 1981.

13 John Romero et al., *Doom*, MS-DOS. id Software, 1993.

14 See Culler, *Theory of the Lyric*, chap. 5.

15 Jordan Magnuson, *Portraits of My Child*, browser, HTML5, Windows, NecessaryGames.com, 2018.

16 PICO-8 is a game maker and virtual machine that intentionally imposes many constraints common to 8-bit-era consoles.

17 dino (formerly nina), *Seasonal Mixtape*, browser, HTML5, Itch.io, 2018, https://mome.itch.io/seasonalmixtape.

18 That is, a game created with the minimalist Bitsy game making tool. As with PICO-8 and other minimalist game editors, Bitsy games often share several recognizable characteristics, a topic that we will touch on in a later chapter of this book.

19 Culler, *Theory of the Lyric*, 187.

Chapter 5 Game Poems Exist in a Ritual Space
Rather than a Narrative Space

1 Muriel Rukeyser, *The Life of Poetry* (Paris Press, 1996), 26.

2 Marjorie Perloff, "Avant-Garde or Endgame?" in *Poetry in Theory: An Anthology 1900–2000*, edited by Jon Cook, 547–58 (Blackwell, 2004), 554. Emphasis added.

3 Jonathan Culler, *Theory of the Lyric* (Harvard University Press, 2015), 121.

4 Werner Wolf, "The Lyric: Problems of Definition and a Proposal for Reconceptualisation," in *Theory Into Poetry: New Approaches to the Lyric*, edited by Eva Müller-Zettelmann and Margarete Rubik, 21–56 (Rodopi, 2005), 39.

5 Again, I would point my reader to Virginia Jackson and Yopie Prins, *The Lyric Theory Reader: A Critical Anthology* (JHU Press, 2014), for a thorough exploration of this topic. The distinction is also noted by Culler and by Eva Müller-Zettelmann in *Lyrik Und Metalyrik* (Winter, 2000). See also Müller-Zettelmann and Margarete Rubik, *Theory Into Poetry: New Approaches to the Lyric* (Amsterdam: Rodopi, 2005), 99.

6 "Still I Rise," in Maya Angelou, *The Complete Poetry* (Random House, 2015), 159. Penguin Random House declined to grant me permission to reprint a few lines from the poem in this book.

7 Culler, *Theory of the Lyric*, 121.

8 As with *Loneliness*, I find that narratological readings of *Passage* can be fruitful, but also miss the mark for me. It seems strange to describe *Passage* as a "good narrative," for instance, as Sezen does, even if it has some narrative elements (though I appreciate Sezen's analysis of the game). See Diğdem Sezen, "Narrative Explorations in Videogame Poetry," in *Interactive Digital Narrative: History, Theory and Practice*, edited by Hartmut Koenitz et al., 227–40 (Routledge, 2015), 234.

9 Jessie Wade, "Jason Rohrer Explains How He Creates Art in Games—Humans Who Make Games Episode 4," *IGN*, February 6, 2019, https://www.ign.com/articles/2019/02/06/jason-rohrer-explains-how-he-creates-art-in-games-a-humans-who-make-games-episode-4.

10 Antonio César Moreno Cantano, "Soledad y memoria en la obra de Jordan Magnuson," in *La vida en juego: la realidad a través de lo lúdico*, edited by Alberto Venegas and Antonio César Moreno Cantano (AnaitGames, 2021), 83–84.

11 Earl Miner, "Why Lyric?," in *The Lyric Theory Reader: A Critical Anthology*, edited by Virginia Jackson and Yopie Prins, 577–89 (JHU Press, 2014), 585. Emphasis added.

12 Rukeyser, *The Life of Poetry*, 31.

13 Pippin Barr, *A Series of Gunshots*, browser, PippinBarr.com, 2015, https://www.pippinbarr.com/2015/11/19/a-series-of-gunshots/.

14 Paolo Pedercini, "Top Ten 2015 Games You Don't Have to Play," *La Molleindustria*, January 3, 2016. http://www.molleindustria.org/blog/top-ten-2015-games-you-dont-have-to-play/.

15 David Rudin, "A Series of Gunshots Calls out Senseless Gun Violence in Games," *Kill Screen*, November 19, 2015, https://killscreen.com/articles/a-series-of-gunshots-calls-out-senseless-gun-violence-in-games/.

16 See for example Richard Lee Walker, "Ghosts of the Horseshoe: A Mobilization of a Critical Interactive" (PhD diss., University of South Carolina, 2014), in which *Loneliness* is read as a "message game" (18) "about the loneliness faced by Korean children" (19).

17 See A. Gazzard and A. Peacock, "Repetition and Ritual Logic in Video Games," *Games and Culture* 6, no. 6 (November 1, 2011): 499–512, https://doi.org/10.1177/1555412011431359; Rachel Wagner, *Godwired: Religion, Ritual and Virtual Reality* (Routledge, 2012); Sun-ha Hong, "When Life Mattered: The Politics of the Real in Video Games' Reappropriation of History, Myth, and Ritual," *Games and Culture* 10, no. 1 (January 2015): 35–56, https://doi.org/10.1177/1555412014557542.

Chapter 6 Game Poems are Hyperbolic

1 Anne Bradstreet, "To My Dear and Loving Husband," in David D. Hall, *Puritans in the New World: A Critical Anthology* (Princeton University Press, 2004), 188–89, ll. 5–8.

2 Jonathan Culler, *Theory of the Lyric* (Harvard University Press, 2015), 259.

3 Werner Wolf, "The Lyric: Problems of Definition and a Proposal for Reconceptualisation," in *Theory Into Poetry: New Approaches to the Lyric*, edited by Eva Müller-Zettelmann and Margarete Rubik, 21–56 (Rodopi, 2005), 39.

4 Culler, *Theory of the Lyric*, 38.

5 See, for example, Doris C. Rusch, *Making Deep Games: Designing Games with Meaning and Purpose* (CRC Press, 2017); Wardrip-Fruin, "Beyond Shooting and Eating: Passage, Dys4ia, and the Meanings of Collision," *Critical Inquiry* 45, no. 1 (2018): 140.

6 Rusch, *Making Deep Games*, 39.

7 Rusch, 39.

8 Culler, *Theory of the Lyric*, 260.

9 Additional examples of this kind of implicit hyperbole can be found in Ed Key and David Kanaga's *Proteus*, Joost Eggermont's *The Wanderer*, and my own *Walk or Die*, among many other games.

10 A relatively rare example of a videogame's creator explicitly using this label. See introduction for more discussion on this topic.

11 Excerpt from "To a Poor Old Woman," by William Carlos Williams, from *THE COLLECTED POEMS: VOLUME I, 1909-1939*, copyright ©1938 by New Directions Publishing Corp. Reprinted by permission of New Directions Publishing Corp.

12 Culler, *Theory of the Lyric*, 260.

13 See Nick Montfort and Ian Bogost, *Racing the Beam: The Atari Video Computer System* (MIT Press, 2009); Ian Bogost, *A Slow Year: Game Poems* (Open Texture, 2010).

14 The most-cited example of this type of reaction is perhaps Marcus Richert's interactive parody, *Passage in 10 Seconds*, browser, Kongregate.com, 2010, https://www.kongregate.com/games/raitendo/passage-in-10-seconds. See Wardrip-Fruin, "Beyond Shooting and Eating," 140–41.

15 Jordan Magnuson, *Grandmother*, browser, Adobe Flash, HTML5, Gametrekking.com, 2011. https://www.gametrekking.com/the-games/vietnam/grandmother/play-now.

16 Remember *Myst*?

17 Culler, *Theory of the Lyric*, 260.

18 As a reminder, in semiotics "indexicality" refers to the phenomenon of a sign denoting a signified because of some *actual connection* between sign and signified (see Charles Sanders Peirce's discussion of indexicality in *Writings of Charles S. Peirce: 1879–1884* (Indiana University Press, 1982)). This phenomenon has been extensively studied in relation to photography and film (see André Bazin and Hugh Gray, "The Ontology of the Photographic Image," *Film Quarterly* 13, no. 4 (1960): 4–9, https://doi.org/10.2307/1210183), because these forms of media present an image of reality that is in some sense created by the thing imaged (and so we might say when speaking informally that the image of a woman in a photo *is* the woman). When I refer to indexicality or indexical realism in relation to videogames, I am speaking loosely of videogames' attempts to mirror indexical media in order to borrow their indexical-realism "cachet" (as discussed by scholars like Galloway). Indexical notions of realism tied to the objective world ("this image is real because it's a photo") stand in stark contrast to subjective conceptions of The Real as explored by metaphoric forms like poetry. See also Muriel Rukeyser's discussion of realism in cinema vs. poetry in *The Life of Poetry* (Paris Press, 1996), 18.

19 Alexander R. Galloway, "Social Realism in Gaming," *Game Studies* 4, no. 1 (2004). http://www.gamestudies.org/0401/galloway/.

Chapter 7 Game Poems are Bound to Metaphor and Ambiguous Imagery

1 Jon Cook, *Poetry in Theory* (Blackwell, 2004), 318.

2 Mary Oliver, *A Poetry Handbook* (Houghton Mifflin Harcourt, 1994), 99.

3 Emily Dickinson, "254," in *The Complete Poems of Emily Dickinson*, edited by Thomas H. Johnson (Little, Brown and Company, 1960), 253, ll. 1.

4 William Shakespeare, *The Tragedy of Macbeth*, edited by Ebenezer Charlton Black and Andrew Jackson George (Ginn and Company, 1908), 2.2.37–40. While it may seem odd to cite one of Shakespeare's tragedies in the context of discussing lyric poetry, Culler and Barfield both treat parts of Shakespeare's plays as examples of lyric poems. As Gérard Genette explains in *The Architext*, "modal" and "generic" definitions of poetry do not always coincide (so, for example, some expression that may be seen as modally lyric may be contained within a text that is classified as drama). See Jonathan Culler, *Theory of the Lyric* (Harvard University Press, 2015), 222; Owen Barfield, *Poetic Diction: A Study in Meaning* (Barfield Press UK, 2010), 107; Northrup Frye, "Theory of Genres," in *The Lyric Theory Reader: A Critical Anthology*, edited by Virginia Jackson and Yopie Prins, 30–39 (JHU Press, 2014), 25. I reference this passage because it is appropriately metaphor-rich, and also because it connects to discussion by Barfield that I would like to build on and reference further.

5 Barfield, *Poetic Diction*, 107. Note that Barfield is an obscure figure within poetry scholarship, but I have found his writings to be insightful, and we will give them a closer look in the second half of this book.

6 D. Fox Harrell, *Phantasmal Media: An Approach to Imagination, Computation, and Expression* (MIT Press, 2013), 343.

7 "Ars Poetica," ll. 23–24, in Archibald MacLeish, *Collected Poems, 1917–1982* (Houghton Mifflin, 1985), 106.

8 Owen Barfield goes so far as to say that our entire conception of poetry is indelibly tied to subjectivity and ambiguity: "The question of whether or not I can call a given group of words 'poetry' is, in fact, immediately dependent on my own inner experiences" (*Poetic Diction*, 34).

9 Umberto Eco, *Postscript to The Name of the Rose* (Harcourt Brace Jovanovich, 1984), 8.

10 See as a few examples Doris C. Rusch, *Making Deep Games: Designing Games with Meaning and Purpose* (CRC Press, 2017); Noah Wardrip-Fruin, "Beyond Shooting and Eating: Passage, Dys4ia, and the Meanings of Collision," *Critical Inquiry* 45, no. 1 (2018); Harrell, *Phantasmal Media*, chap. 4; Ian Bogost, "Frame and Metaphor in Political Games"; Möring, "Games and Metaphor: A Critical Analysis of the Metaphor Discourse in Game Studies,"

Worlds in Play: International Perspectives on Digital Games Research 21 (2007); Roelf Kromhout and Charles Forceville, "Life Is a Journey: Source–Path–Goal Structure in the Videogames 'Half-Life 2', 'Heavy Rain', and 'Grim Fandango,'" *Metaphor and the Social World* 3, no. 1 (2013): 100–116, https://doi.org/10.1075/msw.3.1.05for ; Alison Gazzard, *Mazes in Videogames: Meaning, Metaphor and Design* (McFarland, 2013); Lindsay D. Grace, "The Poetics of Game Design, Rhetoric and the Independent Game," in *Proceedings of DiGRA 2011 Conference: Think Design Play*, 2011, https://www.researchgate.net/publication/262250050_The_Poetics_of_Game_Design_Rhetoric_and_the_Independent_Game; Alexei Othenin-Girard, "Bodies, Games, and Systems: Towards an Understanding of Embodiment in Games," master's thesis, UCSC, 2012.

11 Othenin-Girard, "Bodies, Games, and Systems"; Wardrip-Fruin, "Beyond Shooting and Eating."

12 William C. Wees, "The Poetry Film," in *Words & Moving Images: Essays on Verbal and Visual Expression in Film and Television*, edited by William C. Wees and Michael Dorland (Médiatexte Publications, 1984), 109.

13 The two parts of a metaphoric comparison have been studied under various names, including "ground and figure," "tenor and vehicle," and "target and source." See Zoltan Kovecses, *Metaphor: A Practical Introduction* (Oxford University Press, 2010).

14 A style I first employed in 2010 in *Freedom Bridge* (browser, 2010, https://www.necessarygames.com/my-games/freedom-bridge), then subsequently in *Loneliness* (browser, NecessaryGames.com, 2010. https://www.necessarygames.com/my-games/loneliness), *A Brief History of Cambodia* (browser, NecessaryGames.com, 2012, https://www.necessarygames.com/my-games/brief-history-cambodia), and my *Stations of the Cross* triptych (videogame installation, University of California, Santa Cruz, 2017).

15 Or, "This *is* loneliness." I am less concerned with a distinction between simile and metaphor than with considering metaphor broadly speaking as any direct comparison of words, images, or signs.

16 I also believe that, as with *Dys4ia*, the experience of playing the game works to recast and enliven the word "loneliness" itself—not because *Loneliness* is a Great Game, but because comparisons always work to subtly alter both the figure and the ground of comparison.

17 A conclusion that has been supported by some scholars who have studied the game. See for example Daniel Pettersen De Lucena and Rosilane da Mota, "Games as Expression: On the Artistic Nature of Games," in *Proceedings of SBGames 2017*, 820.

18 Mariam Asad, "Making It Difficult: Modernist Poetry as Applied to Game Design Analysis," master's thesis (Georgia Institute of Technology, 2011), 79.

19 Magnuson, *Freedom Bridge*.

20 See Chapter 7: note 10.

21 None of these observations are original. For rich discussion of metaphor as it operates within *Passage* see Rusch, *Making Deep Games*, 38–39; Harrell, *Phantasmal Media*, chap. 4; Wardrip-Fruin, "Beyond Shooting and Eating: Passage, Dys4ia, and the Meanings of Collision."

22 See Michael Mateas and Noah Wardrip-Fruin, "Defining Operational Logics," in *Breaking New Ground: Innovation in Games, Play, Practice, and Theory; Proceedings of DiGRA 2009* (DiGRA, 2009). I will discuss these ideas in more depth in Part II of this book.

Chapter 8 Game Poems Juxtapose Signified Meaning with Material Meaning

1 Paul Valéry, *Tel quel* (Editions Gallimard, 2016; as translated and quoted in Agamben, "The End of the Poem," 430).

2 Julia Kristeva, "The Ethics of Linguistics," in *Poetry in Theory: An Anthology 1900–2000*, edited by Jon Cook, 437–46 (Blackwell, 2004), 444.

3 See: Werner Wolf, "The Lyric: Problems of Definition and a Proposal for Reconceptualisation," in *Theory Into Poetry: New Approaches to the Lyric*, edited by Eva Müller-Zettelmann and Margarete Rubik, 21–56 (Rodopi, 2005), 39; Mary Oliver, *A Poetry Handbook* (Houghton Mifflin Harcourt, 1994); Jonathan Culler, *Theory of the Lyric* (Harvard University Press, 2015), chap. 4; Max Nänny, "Diagrammatic Iconicity in Poetry," in *Theory into Poetry: New Approaches to the Lyric*, edited by Eva Müller-Zettelmann and Margarete Rubik, 229–49 (Rodopi, 2005).

4 Vladimir Mayakovsky, "How Are Verses Made?," in *Poetry in Theory: An Anthology 1900–2000*, edited by Jon Cook, 144–55 (Blackwell, 2004), 147.

5 Muriel Rukeyser, *The Life of Poetry* (Paris Press, 1996), 10, 115.

6 Culler, *Theory of the Lyric*, 138.

7 Culler, 137.

8 Mark Strand and Eavan Boland, *The Making of a Poem: A Norton Anthology of Poetic Forms* (Norton, 2001), xxv.

9 "The Tyger," in William Blake, *Songs of Innocence and Songs of Experience*, edited by Philip Smith (Dover, 2012), 37, ll. 1–4.

10 Culler, *Theory of the Lyric*, 141.

11 Northrup Frye, "Theory of Genres," in *The Lyric Theory Reader: A Critical Anthology*, edited by Virginia Jackson and Yopie Prins, 30–39 (JHU Press, 2014), 37.

12 See Mariam Asad, "Making It Difficult: Modernist Poetry as Applied to Game Design Analysis," master's thesis (Georgia Institute of Technology, 2011); Thomas J. Papa, *Poetic Videogames: A Haiku Perspective* (Mimicry Games, 2014); Lindsay D. Grace, "The Poetics of Game Design, Rhetoric and the Independent Game," in *Proceedings of DiGRA 2011 Conference: Think Design Play*, 2011, https://www.researchgate.net/publication/262250050_The_Poetics_of_Game_Design_Rhetoric_and_the_Independent_Game.

13 Grace, "The Poetics of Game Design," 4–5.

14 Adam Saltsman, *Canabalt*, browser, Adobe Flash, HTML5, Semi-Secret Software, 2009, http://canabalt.com/.

15 Questions that I and others have investigated. See Magnuson, "Canabalt: A One Button Miracle," Necessary Games, 2009. https://www.necessarygames.com/reviews/canabalt-game-free-download-independent-browser-platformer-sci-fi-singleplayer-casual-gamers; Simon Parkin, "Don't Stop: The Game That Conquered Smartphones," *The New Yorker*, June 7, 2013, https://www.newyorker.com/tech/annals-of-technology/dont-stop-the-game-that-conquered-smartphones"; Jody MacGregor, "What I Talk About When I Talk About Endless Running," ZAM, 2016, https://web.archive.org/web/20160526133836/http://www.zam.com:80/article/548/what-i-talk-about-when-i-talk-about-endless-running.

16 See Mary Oliver: "This quick response to the prevailing rhythmic pattern is true of 'free' verse as well as metrical verse, even though the pattern in free-form poems is less mathematically measurable than it is in metric verse" (*A Poetry Handbook*, 43). Or Northrop Frye: "The aim of 'free' verse is…the articulation of an independent rhythm equally distinct from metre and from prose" ("Theory of Genres," 34).

17 Antonio César Moreno Cantano, "Soledad y memoria en la obra de Jordan Magnuson," in *La vida en juego: la realidad a través de lo lúdico*, edited by Alberto Venegas and Antonio César Moreno Cantano (AnaitGames, 2021), 83.

18 Jon Stone, *Dual Wield: The Interplay of Poetry and Videogames* (De Gruyter Oldenbourg, 2022), 11.

19 As just one reference point, Mary Oliver's *A Poetry Handbook* is full of these kinds of questions.

20 Jordan Magnuson, *The Heart Attack*, browser, Adobe Flash, HTML5, Gametrekking.com, 2011, https://www.gametrekking.com/the-games/viet nam/the-heart-attack.

21 Jordan Magnuson, *The Killer*, browser, Adobe Flash, HTML5, Gametrekking.com, 2011, https://www.gametrekking.com/the-games/cambodia/the-killer.

22 Oliver, *A Poetry Handbook*, 54.

23 Jordan Magnuson, *When Gold Is in the Mountain*, browser, HTML5, Windows, NecessaryGames.com, 2018.

24 See Anita Barrows, *Rilke's Book of Hours: Love Poems to God*, reprint edition (Riverhead Books, 2005).

Chapter 9 The Value of Identifying Game Poems

1 Jahan Ramazani, *Poetry and Its Others: News, Prayer, Song, and the Dialogue of Genres* (University of Chicago Press, 2013), 12–13.

2 Muriel Rukeyser, *The Life of Poetry* (Paris Press, 1996), 91.

3 See, for example, Jonathan Culler's use of this method to help define lyric poetry in chapter 1 of *Theory of the Lyric* (Harvard University Press, 2015).

4 Ralph Cohen, "History and Genre," in *The Lyric Theory Reader: A Critical Anthology*, edited by Virginia Jackson and Yopie Prins, 53–63 (JHU Press, 2014), 53.

5 Stanley Fish, *Is There a Text in This Class? The Authority of Interpretive Communities* (Harvard University Press, 1982), chap. 14.

6 See Jim Andrews, *Arteroids: The Poetry Sploder* (Vispo.com, 2017).

7 Jason Nelson, "Game, Game, Game and Again Game," *The Electronic Literature Collection Volume 2* (2007).

8 Gregory Avery-Weir, *Silent Conversation*, browser. Future Proof Games, 2009. https://futureproofgames.itch.io/silent-conversation.

9 Daniel Benmergui, *Today I Die*, browser, 2008. http://ludomancy.com/.

10 With reviews of over five hundred digital poems in its collection, the website iloveepoetry.org provides one good starting place for exploring perspectives on digital poetry.

11 Stephanie Strickland and Cynthia Lawson Jaramillo, "V: Vniverse," 2002, http://www.stephaniestrickland.com/vniverse.

12 Nick Montfort, "Taroko Gorge," 2009, https://nickm.com/taroko_gorge.

Chapter 10 What is the Material of the
Videogame Poet?

1 William Matthews, "Dull Subjects," *New England Review and Bread Loaf Quarterly* 8, no. 2 (1985): 142–52.

2 Jon Cook, ed., *Poetry in Theory: An Anthology 1900–2000* (Blackwell, 2004), 144.

3 Nick Montfort and Ian Bogost, *Racing the Beam: The Atari Video Computer System* (MIT Press, 2009), 1.

4 Montfort and Bogost, 1.

5 You can find clear and succinct discussion of this topic by a single poet in Mary Oliver, *A Poetry Handbook* (Houghton Mifflin Harcourt, 1994). Or if you prefer, vast and unwieldy discussion by many poets in Cook, *Poetry in Theory*.

6 Hesketh Pearson, *Oscar Wilde: His Life and Wit* (Harper & Bros., 1946), 111.

7 Another analogy that might resonate for some creators is that different programming languages are akin to different spoken languages for a multilingual poet, each with their own sets of sounds and images: a poem in French vs. a poem in German, let's say. This analogy doesn't resonate with me as strongly as the analogy of poetic form, since the range of constraint doesn't seem to match up as well, but it is another perspective to consider.

8 See Thomas Stearns Eliot, "Reflections on Vers Libre," *New Statesman* 8, no. 204 (1917): 518.

9 See for example Shonte Daniels, "Bitsy Makes It Easy to Design Small Narrative Games," *Paste Magazine*, January 18, 2018. https://www.pastemagazine.com/articles/2018/01/bitsy-makes-it-easy-to-design-small-narrative-game.html; Nathan Altice, "The Modest Fantasy of the Pico-8," *Paste Magazine*, January 22, 2016, https://www.pastemagazine.com/articles/2016/01/the-modest-fantasy-of-the-pico-8.html.

10 A visual scripting or visual programming language is one that allows creators to manipulate program elements graphically rather than by using more traditional textual code. I hope it is obvious that I am being sarcastic in my disparagement of such visual languages.

11 See Shoshana Felman, "On Reading Poetry: Reflections on the Limits and Possibilities of Psychoanalytical Approaches," in *Poetry in Theory: An Anthology 1900–2000*, edited by Jon Cook, 477–90 (Blackwell, 2004). Studies of affect in videogames are highly relevant in regard to poetic notions of "felt experience." See Aubrey Anable, *Playing with Feelings: Video Games and Affect* (University of Minnesota Press, 2018).

12 See Mark C. Marino, *Critical Code Studies* (MIT Press, 2020); Montfort and Bogost, *Racing the Beam*, 147; Nick Montfort et al., *10 PRINT CHR$(205.5+RND(1));: GOTO 10* (MIT Press, 2012); D. Fox Harrell, *Phantasmal Media: An Approach to Imagination, Computation, and Expression* (MIT Press, 2013).

13 Unless, of course, we are speaking of *code poetry*, a creative practice that involves foregrounding computer code as something to be directly experienced and encountered by the reader—but this is not the realm of most videogames.

14 Videogame code may be messier in this regard than ink, as large parts of any given codebase are often written by distant programmers (in the form of frameworks, libraries, etc.), and this code itself will not run without additional code written by yet more programmers (virtual machine code, operating system code, etc.). Layers and layers of meaning that are outside of the videogame poet's direct control.

15 Of course, certain traditions of poetry, such as concrete poetry, are very much concerned with such "details."

16 See Werner Wolf, "The Lyric: Problems of Definition and a Proposal for Reconceptualisation" in *Theory Into Poetry: New Approaches to the Lyric*, edited by Eva Müller-Zettelmann and Margarete Rubik, 21–56 (Rodopi, 2005), 24; Muriel Rukeyser, *The Life of Poetry* (Paris Press, 1996), 179.

17 Following a longstanding tradition of artists, poets, and makers throughout history, I sometimes scrawl new work directly over old work, which leaves an interesting and meaningful material trace in itself, even if not "elegant" or "pretty" (e.g., *The Killer* and *Walking with Magnus* were both built on top of *Walk or Die*; *When Gold Is in the Mountain* was built on top of *Icarus Also Flew*).

18 See Virginia Walker Jackson, *Dickinson's Misery: A Theory of Lyric Reading* (Princeton University Press, 2005).

19 A process I am personally constantly engaged in. Even if I make a small game poem for my wife as a private gift, there is a good chance that I will need to port the game to a new technological platform if I want her to be able to play it twenty or thirty years from now.

20 Though it should be noted that a poorly executed videogame port can indeed result in something that feels like an alien artifact compared to the original game, which is not a problem frequently run into with lyric poetry transcription. Perhaps an analogy to poetry translation rather than transcription would be more apt in some cases.

Chapter 11 Thinking in Terms of Language and Signifiers

1 Robert Hass, *A Little Book on Form: An Exploration into the Formal Imagination of Poetry* (Ecco, 2017), 1.

2 Gérard Genette, "Poetic Language, Poetics of Language," *Social Science Information* 7, no. 2 (1968): 141–61. Emphasis added.

3 Julia Kristeva, "The Ethics of Linguistics," in *Poetry in Theory: An Anthology 1900–2000*, edited by Jon Cook, 437–46 (Blackwell, 2004), 444. Emphasis added.

4 For more context regarding the history and theories of language poetry, I would point my reader to the *L=A=N=G=U=A=G=E* magazine and the theories and writings of its various contributors. See especially Ron Silliman, "The New Sentence," in *The New Sentence*, 63–93 (Roof Books, 1987); Lyn Hejinian, *The Language of Inquiry* (University of California Press, 2000). Also relevant (as always) is Ludwig Wittgenstein, *Philosophical Investigations* (John Wiley & Sons, 2010; see particularly Wittgenstein's discussion of "language-games").

5 Hejinian, *Language of Inquiry*, 1–2.

6 Fernande Saint-Martin, *Semiotics of Visual Language* (Indiana University Press, 1990); David Crow, *Visible Signs: An Introduction to Semiotics in the Visual Arts*, 2nd ed. (AVA Publishing, 2010).

7 Jordan Zlatev, "Cognitive Semiotics: An Emerging Field for the Transdisciplinary Study of Meaning," *The Public Journal of Semiotics* 4, no. 1 (2012): 2–24; Line Brandt and Per Aage Brandt, "Cognitive Poetics and Imagery," *European Journal of English Studies* 9, no. 2 (August 2005): 117–30, https://doi.org/10.1080/13825570500171861.

8 Christian Metz, *Film Language: A Semiotics of the Cinema* (University of Chicago Press, 1991); Warren Buckland, *The Cognitive Semiotics of Film* (Cambridge University Press, 2000).

9 Clive Scott, *Spoken Image: Photography and Language* (Reaktion Books, 1999).

10 Scott McCloud, *Understanding Comics* (Harper Collins, 1994).

11 D. Fox Harrell, *Phantasmal Media: An Approach to Imagination, Computation, and Expression* (MIT Press, 2013).

12 I would point my reader to those sources I have already noted (see the previous few notes), as well as the work of foundational semioticians like Saussure, Peirce, and Barthes.

13 Metz, *Film Language*, 97.

14 As visual studies scholars are right to point out. See for example Soraya Murray, *On Video Games: The Visual Politics of Race, Gender and Space* (London: I.B. Tauris, 2017).

15 Espen Aarseth, "Genre Trouble: Narrativism and the Art of Simulation," in *First Person: New Media as Story, Performance, and Game*, edited by Noah Wardrip-Fruin and Pat Harrigan, 45–55 (MIT Press, 2004). Note that Aarseth's perspective on videogame imagery has of course evolved since this article was published.

16 Setting aside, for the moment, questions of whether formalism is attainable or approachable as an abstract ideal.

17 We will consider the specific nature of this intervention in the upcoming chapters. Note that it is quite possible for any artist to approach any medium (painting or photography, for instance) with this kind of perspective. Which, in a way, is my point: that one can approach any medium—*including videogames*—as a kind of language, with poetic intervention as the intended goal. In my mind, this is part of what distinguishes the idea of being a multi-media *poet* from being an "artist" broadly speaking—but we will explore some of these questions shortly, and I am getting ahead of myself.

18 Sean Velasco et al., *Shovel Knight*, Windows, Nintendo 3DS, Wii U (Yacht Club Games, 2014).

19 Shovel Knight™ is a trademark of Yacht Club Games®. ©2022 Yacht Club Games LLC. All rights reserved.

20 Harrell, *Phantasmal Media*, 126. Emphasis added.

21 All of this is to explore the *connotative* layers of meaning present in this sound (that is, associations that have been tied to the sound). On the *denotative* level (that is, the question of what the sound is understood to directly/literally signify), there is nothing really interesting to say with regard to this particular example: we assume the sound of a shotgun reloading indicates what it seems to indicate (a shotgun is being reloaded), because videogames have not historically questioned indexical signification; least of all the indexical signification of sounds related to firearms!

22 An important point, naturally, is that this kind of vernacular is only *vernacular* to those who engage consistently with videogames as a medium— but this holds true for all language (that it is only understood prosaically by a certain group of people, within a given context).

23 Ian Bogost, *Unit Operations: An Approach to Videogame Criticism* (MIT Press, 2008), xiii.

24 See Janet Murray, *Hamlet on the Holodeck: The Future of Narrative in Cyberspace* (MIT Press, 1997), pt. 3; Bogost, *Persuasive Games: The Expressive Power of Videogames* (MIT Press, 2007), chap. 1.

25 Gonzalo Frasca, *September 12th: A Toy World*, browser. Newsgaming, 2010, http://www.newsgaming.com/games/index12.htm.

26 Of course, all modeled systems can be seen as "simple" at some level compared to what they represent, but *September 12* is markedly so.

27 Bogost, *Persuasive Games*, 87.

28 Doris C. Rusch, *Making Deep Games: Designing Games with Meaning and Purpose* (CRC Press, 2017), 41.

29 Wright, Will. *SimCity*. Amiga, Commodore 64, MS-DOS, Mac OS. Maxis, 1989.

30 "Rhetoric, n.1," in *Oxford English Dictionary* (Oxford University Press, June 2010), http://www.oed.com/view/Entry/165178.

31 To quote Roman Jakobson: "Poeticalness is not a supplementation of discourse with rhetorical adornment but a total reevaluation of the discourse and all of its components whatsoever" ("Linguistics and Poetics," in *Style in Language*, 350–77 (MIT Press, 1960), 23).

32 See Jonathan Culler, *Theory of the Lyric* (Harvard University Press, 2015), chap. 4; Werner Wolf, "The Lyric: Problems of Definition and a Proposal for Reconceptualisation," in *Theory Into Poetry: New Approaches to the Lyric*, edited by Eva Müller-Zettelmann and Margarete Rubik, 21–56 (Rodopi, 2005), 39; Mary Oliver, *A Poetry Handbook* (Houghton Mifflin Harcourt, 1994); Max Nänny, "Diagrammatic Iconicity in Poetry," in *Theory Into Poetry: New Approaches to the Lyric*, edited by Eva Müller-Zettelmann and Margarete Rubik, 229–49 (Rodopi, 2005); Kristeva, "The Ethics of Linguistics."

33 A concept Wardrip-Fruin first proposed in 2005 and has since developed in collaboration with Michael Mateas, Joseph Osborn, and others (see Michael Mateas and Noah Wardrip-Fruin, "Defining Operational Logics," in *Breaking New Ground: Innovation in Games, Play, Practice, and Theory; Proceedings of DiGRA 2009* (DiGRA, 2009); Joseph C. Osborn, North Wardrip-Fruin, and Michael Mateas, "Refining Operational Logics," in *Proceedings of the 12th International Conference on the Foundations of Digital Games*, 1–10 (ACM Press, 2017), https://doi.org/10.1145/3102071.3102107; Noah Wardrip-Fruin, *How Pac-Man Eats* (MIT Press, 2020)).

34 See those resources mentioned in the previous note (Chapter 11: note 33) for a thorough investigation of this topic.

35 Mateas and Wardrip-Fruin, "Defining Operational Logics," 1.

36 Mateas and Wardrip-Fruin, 7.

37 Steve Russell, *Spacewar!* PDP-1, 1962.

38 Allan Alcorn, *Pong*, Arcade, Atari, 1972.

39 As Wardrip-Fruin investigates in *How Pac-Man Eats*.

40 Of course, language is never static, and neither is the material of the poet: prosaic language changes over time, which is one of the things we will touch on in the following chapters.

Chapter 12 One Vision of Poetic Intervention

1 Which is likely one reason why many of the videogames that can be readily analyzed as "game poems" are crafted by one person, as is true of most lyric poems.

2 As one starting point for considering some of these historical answers see Jon Cook, *Poetry in Theory* (Blackwell, 2004).

3 Percy Bysshe Shelley et al., *A Defence of Poetry* (Haldeman-Julius, 1969).

4 Julia Kristeva, "The Ethics of Linguistics," in *Poetry in Theory: An Anthology 1900–2000*, edited by Jon Cook, 437–46 (Blackwell, 2004).

5 Owen Barfield, *Poetic Diction: A Study in Meaning* (Barfield Press UK, 2010), 40–41.

6 Metaphor, according to Barfield, is essentially any attempt to "arouse cognition of the unknown by suggestion from the known" (*Poetic Diction*, 106).

7 Barfield's strong emphasis on metaphoric meaning aligns with certain theories within cognitive linguistics as well as object-oriented ontology. See for example George Lakoff, *Philosophy in the Flesh* (Basic Books, 1999); Mark Johnson, *The Body in the Mind: The Bodily Basis of Meaning, Imagination, and Reason* (University of Chicago Press, 2013); Graham Harman, *Object-Oriented Ontology: A New Theory of Everything* (Penguin UK, 2018), chap. 2.

8 The important point here is not to what extent Barfield's perspective accurately reflects the development and evolution of prehistoric language, but rather how it relates to a more contemporary evolution of language that we can see in operation around us: the way newly introduced metaphors gradually go from being striking and ambiguous, to having accepted "literal" meanings as they become part of vernacular language. See, for example, Barfield's discussion of the evolution of the painter's expression "point of view" from metaphor to accepted vernacular (*Poetic Diction*, 106).

9 Barfield, 41.

10 Barfield, 106.

11 Muriel Rukeyser, *The Life of Poetry* (Paris Press, 1996), 166–67.

12 See again Barfield, *Poetic Diction*, 107.

13 See Alexander R. Galloway, "Social Realism in Gaming," *Game Studies* 4, no. 1 (2004). http://www.gamestudies.org/0401/galloway; Merritt Kopas, "Ludus Interruptus: Video Games and Sexuality," in *Ludus Interuptus*, edited by Daniel Goldberg and Linus Larsson (Seven Stories Press, 2015); Paolo Pedercini, "Videogames and the Spirit of Capitalism,"; Poremba, "Real|Unreal: Crafting Actuality in the Documentary Videogame," 42.

14 Kopas, "Ludus Interruptus: Video Games and Sexuality."

15 See D. Fox Harrell, *Phantasmal Media: An Approach to Imagination, Computation, and Expression* (MIT Press, 2013), 129.

16 Brendon Chung, *Thirty Flights of Loving*, Windows, MacOS, Blendo Games, 2012.

17 Alex Mitchell, "Making the Familiar Unfamiliar: Techniques for Creating Poetic Gameplay" (2016), 10.

18 Warren Robinett, *Adventure*, Atari 2600, Atari, 1979

19 See Ron Silliman's investigation of the boundaries of "sense" and "nonsense" ("bring me sugar" and "bring me milk" vs. "milk me sugar") in "The New Sentence" (in *The New Sentence*, 63–93 (Roof Books, 1987)), as well as D. Fox Harrell's discussion of gibberish in the context of "polymorphic poetry" in *Phantasmal Media*, 145. (Some sound poetry is, of course, intentionally made up of "gibberish," but that is another topic for another time.).

20 Shigeru Miyamoto, Takashi Tezuka, and Nintendo EAD et al., *The Legend of Zelda*, NES, Nintendo, 1986.

21 Harrell's polymorphic poetics is based on the concept of semiotic morphism developed by computer scientist Joseph Goguen (see Goguen, "Semiotic Morphisms," Technical Report CS97–553, Dept. Computer Science & Eng., UCSD, 1997). Semiotic morphism is the mapping of meaning "from one semiotic space, called the source space, to another semiotic space, called a target space" (Harrell, *Phantasmal Media*, 142), and provides a basis for thinking of metaphors as "semiotic morphisms from one system of concepts to another" (Goguen, "An Introduction to Algebraic Semiotics, With Application to User Interface Design," in *Computation for Metaphors, Analogy, and Agents*, edited by Chrystopher L. Nehaniv, 242–91 (Springer-Verlag, 1998), 5).

22 Harrell's framework is too robust and complex to consider in detail here but should be noted as an important tool for anyone seeking to understand the creation of ambiguous metaphoric meaning in videogames. My only contention with his poetics as it is laid out in *Phantasmal Media* is that it is rather clinical in its consideration of the mapping of metaphors as a "design problem" to be approached scientifically (141, 153, 164), more so than a poetic problem to be approached artfully. I would also have liked to see more discussion of how the mapping of existing metaphors might relate to the poetic creation of *new* metaphors—even if every new mapping is in some sense a new metaphor. That being said, Harrell does touch on questions of artistry and intuition (165), and I think his impressive poetics framework could be expanded in many directions that would be relevant to would-be makers of game poems.

23 Wardrip-Fruin, "Beyond Shooting and Eating: Passage, Dys4ia, and the Meanings of Collision," *Critical Inquiry* 45, no. 1 (2018): 191.

24 Shelley et al., *A Defence of Poetry*.

Chapter 13 Recasting the Language of Videogames

1 Jordan Magnuson, *A Brief History of Cambodia*, browser, NecessaryGames.com, 2012. https://www.necessarygames.com/my-games/brief-history-cambodia.

2 See Owen Barfield, *Poetic Diction: A Study in Meaning* (Barfield Press UK, 2010) chap. X.

3 Jordan Magnuson, *Walking with Magnus*, browser, Adobe Flash, HTML5, Windows, MacOS, NecessaryGames.com, 2018.

4 Jordan Magnuson, *Stations of the Cross*, videogame installation (University of California, Santa Cruz, 2017).

5 For more information about this installation, see *Stations of the Cross Art Game Installation* (documentary video), *YouTube*, 2018, https://www.yout ube.com/watch?v=Ko1o3e54aiw.

6 "Open Studios," University of California, Santa Cruz, December 8, 2017.

7 I don't see the categories of "game poem," "new media installation artwork," "spiritual/religious artifact," and "contemplation game" as mutually exclusive any more than I see the categories of "videogame" and "poem" as mutually exclusive, and I believe that my *Stations of the Cross* installation can be fruitfully considered from any of these vantagepoints.

8 "Videogames After Poetry" in *Receivership*, University of California, Santa Cruz, April 26–May 12, 2019.

9 Videogame distribution platforms like Newgrounds and Steam can also provide this kind of "videogames assumed" framing within an online context.

10 As we discussed in Chapter 2, this kind of intentional positioning in relation to videogames can be seen to operate in one way or another for all of the games we have surveyed in this book. *Passage*, for example, makes use of recognizable videogame iconography, point collection, etc. as various scholars have noted; *A Slow Year* situates itself strongly in relation to a famous videogame console, down to the cover art designed to evoke Atari 2600-era videogames.

11 Ota et al., *Dance Dance Revolution (DDR)*, Arcade. Konami, 1998.

Chapter 14 Making Game Poems in Practice

1 Friedensreich Hundertwasser, forward for a brochure on the occasion of the international traveling exhibition of the SOS-Kinderdörfer "Kinder Kunst," Palais Palffy, Vienna, September/October, 1981 "Hundertwasser—Text Detail" (accessed September 26, 2022), https://www.hundertwasser.com/en/texts/vom_schoepferisch_wissenden_zum_unwissenden).

2 Or any tiny, accessible game engine. See Appendix I for a list of recommendations.

3 Jordan Magnuson, *First Smile*, Windows, MacOS, Browser, HTML5, Meditations, 2018, https://meditations.games/.

4 See again Thomas Stearns Eliot, "Reflections on Vers Libre," *New Statesman* 8, no. 204 (1917).

5 I have found books like ARAS' *The Book of Symbols: Reflections on Archetypal Images* to be particularly helpful when it comes to this kind of freeform brainstorming and ideation.

6 See Appendix I for some examples.

7 A "game jam" refers loosely to the idea of making games in the context of other people also making games (whether physically adjacent or not), often with shared prompts or constraints. Ludum Dare is a tightly constrained online game jam that is held on a regular schedule. See Appendix I for some other examples.

8 Marilynne Robinson expresses this sentiment nicely when she writes, "One of the things I love about Emily Dickinson is...the extreme compression of her poems, which strip away everything inessential, greatly magnifying the potency of each individual word" ("Marilynne Robinson on Finding the Right Word," *New York Times*, September 22, 2017, sec. Book Review, https://www.nytimes.com/2017/09/22/books/review/marilynne-robinson-on-finding-the-right-word.html).

9 Mary Oliver, *A Poetry Handbook* (Houghton Mifflin Harcourt, 1994), 13.

10 Marjorie Perloff, "Poetry on the Brink: Reinventing the Lyric," *Boston Review* (accessed March 2, 2022), https://bostonreview.net/forum/poetry-brink/.

11 Blackout poetry is made by taking an existing page of text and using a pen or marker to "black out" words until the looked-for poem emerges from the words that remain.

12 Saltsman, Adam. *Fathom*. Browser, Adobe Flash, 2009.

13 See Introduction: notes 6, 8 for some options.

14 Remember that you'll typically want your game poems to have some connection to videogames as a medium, if you want your work to be perceived as connected to videogames in some way (see Chapter 9, Chapter 12). Still, exploring the outer edges of popular conceptions of videogames is a useful exercise for anyone who wants to understand and work with the medium.

15 See Chapter 6, Chapter 12.

16 Annie Dillard, *The Writing Life* (Harper Perennial, 1990).

17 Paolo Pedercini, "Videogames and the Spirit of Capitalism," *La Molleindustria*, February 14, 2014, http://www.molleindustria.org/blog/videogames-and-the-spirit-of-capitalism/.

18 Allen Ginsberg, quoted in Barry Miles, *Ginsberg: A Biography* (Simon and Schuster, 1989), 520.

19 Thomas Merton, *The Way of Chuang Tzu*, 2nd ed. (New Directions, 2010), 110.

20 Kathleen Norris, *The Cloister Walk* (Penguin 1997), 142.

21 Merton, *The Way of Chuang Tzu*, 110.

22 Rachel Blau DuPlessis, "Statement on Poetics," in *Inciting Poetics: Thinking and Writing Poetry*, edited by Jeanne Heuving and Tyrone Williams, 13–37 (University of New Mexico Press, 2019), 16.

23 Stephen King, *On Writing: A Memoir of the Craft* (Simon and Schuster, 2020), 157.

24 As Muriel Rukeyser notes: "All of this *re-writing* is conscious throughout, as distinct from the writing of the poem, in which suggestions, relations, images, phrases, sailed in from everywhere" (*The Life of Poetry* (Paris Press, 1996), 185, emphasis added).

25 As Annie Dillard advises, "spend it all, shoot it, play it, lose it, all, right away, every time. Do not hoard what seems good for a later place in the [game poem] or for another [game poem]; give it, give it all, give it now" (*The Writing Life*, adapted).

Chapter 15 Why We Need Game Poems

1 Jacques Derrida, "Che Cos'è La Poesia?," in *Poetry in Theory: An Anthology 1900–2000*, edited by Jon Cook, 533–37 (Blackwell, 2004), 536.
2 Mark Strand and Eavan Boland, *The Making of a Poem: A Norton Anthology of Poetic Forms* (Norton, 2001), xxv.
3 Mary Oliver, *A Poetry Handbook* (Houghton Mifflin Harcourt, 1994), 122.
4 Dylan Thomas, quoted in Andrea Gibson and Megan Falley, *How Poetry Can Change Your Heart* (Chronicle Books, 2019), 12.
5 Lisa A. Crayton, *Reading and Interpreting the Works of Alice Walker* (Enslow Publishing, LLC, 2016), 95.
6 Rainer Maria Rilke, *Letters to a Young Poet* (Courier Dover Publications, 2021), 65.
7 Czeslaw Milosz, *The Witness of Poetry* (Harvard University Press, 1983), 25.
8 Annie Dillard, *The Writing Life* (Harper Perennial, 1990), 72.
9 Beginnings admittedly separated by thousands of years!
10 Piotr Kubiński, "Micropoetics and Video Games, or a Minimalistic Encomium to Short-Sightedness," Forum Poetyki (Forum of Poetics), 2017, http://fp.amu.edu.pl/micropoetics-and-video-games-or-a-minimalistic-encomium-to-short-sightedness," 63.
11 See Hallmark Greeting Cards et al.
12 The lenses of narratology and procedural rhetoric, respectively.
13 Derrida, "Che Cos'è La Poesia?" 536.
14 Derrida, 536.
15 Oliver, *A Poetry Handbook*, 122.

Appendix I: Tools and Resources for Finding and Making Game Poems

1 See discussion of *Dys4ia* in Chapter 7.
2 Which was itself inspired by DrPetter's sfxr, a tool made in connection with the 10th Ludum Dare game jam in 2007, which became a popular tool among indie game developers for several years thereafter.
3 Archive for Research in Archetypal Symbolism (ARAS), *The Book of Symbols. Reflections on Archetypal Images*. Much thanks to Elizabeth Swensen at UC Santa Cruz for introducing me to this rich volume.

Bibliography

Aarseth, Espen. "Genre Trouble: Narrativism and the Art of Simulation." In *First Person: New Media as Story, Performance, and Game*, edited by Noah Wardrip-Fruin and Pat Harrigan, 45–55. MIT Press, 2004.

Alcorn, Allan. *Pong*. Arcade. Atari, 1972.

Altice, Nathan. *Diving Bell*. Browser, HTML5, 2021. https://ex-writer.itch.io/diving-bell.

Altice, Nathan. "The Modest Fantasy of the Pico-8." *Paste Magazine*, January 22, 2016. https://www.pastemagazine.com/articles/2016/01/the-modest-fantasy-of-the-pico-8.html.

Anable, Aubrey. *Playing with Feelings: Video Games and Affect*. University of Minnesota Press, 2018.

Andrews, Bruce, and Charles Bernstein, eds. *L=A=N=G=U=A=G=E*. Magazine archive. Accessed May 3, 2019. http://eclipsearchive.org/projects/LANGUAGE/language.html.

Andrews, Jim. *Arteroids: The Poetry Sploder*. Vispo.com, 2017.

Angelou, Maya. *The Complete Poetry*. Random House, 2015.

Archive for Research in Archetypal Symbolism (ARAS). *The Book of Symbols. Reflections on Archetypal Images*. Illustrated edition. TASCHEN, 2010.

Asad, Mariam. "Making It Difficult: Modernist Poetry as Applied to Game Design Analysis." Master's thesis, Georgia Institute of Technology, 2011.

Avery-Weir, Gregory. *Silent Conversation*. Browser. Future Proof Games, 2009. https://futureproofgames.itch.io/silent-conversation.

Barfield, Owen. *Poetic Diction: A Study in Meaning*. Barfield Press UK, 2010.

Barr, Pippin. *A Series of Gunshots*. Browser. PippinBarr.com, 2015. https://www.pippinbarr.com/2015/11/19/a-series-of-gunshots/.

Barrows, Anita. *Rilke's Book of Hours: Love Poems to God*. Reprint edition. Riverhead Books, 2005.

Bateman, Chris. *Imaginary Games*. Zero Books, 2011.

Bateman, Chris, and Richard Boon. *21st Century Game Design*. Charles River Media, 2006.

Bazin, André, and Hugh Gray. "The Ontology of the Photographic Image." *Film Quarterly* 13, no. 4 (1960): 4–9. https://doi.org/10.2307/1210183.

Benmergui, Daniel. Road to the IGF: Daniel Benmergui's Today I Die. Interview by Kris Graft. Gamasutra, February 2, 2010. http://www.gamasutra.com/view/news/117979/Road_To_The_IGF_Daniel_Benmerguis_Today_I_Die.php.

Benmergui, Daniel. *Today I Die*. Browser, 2008. http://ludomancy.com/.

Blake, William. *Songs of Innocence and Songs of Experience*. Edited by Philip Smith. Dover, 2012.

Blau DuPlessis, Rachel. "Statement on Poetics." In *Inciting Poetics: Thinking and Writing Poetry*, edited by Jeanne Heuving and Tyrone Williams, 13–37. University of New Mexico Press, 2019.

Bogost, Ian. "Frame and Metaphor in Political Games." *Worlds in Play: International Perspectives on Digital Games Research* 21 (2007): 77.

Bogost, Ian. *How to Do Things with Videogames*. University of Minnesota Press, 2011.

Bogost, Ian. *Persuasive Games: The Expressive Power of Videogames*. MIT Press, 2007.

Bogost, Ian. *A Slow Year: Game Poems*. Open Texture, 2010.

Bogost, Ian. *Unit Operations: An Approach to Videogame Criticism*. MIT Press, 2008.

Bogost, Ian. "Video Games Are Better without Stories." *The Atlantic* 25 (2017).

Bogost, Ian. "Videogames Are a Mess." Keynote address presented at the Digital Games Research Association (DiGRA) conference, Uxbridge, UK, September 2009. http://bogost.com/writing/videogames_are_a_mess/.

Bradley, Adam. *Book of Rhymes: The Poetics of Hip Hop*. Basic Books, 2009.

Brandt, Line, and Per Aage Brandt. "Cognitive Poetics and Imagery." *European Journal of English Studies* 9, no. 2 (August 2005): 117–30. https://doi.org/10.1080/13825570500171861.

Brown, Harry J. *Videogames and Education*. Routledge, 2014. https://doi.org/10.4324/9781315698373.

Buckland, Warren. *The Cognitive Semiotics of Film*. Cambridge University Press, 2000.

Burns, Robert. *Reliques of Robert Burns: Consisting Chiefly of Original Letters, Poems, and Critical Observations on Scottish Songs*. Bradford and Inskeep, 1809.

Burrill, Derek. "Queer Theory, the Body, and Video Games." In *Queer Game Studies*, edited by Bonnie Ruberg and Adrienne Shaw, 25–34. University of Minnesota Press, 2017. http://www.jstor.org/stable/10.5749/j.ctt1mtz7kr.6.

Cantano, Antonio César Moreno. "Soledad y memoria en la obra de Jordan Magnuson." In *La vida en juego: la realidad a través de lo lúdico*, edited by Alberto Venegas and Antonio César Moreno Cantano, 57–84. AnaitGames, 2021.

Champion, Edward. "The Video Game as Art." *Reluctant Habits* (blog), January 21, 2008. http://www.edrants.com/the-video-game-as-art/.

Chung, Brendon. *Thirty Flights of Loving*. Windows, MacOS. Blendo Games, 2012.

Clark, Naomi. "What Is Queerness in Games, Anyway?" In *Queer Game Studies*, edited by Bonnie Ruberg and Adrienne Shaw, 3–14. University of Minnesota Press, 2017. http://www.jstor.org/stable/10.5749/j.ctt1mtz7kr.4.

Clarke, Andy, and Grethe Mitchell. *Videogames and Art*. Intellect Books, 2007.

Cohen, Ralph. "History and Genre." In *The Lyric Theory Reader: A Critical Anthology*, edited by Virginia Jackson and Yopie Prins, 53–63. JHU Press, 2014.

Cook, Jon, ed. *Poetry in Theory: An Anthology 1900–2000*. Blackwell, 2004.

Crayton, Lisa A. *Reading and Interpreting the Works of Alice Walker*. Enslow Publishing, LLC, 2016.

Crow, David. *Visible Signs: An Introduction to Semiotics in the Visual Arts*. 2nd ed. AVA Publishing, 2010.

Csikszentmihalyi, Mihaly. "Toward a Psychology of Optimal Experience." In *Flow and the Foundations of Positive Psychology*, 209–26. Springer, 2014.

Culler, Jonathan. *Theory of the Lyric*. Harvard University Press, 2015.

Daniels, Shonte. "Bitsy Makes It Easy to Design Small Narrative Games." *Paste Magazine*, January 18, 2018. https://www.pastemagazine.com/artic les/2018/01/bitsy-makes-it-easy-to-design-small-narrative-game.html.

De Lucena, Daniel Pettersen, and Rosilane Ribeiro da Mota. "Games as Expression: On the Artistic Nature of Games." In *Proceedings of SBGames 2017*, 812–21, 2017.

Derrida, Jacques. "Che Cos'è La Poesia?" In *Poetry in Theory: An Anthology 1900–2000*, edited by Jon Cook, 533–37. Blackwell, 2004.

Dickinson, Emily. *The Complete Poems of Emily Dickinson*. Edited by Thomas H. Johnson. Little, Brown and Company, 1960.

Dillard, Annie. *The Writing Life*. Harper Perennial, 1990.

dino (formerly nina). *Seasonal Mixtape*. Browser, HTML5. Itch.io, 2018.

Dowling, Sarah. "Ethos and Graphos." In *Inciting Poetics: Thinking and Writing Poetry*, edited by Jeanne Heuving and Tyrone Williams, 121–36. University of New Mexico Press, 2019.

Dubrow, Heather. "Lyric Forms." In *The Cambridge Companion to English Literature, 1500–1600*, edited by Arthur F. Kinney, 178–99. Cambridge Companions to Literature. Cambridge University Press, 1999. https://doi. org/10.1017/CCOL0521582946.009.

Eco, Umberto. *Postscript to The Name of the Rose*. Harcourt Brace Jovanovich, 1984.

Egenfeldt-Nielsen, Simon, Jonas Heide Smith, and Susana Pajares Tosca. *Understanding Video Games: The Essential Introduction*. Routledge, 2015.

Eliot, Thomas Stearns. "Reflections on Vers Libre." *New Statesman* 8, no. 204 (1917): 518.

Ensslin, Astrid. *Literary Gaming*. Illustrated edition. The MIT Press, 2014.

Eskelinen, Markku. "The Gaming Situation." *Game Studies* 1, no. 1 (2001): 68.

Extra Credits. "Mechanics as Metaphor – I: How Gameplay Itself Tells a Story." *YouTube*, November 2, 2003. https://www.youtube.com/watch?v=4Qwc I4iQt2Y.

Fagone, Jason. "The Video-Game Programmer Saving Our 21st-Century Souls." *Esquire*, November 20, 2008. https://www.esquire.com/features/best-and-brightest-2008/future-of-video-game-design-1208.

Felman, Shoshana. "On Reading Poetry: Reflections on the Limits and Possibilities of Psychoanalytical Approaches." In *Poetry in Theory: An Anthology 1900–2000*, edited by Jon Cook, 477–90. Blackwell, 2004.

Fish, Stanley. *Is There a Text in This Class? The Authority of Interpretive Communities*. Harvard University Press, 1982.

Frasca, Gonzalo. "Ludology Meets Narratology: Similitude and Differences Between (Video) Games and Narrative." Ludology, 1999. https://www.ludology.org/articles/ludology.htm.

Frasca, Gonzalo. *September 12th: A Toy World*. Browser. Newsgaming, 2010. http://www.newsgaming.com/games/index12.htm.

Frasca, Gonzalo. "Simulation Versus Narrative: Introduction to Ludology." In *The Video Game Theory Reader*, edited by Mark J. P. Wolf and Bernard Perron, 221–35. Routledge, 2003.

Freeman, Nina. Interview by Asher Penn. *Sex Magazine*, Summer 2014. http://sexmagazine.us/articles/nina-freeman.

Frye, Northrop. *Anatomy of Criticism: Four Essays*. Princeton University Press, 2020.

Frye, Northrop. "Theory of Genres." In *The Lyric Theory Reader: A Critical Anthology*, edited by Virginia Jackson and Yopie Prins, 30–39. JHU Press, 2014.

Fullerton, Tracy. *Game Design Workshop: A Playcentric Approach to Creating Innovative Games*. 2nd edition. Morgan Kaufmann, 2008.

Funkhouser, C. T. *New Directions in Digital Poetry*. A&C Black, 2012.

Funkhouser, Christopher Thompson. *Prehistoric Digital Poetry: An Archaeology of Forms, 1959–1995*. University of Alabama Press, 2007.

Gagnon, Diana. "Videogames and Spatial Skills: An Exploratory Study." *Educational Technology Research and Development* 33, no. 4 (December 1985): 263–75.

Galloway, Alexander R. "Social Realism in Gaming." *Game Studies* 4, no. 1 (2004). http://www.gamestudies.org/0401/galloway/.

Galvin, Mary E. *Queer Poetics: Five Modernist Women Writers*. Praeger, 1999.

Gard, Toby, and Core Design et al. *Tomb Raider*. Sega Saturn, PlayStation, MS-DOS. Eidos Interactive, 1996.

Gazzard, A., and A. Peacock. "Repetition and Ritual Logic in Video Games." *Games and Culture* 6, no. 6 (November 1, 2011): 499–512. https://doi.org/10.1177/1555412011431359.

Gazzard, Alison. *Mazes in Videogames: Meaning, Metaphor and Design.* McFarland, 2013.

Gee, James Paul. *What Video Games Have to Teach Us About Learning and Literacy.* Palgrave Macmillan, 2004.

Genette, Gérard. "Poetic Language, Poetics of Language." *Social Science Information* 7, no. 2 (1968): 141–61.

Genette, Gérard. *The Architext: An Introduction.* Quantum Books. University of California Press, 1992.

Gibson, Andrea, and Megan Falley. *How Poetry Can Change Your Heart.* Chronicle Books, 2019.

Gibson Dodd, Scott A. "Not-Games in Secondary English Language Arts." Master's thesis, University of Alberta, 2014.

Goguen, Joseph. "An Introduction to Algebraic Semiotics, With Application to User Interface Design." In *Computation for Metaphors, Analogy, and Agents,* edited by Chrystopher L. Nehaniv, 242–91. Springer-Verlag, 1998.

Goguen, Joseph. "Semiotic Morphisms." Technical Report CS97–553, Dept. Computer Science & Eng., UCSD, 1997.

Google Female Rapper—Kellee Maize, 2012. https://www.youtube.com/watch?v=VhhdXG5UM2o.

Grace, Lindsay D. "The Poetics of Game Design, Rhetoric and the Independent Game." In *Proceedings of DiGRA 2011 Conference: Think Design Play,* 2011. https://www.researchgate.net/publication/262250050_The_Poetics_of_Game_Design_Rhetoric_and_the_Independent_Game.

Griffiths, Mark D. "The Educational Benefits of Videogames." *Education and Health* 20, no. 3 (2002): 47–51.

Hall, David D., ed. *Puritans in the New World: A Critical Anthology.* Princeton University Press, 2004.

Hamburger, Käte. *The Logic of Literature.* Indiana University Press, 1993.

Harman, Graham. *Object-Oriented Ontology: A New Theory of Everything.* Penguin UK, 2018.

Harrell, D. Fox. *Phantasmal Media: An Approach to Imagination, Computation, and Expression.* MIT Press, 2013.

Harrigan, Pat, and Noah Wardrip-Fruin. *Second Person: Role-Playing and Story in Games and Playable Media.* MIT Press, 2010.

Harvey, Auriea, and Michaël Samyn. *The Graveyard.* Windows, MacOS. Tale of Tales, 2009.

Hass, Robert. *A Little Book on Form: An Exploration into the Formal Imagination of Poetry.* Ecco, 2017.

Hawreliak, Jason. *Multimodal Semiotics and Rhetoric in Videogames.* Routledge, 2018.

Hayles, N. Katherine. *Electronic Literature: New Horizons for the Literary.* University of Notre Dame, 2008.

Hegel, Georg Wilhelm Friedrich. *Aesthetics: Lectures on Fine Art.* Clarendon Press, 1998.

Hejinian, Lyn. *The Language of Inquiry.* University of California Press, 2000.

Heuving, Jeanne, and Tyrone Williams, eds. *Inciting Poetics: Thinking and Writing Poetry.* University of New Mexico Press, 2019.

Holmes, Steve. *The Rhetoric of Videogames as Embodied Practice: Procedural Habits*. Routledge, 2017.

Homan, Daniel, and Sidney Homan. "The Interactive Theater of Video Games: The Gamer as Playwright, Director, and Actor." *Comparative Drama* 48, no. 1–2 (2014): 169–86. https://doi.org/10.1353/cdr.2014.0000.

Hong, Sun-ha. "When Life Mattered: The Politics of the Real in Video Games' Reappropriation of History, Myth, and Ritual." *Games and Culture* 10, no. 1 (January 2015): 35–56. https://doi.org/10.1177/1555412014557542.

Howe, Julia Ward. *Words for the Hour*. Ticknor and Fields, 1857.

Huizinga, Johan. *Homo Ludens*. Routledge, 1949.

Humble, Rod. *The Marriage*. Windows, 2007. https://www.rodvik.com/rodgames/marriage.html.

"Hundertwasser—Text Detail." Accessed September 26, 2022. https://www.hundertwasser.com/en/texts/vom_schoepferisch_wissenden_zum_unwissenden.

Isbister, Katherine. *How Games Move Us: Emotion by Design*. MIT Press, 2017.

Jackson, Virginia, and Yopie Prins, eds. *The Lyric Theory Reader: A Critical Anthology*. JHU Press, 2014.

Jackson, Virginia Walker. *Dickinson's Misery: A Theory of Lyric Reading*. Princeton University Press, 2005.

Jakobson, Roman. "Linguistics and Poetics." In *Style in Language*, 350–77. MIT Press, 1960.

Museum of Modern Art. "Jason Rohrer. Passage. 2007 | MoMA." Accessed September 24, 2022. https://www.moma.org/collection/works/145533.

Johnson, Mark. *The Body in the Mind: The Bodily Basis of Meaning, Imagination, and Reason*. University of Chicago Press, 2013.

Johnson, W. R. "On the Absence of Ancient Lyric Theory." In *The Lyric Theory Reader: A Critical Anthology*, edited by Virginia Jackson and Yopie Prins, 91–103. JHU Press, 2014.

Johnston, Philip G. *The Power of Paradox in the Work of Spanish Poet Antonio Machado (1875–1939)*. Edwin Mellen Press, 2002.

Juul, Jesper. "Fear of Failing? The Many Meanings of Difficulty in Video Games." In *The Video Game Theory Reader 2*, edited by Mark J. P. Wolf and Bernard Perron, 237–52. Routledge, 2009. https://www.jesperjuul.net/text/fearoffailing/.

Kapell, Matthew Wilhelm, and Andrew B. R. Elliott. *Playing with the Past: Digital Games and the Simulation of History*. Bloomsbury Publishing USA, 2013.

Keogh, Brendan. *A Play of Bodies: How We Perceive Videogames*. MIT Press, 2018.

King, Stephen. *On Writing: A Memoir of the Craft*. Simon and Schuster, 2020.

Kokonis, Michalis. "Intermediality Between Games and Fiction: The 'Ludology vs. Narratology' Debate in Computer Game Studies: A Response to Gonzalo Frasca." *Acta Universitatis Sapientiae, Film and Media Studies* 9, no. 1 (January 1, 2014). https://doi.org/10.1515/ausfm-2015-0009.

Kopas, Merritt. "Ludus Interruptus: Video Games and Sexuality." In *The State of Play: Creators and Critics on Video Game Culture.*, edited by Daniel Goldberg and Linus Larsson, n.p. Seven Stories Press, 2015.

Koster, Raph. "The Gametrekking Omnibus." Raph's Website, September 25, 2012. https://www.raphkoster.com/2012/09/25/the-gametrekking-omnibus/.

Koster, Raph. *Theory of Fun for Game Design*. O'Reilly Media, 2013.

Kovecses, Zoltan. *Metaphor: A Practical Introduction*. Oxford University Press, 2010.

Kristeva, Julia. "The Ethics of Linguistics." In *Poetry in Theory: An Anthology 1900–2000*, edited by Jon Cook, 437–46. Blackwell, 2004.

Kromhout, Roelf, and Charles Forceville. "Life Is a Journey: Source–Path–Goal Structure in the Videogames 'Half-Life 2', 'Heavy Rain', and 'Grim Fandango.'" *Metaphor and the Social World* 3, no. 1 (2013): 100–116. https://doi.org/10.1075/msw.3.1.05for.

Kubiński, Piotr. "Micropoetics and Video Games, or a Minimalistic Encomium to Short-Sightedness." Forum Poetyki (Forum of Poetics), 2017. http://fp.amu.edu.pl/micropoetics-and-video-games-or-a-minimalistic-encomium-to-short-sightedness/.

Lakoff, George. *Philosophy in the Flesh*. Basic Books, 1999.

Larson, Sarah. "Jason Rohrer and the Art of the Video Game." *The New Yorker*, June 23, 2016. https://www.newyorker.com/culture/culture-desk/jason-rohrer-and-the-art-of-the-video-game.

Lauteren, Georg. "The Pleasure of the Playable Text: Towards an Aesthetic Theory of Computer Games." In *Computer Games and Digital Cultures Conference Proceedings*. Tampere University Press, 2002.

Lerer, Seth. "The Genre of the Grave and the Origins of the Middle English Lyrics." *Modern Language Quarterly* 58, no. 2 (June 1, 1997): 127–61. https://doi.org/10.1215/00267929-58-2-127.

"Literary Analysis: Art Games." *YouTube*, December 15, 2014. https://www.youtube.com/watch?v=l0OQQtIeEKI&list=PLgd64Tsovv9l15p9klJCOqSz3BsxBhFQH&index=9&t=7s.

Longfellow, Henry Wadsworth. *The Complete Poetical Works of Henry Wadsworth Longfellow*. Houghton, Mifflin and Company, 1920.

MacGregor, Jody. "What I Talk About When I Talk About Endless Running." ZAM, 2016. https://web.archive.org/web/20160526133836/http://www.zam.com:80/article/548/what-i-talk-about-when-i-talk-about-endless-running.

MacLeish, Archibald. *Collected Poems, 1917–1982* (Houghton Mifflin, 1985).

Magnuson, Jordan. *A Brief History of Cambodia*. Browser. NecessaryGames.com, 2012. https://www.necessarygames.com/my-games/brief-history-cambodia.

Magnuson, Jordan. "[AGBIC] Walk or Die (Open Source) [FINISHED]." TIGForums, July 26, 2010. https://forums.tigsource.com/index.php?topic=14085.

Magnuson, Jordan. "Canabalt: A One Button Miracle." Necessary Games, 2009. https://www.necessarygames.com/reviews/canabalt-game-free-download-independent-browser-platformer-sci-fi-singleplayer-casual-gamers.

Magnuson, Jordan. *First Smile*. Windows, MacOS, Browser, HTML5. In *Meditations*, 2018. https://meditations.games/.

Magnuson, Jordan. *Freedom Bridge*. Browser, 2010. https://www.necessarygames.com/my-games/freedom-bridge.

Magnuson, Jordan. *Grandmother*. Browser, Adobe Flash, HTML5. Gametrekking. com, 2011. https://www.gametrekking.com/the-games/vietnam/grandmot her/play-now.

Magnuson, Jordan. *The Heart Attack*. Browser, Adobe Flash, HTML5. Gametrekking.com, 2011. https://www.gametrekking.com/the-games/viet nam/the-heart-attack.

Magnuson, Jordan. *The Killer*. Browser, Adobe Flash, HTML5. Gametrekking. com, 2011. https://www.gametrekking.com/the-games/cambodia/the-killer.

Magnuson, Jordan. *Loneliness*. Browser. NecessaryGames.com, 2010. https:// www.necessarygames.com/my-games/loneliness.

Magnuson, Jordan. *Portraits of My Child*. Browser, HTML5, Windows. NecessaryGames.com, 2018.

Magnuson, Jordan. *Stations of the Cross*. Videogame installation. University of California, Santa Cruz, 2017.

Magnuson, Jordan. *Walking with Magnus*. Browser, Adobe Flash, HTML5, Windows, MacOS. NecessaryGames.com, 2018.

Magnuson, Jordan. *When Gold Is in the Mountain*. Browser, HTML5, Windows. NecessaryGames.com, 2018.

Marino, Mark C. *Critical Code Studies*. MIT Press, 2020.

Marshall, P. David. "Technophobia: Video Games, Computer Hacks and Cybernetics." *Media International Australia* 85, no. 1 (November 1997): 70–78. https://doi.org/10.1177/1329878X9708500111.

Mateas, Michael. "A Preliminary Poetics for Interactive Drama and Games." *Digital Creativity* 12, no. 3 (September 1, 2001): 140–52. https://doi.org/ 10.1076/digc.12.3.140.3224.

Mateas, Michael, and Noah Wardrip-Fruin. "Defining Operational Logics." In *Breaking New Ground: Innovation in Games, Play, Practice, and Theory; Proceedings of DiGRA 2009*. DiGRA, 2009.

Matthews, William. "Dull Subjects." *New England Review and Bread Loaf Quarterly* 8, no. 2 (1985): 142–52.

Mawhorter, Peter, Michael Mateas, Noah Wardrip-Fruin, and Arnav Jhala. "Towards a Theory of Choice Poetics." In *Proceedings of the 9th International Conference on the Foundations of Digital Games*. Ft. Lauderdale, FL, 2014. http://www.fdg2014.org/papers/fdg2014_paper_19.pdf.

Mayakovsky, Vladimir. "How Are Verses Made?" In *Poetry in Theory: An Anthology 1900–2000*, edited by Jon Cook, 144–55. Blackwell, 2004.

McCabe, Susan. *Cinematic Modernism: Modernist Poetry and Film*. Cambridge University Press, 2005.

McCloud, Scott. *Understanding Comics*. Harper Collins, 1994.

McGonigal, Jane. *Reality Is Broken: Why Games Make Us Better and How They Can Change the World*. Penguin, 2011.

Merton, Thomas. *The Way of Chuang Tzu*. 2nd edition. New Directions, 2010.

Metz, Christian. *Film Language: A Semiotics of the Cinema*. University of Chicago Press, 1991.

Meyers, Rachel Elizabeth. "In Search of an Author: From Participatory Culture to Participatory Authorship." Master's thesis, Brigham Young University, 2014.

Miles, Barry. *Ginsberg: A Biography*. Simon and Schuster, 1989.

Mill, John Stuart. "Thoughts on Poetry and Its Varieties." *The Crayon* 7, no. 5 (1860): 123–28. https://doi.org/10.2307/25528049.

Milosz, Czeslaw. *The Witness of Poetry*. Harvard University Press, 1983.

Miner, Earl. "Why Lyric?" In *The Lyric Theory Reader: A Critical Anthology*, edited by Virginia Jackson and Yopie Prins, 577–89. JHU Press, 2014.

Mitchell, Alex. "Antimimetic Rereading and Defamiliarization in Save the Date." In *Proceedings of DiGRA* 2018, 17.

Mitchell, Alex. "Making the Familiar Unfamiliar: Techniques for Creating Poetic Gameplay." In *Proceedings of DiGRA* 2016, 16.

Mitchell, Alex, Yuin Theng Sim, and Liting Kway. "Making It Unfamiliar in the 'Right' Way." *In Proceedings of DiGRA* 2017, 18.

Miyamoto, Shigeru, Takashi Tezuka, and Nintendo EAD et al. *The Legend of Zelda*. NES. Nintendo, 1986.

Miyamoto, Shigeru, Yoshiaki Koizumi, Takashi Tezuka, and Nintendo EAD et al. *Super Mario 64*. Nintendo 64. Nintendo, June 23, 1996.

Montfort, Nick. "PvP: Portal versus Passage." *Grand Text Auto* (blog), February 24, 2008. https://grandtextauto.soe.ucsc.edu/2008/02/24/pvp-portal-versus-passage/.

Montfort, Nick. "Taroko Gorge," 2009. https://nickm.com/taroko_gorge/.

Montfort, Nick. *Twisty Little Passages: An Approach to Interactive Fiction*. MIT Press, 2005.

Montfort, Nick, Patsy Baudoin, John Bell, Ian Bogost, Jeremy Douglass, Mark C. Marino, Michael Mateas, Casey Reas, Mark Sample, and Noah Vawter. *10 PRINT CHR$(205.5+RND(1));: GOTO 10*. MIT Press, 2012.

Montfort, Nick, and Ian Bogost. *Racing the Beam: The Atari Video Computer System*. MIT Press, 2009.

Möring, Sebastian. "Games and Metaphor: A Critical Analysis of the Metaphor Discourse in Game Studies." PhD diss., IT University of Copenhagen, 2014.

Müller-Zettelmann, Eva. *Lyrik Und Metalyrik*. Winter, 2000.

Müller-Zettelmann, Eva, and Margarete Rubik, eds. *Theory into Poetry: New Approaches to the Lyric*. Rodopi, 2005.

Murray, Janet. "Did It Make You Cry? Creating Dramatic Agency in Immersive Environments." In *International Conference on Virtual Storytelling*, 83–94. Springer, 2005.

Murray, Janet. *Hamlet on the Holodeck: The Future of Narrative in Cyberspace*. MIT Press, 1997.

Murray, Janet H. "The Last Word on Ludology v Narratology in Game Studies." In *Proceedings of the 2005 Digra International Conference: Changing Views: Worlds in Play*. DiGRA, 2005. https://www.researchgate.net/publication/251172237_The_Last_Word_on_Ludology_v_Narratology_in_Game_Studies.

Murray, Soraya. *On Video Games: The Visual Politics of Race, Gender and Space*. I.B. Tauris, 2017.

Nänny, Max. "Diagrammatic Iconicity in Poetry." In *Theory into Poetry: New Approaches to the Lyric*, edited by Eva Müller-Zettelmann and Margarete Rubik, 229–49. Rodopi, 2005.

Nelson, Jason. "Game, Game, Game and Again Game." *The Electronic Literature Collection Volume 2* (2007).

Nichols, Bill. "The Work of Culture in the Age of Cybernetic Systems." *Screen* 29, no. 1 (Winter 1988): 22–47. https://doi.org/10.1093/screen/29.1.22.

Nielsen, Aldon. "White Mischief." In *Inciting Poetics: Thinking and Writing Poetry*, edited by Jeanne Heuving and Tyrone Williams, 137–54. University of New Mexico Press, 2019.

Norris, Kathleen. *The Cloister Walk*. Penguin, 1997.

Oldenburg, Aaron. "Abstracting Evidence: Documentary Process in the Service of Fictional Gameworlds." *Game Studies* 17, no. 1 (July 2017): 18.

Oliver, Mary. *A Poetry Handbook*. Houghton Mifflin Harcourt, 1994.

Olsen, Redell. *Film Poems*. Les Figues Press, 2014.

Osborn, Joseph C., Noah Wardrip-Fruin, and Michael Mateas. "Refining Operational Logics." In *Proceedings of the 12th International Conference on the Foundations of Digital Games*, 1–10. ACM Press, 2017. https://doi.org/10.1145/3102071.3102107.

Ota, Yoshihiko, Katsunori Okita, Kazuya Takahashi, Konami, and Bemani et al. *Dance Dance Revolution (DDR)*. Arcade. Konami, 1998.

Othenin-Girard, Alexei. "Bodies, Games, and Systems: Towards an Understanding of Embodiment in Games." Master's thesis, UCSC, 2012.

Papa, Thomas J. *Poetic Videogames: A Haiku Perspective*. Mimicry Games, 2014.

Papas, Robert, and Konami et al. *Frogger*. Arcade. Sega, 1981.

Parkin, Simon. "Don't Stop: The Game That Conquered Smartphones." *The New Yorker*, June 7, 2013. https://www.newyorker.com/tech/annals-of-technology/dont-stop-the-game-that-conquered-smartphones.

Pate, Alexs. *In the Heart of the Beat: The Poetry of Rap*. Scarecrow Press, 2009.

Pearson, Hesketh. *Oscar Wilde: His Life and Wit*. Harper & Bros., 1946.

Pedercini, Paolo. "Top Ten 2015 Games You Don't Have to Play." *La Molleindustria*, January 3, 2016. http://www.molleindustria.org/blog/top-ten-2015-games-you-dont-have-to-play/.

Pedercini, Paolo. "Videogames and the Spirit of Capitalism." La Molleindustria, February 14, 2014. http://www.molleindustria.org/blog/videogames-and-the-spirit-of-capitalism/.

Peirce, Charles Sanders. *Writings of Charles S. Peirce: 1879–1884*. Indiana University Press, 1982.

Perloff, Marjorie. "Avant-Garde or Endgame?" In *Poetry in Theory: An Anthology 1900–2000*, edited by Jon Cook, 547–58. Blackwell, 2004.

Perloff, Marjorie. "Poetry on the Brink: Reinventing the Lyric." *Boston Review*. Accessed March 2, 2022. https://bostonreview.net/forum/poetry-brink/.

Poremba, Cynthia Katherine. "Real|Unreal: Crafting Actuality in the Documentary Videogame." PhD thesis, Concordia University, 2011.

Pound, Ezra. "In a Station of the Metro." *Poetry* 2, no. 1 (1913): 12.

Preminger, Alex, Frank J. Warnke, and O. B. Hardison Jr. *Princeton Encyclopedia of Poetry and Poetics*. Princeton University Press, 2015.

Prensky, Marc. "Fun, Play and Games: What Makes Games Engaging." *Digital Game-Based Learning* 5, no. 1 (2001): 5–31.

Ramazani, Jahan. *Poetry and Its Others: News, Prayer, Song, and the Dialogue of Genres*. University of Chicago Press, 2013.

Reed, Anthony. "The Erotics of Mourning in Recent Experimental Black Poetry." *The Black Scholar* 47, no. 1 (January 2, 2017): 23–37. https://doi.org/10.1080/00064246.2017.1264851.

Rettberg, Scott. *Electronic Literature*. John Wiley & Sons, 2018.

"Rhetoric, n.1." In *Oxford English Dictionary*. Oxford University Press, June 2010. http://www.oed.com/view/Entry/165178.

Richert, Marcus. *Passage in 10 Seconds*. Browser. Kongregate.com, 2010. https://www.kongregate.com/games/raitendo/passage-in-10-seconds.

Rilke, Rainer Maria. *Letters to a Young Poet*. Courier Dover Publications, 2021.

Robinett, Warren. *Adventure*. Atari 2600. Atari, 1979.

Robinson, Marilynne. "Marilynne Robinson on Finding the Right Word." *New York Times*, September 22, 2017, sec. Book Review. https://www.nytimes.com/2017/09/22/books/review/marilynne-robinson-on-finding-the-right-word.html.

Rohrer, Jason. *Passage*. Windows, MacOS, Linux, 2007. http://hcsoftware.sourceforge.net/passage/.

Rohrer, Jason. "What I Was Trying to Do With Passage." SourceForge, November 2007. http://hcsoftware.sourceforge.net/passage/statement.html.

Romero, John, John Carmack, Sandy Peterson, American McGee, Shawn Green, and id Software et al. *Doom*. MS-DOS. id Software, 1993.

Ruberg, Bonnie. *Video Games Have Always Been Queer*. New York University Press, 2019.

Ruberg, Bonnie, and Adrienne Shaw. *Queer Game Studies*. University of Minnesota Press, 2017.

Rudin, David. "A Series of Gunshots Calls Out Senseless Gun Violence in Games." *Kill Screen*, November 19, 2015. https://killscreen.com/articles/a-series-of-gunshots-calls-out-senseless-gun-violence-in-games/.

Ruiz, Susana, Benjamin Stokes, and Jeff Watson. "Mobile and Locative Games in the 'Civic Tripod': Activism, Art and Learning." *International Journal of Learning and Media* 3, no. 3 (July 2011). https://doi.org/10.1162/ijlm_a_00078.

Rukeyser, Muriel. *The Life of Poetry*. Paris Press, 1996.

Rusch, Doris C. *Making Deep Games: Designing Games with Meaning and Purpose*. CRC Press, 2017.

Russell, Steve. *Spacewar!* PDP-1, 1962.

Saint-Martin, Fernande. *Semiotics of Visual Language*. Indiana University Press, 1990.

Salen, Katie, and Eric Zimmerman. *Rules of Play: Game Design Fundamentals.* MIT Press, 2004.

Saltsman, Adam. *Canabalt.* Browser, Adobe Flash, HTML5. Semi-Secret Software, 2009. http://canabalt.com/.

Saltsman, Adam. *Fathom.* Browser, Adobe Flash, 2009.

Schell, Jesse. *The Art of Game Design: A Book of Lenses.* CRC Press, 2008.

Scott, Clive. *Spoken Image: Photography and Language.* Reaktion Books, 1999.

Sezen, Diğdem. "Narrative Explorations in Videogame Poetry." In *Interactive Digital Narrative: History, Theory and Practice,* edited by Hartmut Koenitz, Gabriele Ferri, Mads Haahr, Diğdem Sezen, and Tonguç İbrahim Sezen, 227–40. Routledge, 2015.

Shakespeare, William. *Shakespeare's Sonnets.* American Book Company, 1905.

Shakespeare, William. *The Tragedy of Macbeth.* Edited by Ebenezer Charlton Black and Andrew Jackson George. Ginn and Company, 1908.

Shelley, Percy Bysshe. *The Complete Poetical Works of Percy Bysshe Shelley.* Edited by George Edward Woodberry. Houghton, Mifflin Company, 1901.

Shelley, Percy Bysshe, Patrick Garland, Richard Marquard, and Gary Watson. *A Defence of Poetry.* Haldeman-Julius, 1969.

Shyba, Lori. "The Spontaneous Playfulness of Creativity: Lessons from Interactive Theatre for Digital Games." In *Situated Play: Proceedings of the 2007 DiGRA International Conference.* Authors & Digital Games Research Association (DiGRA), 2007.

Sidhu, Sonny. "Poetics of the Videogame Setpiece." Master's thesis, MIT, 2013.

Silliman, Ron. "The New Sentence." In *The New Sentence,* 63–93. Roof Books, 1987.

Soderman, Braxton. "Intrinsic Motivation: FlOw, Video Games, and Participatory Culture." Edited by Rebecca Carlson. *Transformative Works and Cultures* 2 (March 15, 2009). https://doi.org/10.3983/twc.2009.097.

Speranza, Robert Scott. "Verses in the Celluloid: Poetry in Film from 1910–2002, With Special Attention to the Development of the Film-Poem." PhD thesis, University of Sheffield, 2002.

Squire, Kurt. "From Content to Context: Videogames as Designed Experience." *Educational Researcher* 35, no. 8 (2006): 19–29.

Stafford, William. *Ask Me: 100 Essential Poems of William Stafford.* Graywolf Press, 2014.

Stations of the Cross Art Game Installation. Documentary video. *YouTube,* 2018. https://www.youtube.com/watch?v=Kolo3e54aiw.

Stone, Jon. *Dual Wield: The Interplay of Poetry and Videogames.* De Gruyter Oldenbourg, 2022.

Strand, Mark, and Eavan Boland. *The Making of a Poem: A Norton Anthology of Poetic Forms.* Norton, 2001.

Strickland, Stephanie, and Cynthia Lawson Jaramillo. "V: Vniverse," 2002. http://www.stephaniestrickland.com/vniverse.

Tavinor, Grant. *The Art of Videogames.* John Wiley & Sons, 2009.

Tale of Tales. "The Graveyard." Accessed December 13, 2017. http://tale-of-tales. com/TheGraveyard/.

Thompson, Clive. "Poetic Passage Provokes Heavy Thoughts on Life, Death." *Wired*, April 21, 2008. https://www.wired.com/2008/04/gamesfrontiers-421/.

Trans, Nate. "Video Game Poetry." Video Game Expressionism, January 25, 2011. http://mr-wonderful.blogspot.com/2011/01/video-game-poetry.html?q= video+game+poetry.

Trimarco, Paola. *Digital Textuality*. Macmillan International Higher Education, 2014.

"U B U W E B:: Anthology of Conceptual Writing." Accessed March 9, 2022. https://www.ubu.com/concept/.

Valéry, Paul. *Tel quel*. Editions Gallimard, 2016.

Velasco, Sean, Michael Herbster, Alec Faulkner, and Yacht Club Games et al. *Shovel Knight*. Windows, Nintendo 3DS, Wii U. Yacht Club Games, 2014.

Vendler, Helen. *The Art of Shakespeare's Sonnets*. Harvard University Press, 1999.

Vertov, Dziga. *Kino-Eye: The Writings of Dziga Vertov*. University of California Press, 1984.

Wade, Jessie. "Jason Rohrer Explains How He Creates Art in Games—Humans Who Make Games Episode 4." *IGN*, February 6, 2019. https://www.ign.com/ articles/2019/02/06/jason-rohrer-explains-how-he-creates-art-in-games-a- humans-who-make-games-episode-4.

Wagner, Rachel. *Godwired: Religion, Ritual and Virtual Reality*. Routledge, 2012.

Walker, Richard Lee. "Ghosts of the Horseshoe: A Mobilization of a Critical Interactive." PhD diss., University of South Carolina, 2014.

Wardrip-Fruin, Noah. "Beyond Shooting and Eating: Passage, Dys4ia, and the Meanings of Collision." *Critical Inquiry* 45, no. 1 (2018): 137–67.

Wardrip-Fruin, Noah. *Expressive Processing: Digital Fictions, Computer Games, and Software Studies*. MIT Press, 2009.

Wardrip-Fruin, Noah. *How Pac-Man Eats*. The MIT Press, 2020.

Wardrip-Fruin, Noah, and Pat Harrigan, eds. *First Person: New Media as Story, Performance, and Game*. MIT Press, 2004.

Wees, William C. "Poetry-Films and Film Poems." *Film Poems' Programme Notes*, 1999.

Wees, William C. "The Poetry Film." In *Words & Moving Images: Essays on Verbal and Visual Expression in Film and Television*, edited by William C. Wees and Michael Dorland, 105–113. Médiatexte Publications, 1984.

White, Gillian. *Lyric Shame: The "Lyric" Subject of Contemporary American Poetry*. Harvard University Press, 2014.

Williams, William Carlos. *The Collected Poems of William Carlos Williams: 1909– 1939*. New Directions Publishing, 1986.

Wittgenstein, Ludwig. *Philosophical Investigations*. John Wiley & Sons, 2010.

Wolf, Werner. "The Lyric: Problems of Definition and a Proposal for Reconceptualisation." In *Theory Into Poetry: New Approaches to the Lyric*, edited by Eva Müller-Zettelmann and Margarete Rubik, 21–56. Rodopi, 2005.

Wordsworth, William, and Samuel Taylor Coleridge. *Lyrical Ballads: 1798 and 1802*. Oxford University Press, 2013.

Wright, Will. *SimCity*. Amiga, Commodore 64, MS-DOS, Mac OS. Maxis, 1989.

Zagal, José P., Michael Mateas, Clara Fernández-Vara, Brian Hochhalter, and Nolan Lichti. "Towards an Ontological Language for Game Analysis." In *Proceedings of DiGRA 2005 Conference: Changing Views—Worlds in Play*. Authors & Digital Games Research Association (DiGRA), 2005.

Zlatev, Jordan. "Cognitive Semiotics: An Emerging Field for the Transdisciplinary Study of Meaning." *The Public Journal of Semiotics* 4, no. 1 (2012): 2–24.